Mario Erasmo is Professor of Clas[...]
He is the author of several books o[...]
and the cultural history of Italy, in[...]
Rome (2008), *Death: Antiquity and Its Legacy* (I.B. Tauris, 2012), and
Strolling Through Rome: The Definitive Walking Guide to the Eternal City
(I.B.Tauris, 2014). He has extensive experience leading tours through-
out Europe.

Praise for *Strolling through Rome*:

'Erasmo successfully brings Rome's rich and varied history to life. Art, architecture, urban life and a sense of "being" are combined in this essential read.'

– Wanderlust

'Comprehensive … encyclopaedic in its knowledge and full of enthusiasm for its subject … completing these walks would be deeply satisfying.'

– The Lady

'Eloquent … Erasmo's expertise on Rome's ancient history is evident but he is also strong on Rome's modern history.'

– Good Book Guide

STROLLING
THROUGH FLORENCE

THE DEFINITIVE WALKING GUIDE
TO THE RENAISSANCE CITY

MARIO ERASMO

I.B. TAURIS
LONDON · NEW YORK

Published in 2018 by
I.B.Tauris & Co. Ltd
London • New York
www.ibtauris.com

ISBN: 978 1 78076 214 2
eISBN: 978 1 78672 276 8
ePDF: 978 1 78673 276 7

A full CIP record for this book is available from the British Library
A full CIP record is available from the Library of Congress

Library of Congress Catalog Card Number: available

Typeset by Free Range Book Design & Production Limited

Contents

List of Illustrations

Images are photographed and supplied by the author with the exception of 3, 6, and 11 which are in the public domain.

All maps@OpenStreetMap Contributors. Data is available under the Open Database License.

Acknowledgements

I am grateful for the kind assistance and encouragement from Danielle Carrabino, Jeff Curto, Dora Erasmo, Josh Koons, Christopher P. Robinson, and Kristine Schramer. I owe special thanks to Tatiana Wilde and the editorial staff at I.B.Tauris.

Preface

Florence, the cradle of the Renaissance, with medieval streets winding into darkness, brooding towers, serene Madonnas in street shrines and David reenacting his victory over Goliath simultaneously all over the city is also the contemporary city of high fashion and a thriving arts community. Flowing through the city is the Arno under the Ponte Vecchio that connects Palazzo Vecchio in Piazza della Signoria to the area of Oltrarno ('across the Arno') dominated by Palazzo Pitti the home of the Medici following Cosimo I's rise to Duke and later Grand Duke of Tuscany. Strolling through the historic streets of Florence is a walk through time in the footsteps of the now anonymous craftsmen and workers who turned Florence into a thriving commercial centre and built the monuments such as Brunelleschi's dome and the famous Florentines that populate the annals of history: political leaders, popes, authors, artists, scientists, explorers, and visitors, including Dante, Filippo, Brunelleschi, Lorenzo the Magnificent, Pope Leo X de' Medici, Galileo, Michelangelo, Leonardo da Vinci, Mona Lisa, Giovanni da Verrazzano, Sir Robert Dudley, Charles Edward Stuart, and the Brownings.

Tours are sequential but may also be taken in any order. The walking distance of tours and times will vary depending on the number of sites visited. Many itineraries include options to visit additional sites requiring a longer stroll or transportation by ATAF, Florence's public transportation system. Stroll on!

INTRODUCTION

The Renaissance City

Florence, the Renaissance City synonymous with the Medici and the birth of humanism and modern science, sits proudly under the shadow of Brunelleschi's Dome with the Arno River cutting through the Historic Centre (Centro Storico) and Oltrarno. The rivalry between the four quarters of the historic city centre is now played out in the Calcio Storico in Piazza Santa Croce but civic pride is still focused on the Florentine lily, the *giglio* and *Marzocco*, the lion symbol of the city protected by its patron saint, John the Baptist.

The region of Tuscany with hilltop medieval towns over rolling hills neatly ordered with rows of grape vines and olive groves owes its origins to the **Etruscans** of ancient Etruria whose League of Twelve Cities stretched as far south as Rome. The modern identity of Tuscany, however, is connected to the birth of antiquarianism and archaeology through the exploration of Etruscan necropolis and sacred sites beginning in the 17th century that revealed a sophisticated culture in contact with the Greeks, Phoenicians and Romans. D. H. Lawrence's *Etruscan Places* animated the sites and tombs of the Etruscans for a generation of readers and travellers, as Henry James before him, looking for the unspoiled Italy of before Italian Unification.

The Romans founded ancient **Florentia** as a fortified town in the strategic location in the Arno valley already inhabited by the Etruscans in the neighbouring hilltop town of Fiesole. The civic heart of the town was centred on the Forum area of modern-day Piazza della Repubblica. Monumental construction in the early Imperial period included public buildings such as the theatre and amphitheatre. After the fall of the western Empire and the growing power of the

papacy, Rome emerged as the spiritual *Caput Mundi* centred on the tomb of St. Peter that attracted both dignitaries and pilgrims. Other cities and towns declined in importance but the location of Florence ensured its relevance. St. Ambrose consecrated the first basilica in Florence in 393 dedicated to St. Lawrence. Monasteries founded by St. Benedict in Italy provided important cultural and communication links between the Classical and medieval worlds. The consular roads of ancient Rome continued to connect cities all over Italy to the former capital of the Roman Empire even as incursions by the Visigoths and Lombards threatened communication and travel north of Florence to the Byzantine-controlled city of Ravenna.

Rome is built over successive layers of habitation stretching back to the city's legendary founding by Romulus in 753 BCE, but Florence founded around 700 years later, was a provincial town with fewer monuments than the Imperial capital that could be quarried and reused in later periods. The few lapsed monuments of Roman Florentia in the Middle Ages were used to transform the ancient city into a medieval commercial centre with robust wool and leather industries. Powerful families, often from strongholds built on the sites of ancient ruins, controlled various parts of the city and access across the Arno especially the area around Piazza Santa Croce. The medieval skyline was dominated by tall menacing towers such as those at San Gimignano and the Arno was lined with commercial and factory activity controlled by **guilds**, especially the powerful wool and cloth merchant guild Arte di Calimala that commissioned civic and religious art and architecture. Against this backdrop was the ferocious factional strife between the **Guelphs** and **Ghibellines** that defined the 12th to 14th centuries. The historic centre is largely the creation of late 19th-century Neo-Renaissance renovations of sites like the Bargello and the destruction of historic monuments due to the modernizing of areas following Italian Unification.

The rebirth (the meaning of the term Renaissance) of Classical antiquity in Florence through humanism that is synonymous with Michelangelo's *David* begins earlier with the transition from Gothic art of the Middle Ages to the art and literature of the early Renaissance. The towering figures of **Cimabue** in art and **Arnolfo di Cambio** in architecture in the 13th century anticipate the increasing naturalism of **Giotto** who was in Rome for the Jubilee of 1300. Giotto's increased

appreciation of the monumentality of ancient Rome and perhaps contact with the naturalistic art of Pietro Cavallini influences generations of artists in Florence, including **Andrea Pisano** and **Orcagna** (Andrea di Cione) in the 14th century and **Masaccio Tommaso di Ser Giovanni di Simone** and **Masolino da Panicale** in the early 15th century.

The early 14th century Renaissance also influenced literature and the development of the modern Italian language. *The Divine Comedy* of **Dante Alighieri** recast the epics of Classical antiquity for contemporary audiences in the vernacular but the poet and scholar **Petrarch**, the Father of Humanism, whose rediscovery and imitation of the Latin authors Cicero, Seneca the Younger, and Vergil in Italian played a pivotal role in the advancement of humanism and the Renaissance. **Geoffrey Chaucer** visited Florence in 1372 while on a mission to secure a treaty for the port of Genoa and met the two poets but his *Canterbury Tales* are more influenced by **Giovanni Boccaccio's** *Decameron* set in nearby Fiesole against the events of the **Black Death** (1348) that devastated Florence and the whole of Europe.

The 15th century in Florence was politically and artistically consequential. **Brunelleschi** and **Donatello** in Rome from 1402 to 1404 returned to Florence inspired by Classical art and architecture that was systematically revived by **Leon Battista Alberti** and **Bernardo Rossellino**. Also active in translating humanism in Renaissance art were the generation of Tuscan artists, including the teachers of the Great Masters who trained **Leonardo da Vinci**, **Michelangelo** and **Raphael** under the high Renaissance: Piero della Francesca, Andrea del Castagno, Paolo Uccello, Antonio Pollaiolo, Andrea del Verrocchio, and painters of the Vatican Sistine Chapel walls: Domenico Ghirlandaio, Botticelli, Luca Signorelli, and Perugino.

Against this artistic backdrop were the rise of the Medici bank and the political power of family patriarch **Cosimo the Elder** under the Florence Republic whose noble families, such as the Albizzi offered resistance and imposed exile to check the threat to their own power. The Peruzzi and Bardi banking families preceded the Medici and funded Edward III of England's Crusade but his failure to repay the loan led to the collapse of their banking empire. The **Duke of Athens** who was invited to settle the factional strife between the Guelphs and Ghibellines was overthrown in 1343. Cosimo the Elder transformed the city with architect **Michelozzo** who designed the Palazzo Medici-

Riccardi but the Palazzo Vecchio, once his prison, became the Medici home symbolizing the family's domination over the Republic, also evidenced at his funeral when he was honoured with the title *Pater Patriae*, Father of the Fatherland, previously bestowed upon the Roman emperor Augustus.

Resistance to the Medici continued under **Lorenzo the Magnificent** whose brother was assassinated in the **Pazzi Conspiracy** (1478) orchestrated by Medici enemy Pope Sixtus IV della Rovere, the uncle of Pope Julius II della Rovere, popularly known for the rebuilding of St. Peter's Basilica in Rome. The Dominican **Savonarola** who staged the 'Bonfire of the Vanities' contributed to the political turbulence and another Medici exile. The Medici enter the world politics of Papal Rome through the marriage between Lorenzo the Magnificent and **Clarice Orsini**, a member of the powerful Orsini family in Rome. Their son Giovanni would become Pope Leo X de' Medici, the first Florentine Pope. Lorenzo's cultivation of a circle of humanists, including Marsilio Ficino and Giovanni Pico della Mirandola evokes Plato's Academy of Classical Greece. As a patron of the arts, Lorenzo's collection at the nucleus of the great art collections of the Medici Grand Dukes is now divided among several museums in Florence and dispersed all over the world.

The return of the Medici from exile in 1512 and renewed power in 16th century Florence coincides with their ascendancy to political power in Rome with the election of **Pope Leo X de' Medici** during the consequential reigns of Francis I of France, the patron of **Leonardo da Vinci**, Henry VIII of England, and the **Holy Roman Emperor Charles V** who was also King of Spain (as Charles I). Leo X continued Pope Julius II della Rovere's work on the new St. Peter's Basilica and Florentine artists who found patronage include Raphael who painted the Papal Apartments in the Vatican and Michelangelo who designed the Medici tombs for the Basilica of San Lorenzo in Florence. Humanism defines his papacy with humanists from Florence at his court such as Pietro Bembo of the Vatican Library who develops a model of modern Italian from the works of Petrarch.

The second Medici elected to the papacy, **Clement VII de' Medici** raised as Leo X's brother following his father's assassination, is associated with the pivotal historical events of the **Sack of Rome** in 1527 (that coincided with another exile of the Medici from Florence

from 1527 to 1530) and his refusal to annul the marriage of **Henry VIII** and **Catherine of Aragon** the aunt of the Holy Roman Emperor Charles V. Clement VII was successful in elevating the family through the marriage of his niece **Catherine de' Medici** to the future Henry II of France to become the mother of three French kings and of daughters who marry two kings, the future kings of Spain and France. Catherine de' Medici introduced Italian culture to the French court and built the now destroyed Tuileries Palace in Paris. Under his papacy, **Michelangelo** leaves Florence for Rome in 1534 never to return and resumes the artistic achievements of the Renaissance in Rome after the Sack of 1527 when artists left for Florence. Medici rule in Florence continued under Catherine de' Medici's brother **Alessandro de' Medici** who was appointed Duke of Florence by the Holy Roman Emperor Charles V who visited his future son-in-law in Florence in 1530 (Alessandro married his daughter Margaret of Parma who then married Ottavio Farnese, the nephew of Pope Paul III Farnese).

After the assassination of Alessandro de' Medici, **Cosimo I de' Medici** a cousin from the minor branch of the family descended from Cosimo the Elder's brother formed an alliance with the Holy Roman Emperor Charles V and fought off Strozzi-led resistance at the Battle of Montemurlo (1537) to establish himself as Duke of Florence and later as Grand Duke of Tuscany. Cosimo I restored Medici wealth and influence in Florence and Tuscany, advertised through his transformation of the city and its monuments with architects **Bernardo Buontalenti** and **Giorgio Vasari** who is synonymous with Mannerist art and architecture with his contemporary **Bartolomeo Ammannati**. Cosimo I's distant relative **Pope Pius IV de' Medici** continued Medici influence in Rome and gave him access to antiquities first collected by the Medici a century earlier by Cosimo the Elder. The papacy of the fourth Medici pope, **Pope Leo XI de' Medici**, only lasted one month before his death. Under the successive Medici Grand Dukes, the arts and sciences flourished evidenced by their patronage of **Galileo Galilei**.

Cosimo I's marriage to **Eleonora of Toledo** gave the formerly minor branch of the Medici family entry into the royal houses of Europe. His granddaughter **Marie de Médicis** became Queen of France and Navarre, the grandmother of Louis XIV, who with her husband **Henry IV** established the **Bourbon dynasty** with dynastic alliances with Spain, France, and later England, when her daughter

Henrietta Maria married King Charles I. The city's long-standing ties to England through loans with Florentine banking families extend back to the Plantagenets with Edward I and later to the Tudors: Pope Leo X de' Medici hired **Baccio Bandinelli** to design Henry VIII's funerary monument and Florentine artists such as Giovanni da Maiano and Benedetto da Rovezzano worked at Hampton Court (first for Cardinal Wolsey) and other palaces for Henry VIII until his break with Rome ended the reception of the Italian Renaissance in Tudor England. Commercial treaties with Cosimo I de' Medici ensured access to the lucrative port of Leghorn (Livorno). The Medici popes were succeeded by Florentine popes synonymous with the Baroque and Neoclassical periods in Rome; Pope **Urban VIII Barberini** whose patronage of Gian Lorenzo Bernini transformed the urban landscape of Rome, and **Clement XII Corsini** popularly associated with the construction of the Trevi Fountain.

With the death of the seventh and last Medici Grand Duke **Gian Gastone de' Medici** the Grand Duchy of Tuscany passed to **Francis I, Holy Roman Emperor** and Grand Duke of Tuscany, the father of **Marie Antoinette,** and founder of the **Habsburg-Lorraine dynasty**. Francis I was succeeded by his son **Peter Leopold** (his older brother Joseph became Holy Roman Emperor after the death of their father but the title passed to him and he became known as **Leopold II, Holy Roman Emperor**) who was unpopular, despite practical economic and social reforms, for his actions against the church. The rule of **Ferdinand III** was interrupted by the periods of the French Revolution and Napoleonic Wars when Tuscany was under French control as the **Kingdom of Etruria**. The last Grand Duke of Tuscany was **Leopold II** (1824–1859) who ruled during the tumultuous events of 1848 across Europe and the **Risorgimento** in Italy. Replacing Turin (Torino), Florence was the capital of the **Kingdom of Italy** (1865–1869) united under **King Vittorio Emanuele II** from the **House of Savoy** who resided in Palazzo Pitti. He moved to Rome following the fall of the Papal States (1870) when Rome became the capital of Italy (1871) for the first time since the Roman Empire. Urbanization and Neo-Renaissance construction projects in Florence at this time, like the creation of **Piazza della Repubblica**, altered the historic texture of the city. More modern buildings replaced the historic structures along the Arno damaged by the bombing of bridges by retreating Germans

in World War II. The devastating **Flood of 1966** attracted volunteers known as the Mud Angels that were part of an international effort to preserve the city's cultural heritage.

As a **Grand Tour** destination, Florence was initially bypassed for Siena on journeys south from Venice but in the 19th century, the city attracted English and American visitors, including literary and artistic figures of the Romantic and Pre-Raphaelite movements, whose sojourns extended to months and years, earning it the name of the *ville tout Anglaise*. The city was immortalized in E.M. Forster's *A Room with a View* (1908) as a destination for cultural and personal discovery that was recently renewed with Frances Mayes' *Under the Tuscan Sun* (1996). Florence remains a top tourist destination and the large number of international study abroad programmes based in the city gives the historic centre, the first to be nominated as a **Unesco World Heritage Site** (1982), the feel of a college campus. At the start of the new Millennium, with a vibrant arts scene, fashion and cuisine, Florence's cultural history and influence on Western culture ensures its enduring draw as a cultural capital.

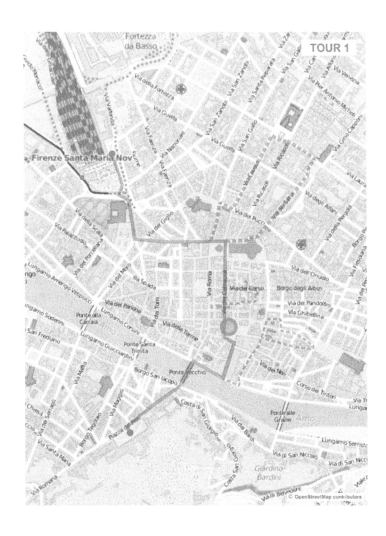

Sites: S. Maria Novella; Duomo and Baptistery; S. Lorenzo; Cappelle Medicee; Palazzo Medici-Riccardi; Galleria dell' Accademia; Spedale degli Innocenti; Casa di Dante; Orsanmichele; Piazza della Signoria; the Uffizi; Palazzo Vecchio; the Bargello; Santa Croce; Ponte Vecchio; Palazzo Pitti; Boboli Gardens.

Distance: 1.25 km + Tour Options

Tour 1

FLORENCE IN A DAY

Arrive in Florence by train at the Central Station (Stazione Centrale di S. Maria Novella) and begin a fast-paced stroll in the heart of historic Florence under the shadow of Brunelleschi's dome through winding medieval streets to Piazza della Signoria and across the Ponte Vecchio to Palazzo Pitti and Boboli Gardens in Oltrarno.

The tour includes several options to explore the monuments and sites associated with important periods and personalities of Florence's history: Dante Alighieri, the Medici, Brunelleschi and Michelangelo.

Begin the tour at **Stazione Centrale di S. Maria Novella** (Firenze SMN) that was built in 1935 in the Rationalist architectural style by Tuscan architects under the direction of Giovanni Michelucci. The station is a major transportation hub filled with travellers but linger a moment to visit a memorial at the end of Platform 16 that commemorates the Holocaust and the trainloads of Jews deported from Italy to Nazi Concentration Camps during World War II.

Exit on the left side with the tracks behind you into Piazza della Stazione. The back of the church of S. Maria Novella is straight ahead and Brunelleschi's dome of the Duomo rises to your left. To reach the front of the church, follow the sidewalk around the right side of the piazza then turn right on Via degli Avelli ('Street of the Tombs') to walk along the right hand side of the church lined with tombs that formerly faced a cemetery into Piazza S. Maria Novella. The entrance to the church faces the piazza that has two obelisks with fleur-de-lys decoration.

Santa Maria Novella (Tour 6) with its early Renaissance facade is an extensive Dominican basilica complex with famous frescoes, including Masaccio's *Trinità* and chapels with 15th-century fresco

decoration, including the Tornabuoni Chapel with frescoes by Domenico Ghirlandaio and the Filippo Strozzi Chapel with frescoes by Filippino Lippi. The Spanish Chapel with beautiful frescoes is accessible from the Museum.

At the mid-point of the piazza, turn left on Via de' Banchi to proceed to the Duomo. Continue on Via de' Banchi when the name changes to Via de' Cerretani. The dome of the Cappelle Medicee with the tombs of the Medici Grand Dukes is visible to your left on Via de' Conti (an option to explore the area of S. Lorenzo after visiting the Duomo is below). Continue past the church of S. Maria Maggiore to your right (look up the tower to see the head of a Roman statue incorporated into the facade) into Piazza S. Giovanni past the Column of San Zenobio alongside the Baptistery into Piazza del Duomo. See Tour 2 for a detailed tour of the **Duomo** (S. Maria del Fiore), Brunelleschi's **Dome**, Giotto's **Campanile** and the **Baptistery** where the poet Dante was baptized. Michelangelo called the east doors, designed by Lorenzo Ghiberti, the 'Gate of Paradise'.

Proceed directly to Piazza della Signoria on **Via dei Calzaiuoli** that starts in the piazza between the Duomo and the Baptistery and ends at Piazza della Signoria (Tour 2). Directions resume following the optional tour of the area.

To explore optional sites associated with the Medici, Michelangelo's *David* and Brunelleschi's Spedale degli Innocenti before proceeding to Piazza della Signoria (1.80 km), with the back of the Baptistery behind you, turn right on Borgo S. Lorenzo and follow into Piazza S. Lorenzo. The church of **San Lorenzo** (Tour 6) was the parish of the Medici whose tombs by Michelangelo are in the New Sacristy of the **Cappelle Medicee** with the later tombs of the Medici Grand Dukes of Tuscany.

Exit Piazza S. Lorenzo on the left side (with the facade of the church behind you) past the seated statue of Grand Duke Cosimo I's father, Giovanni delle Bande Nere, by Baccio Bandinelli (1540) to walk on Via de' Gori for one block to Via Cavour. Turn left to walk along **Palazzo Medici-Riccardi** built by Michelozzo Michelozzi for Cosimo de' Medici the Elder (Tour 6) with Benozzo Gozzoli's 'Adoration of the Magi' fresco cycle (1459–1461) that includes members of the Medici family and follow into Piazza S. Marco. The **church and convent of San Marco** that includes frescoes by Fra' Angelico (now Beato Angelico) and the cells of Cosimo the Elder and Savonarola is

straight ahead (see Tour 5). If entering the **Galleria dell' Accademia** with Michelangelo's *David* (Tour 5) turn right at the beginning of the piazza then turn right on Via Ricasoli and walk to the middle of the block for the entrance to the Galleria dell' Accademia. If continuing on the tour, walk around the right side of the piazza past Via Ricasoli to Via Cesare Battisti. Turn right for a short walk into Piazza della Santissima Annunziata.

The church of **Santissima Annunziata** (Tour 5) is to your left. Filippo Brunelleschi's **Spedale degli Innocenti** (Tour 5) begun in 1419, was an orphanage (look for the infants in the tondi), is straight ahead. In the centre of the piazza is the equestrian statue of Grand Duke Ferdinando I that faces Via dei Servi. Stroll along the palazzo-lined **Via dei Servi** to reenter the Piazza del Duomo. A plaque at No. 17 commemorates property rented from the Bandini in 1427 by the painter **Masaccio**. At No. 12 at the corner of Via Castellaccio is the 16th-century **Palazzo Sforza Almeni** built for Antonio Taddei with famous ceiling frescoes by Giorgio Vasari (*c.*1555). The palace was confiscated by Cosimo I de' Medici and given to Sforza Almeni. A plaque on Palazzo Pasqui (No. 44 red) commemorates the location of the 15th-century sculptor Benedetto da Maiano's studio. Walk around the Duomo for the start of the Via dei Calzaiuoli to rejoin the tour.

As you stroll along Via dei Calzaiuoli, look to your right at Via degli Speziali for a glimpse at the triumphal arch in Piazza della Repubblica (Tour 7). At Via Orsanmichele, is the church of **Orsanmichele** (Tour 2) the former grain market that was later converted into a church for the city's powerful guilds that commissioned statues of their patron saints for the tabernacles that line the exterior facade. A copy of Donatello's *St. George* is in a niche along Via Orsanmichele.

For an optional visit to the **Casa di Dante** (Tour 2) dedicated to **Dante Alighieri**, the author of the *Divine Comedy*, before proceeding into Piazza della Signoria (.45 km), turn left on Via dei Tavolini and continue past Via de' Cerchi through Piazza de' Cimatori when the name changes to Via Dante Alighieri. The Casa di Dante is to your left at the corner of Via di S. Margherita. Look for the arch on Via di S. Margherita next to the church of **S. Margherita de' Cerchi** known as the 'Church of Dante' where **Beatrice Portinari** is buried. Retrace your steps to Via dei Calzaiuoli.

Continue on Via dei Calzaiuoli into **Piazza della Signoria** (Tour 3) with **Palazzo Vecchio** to your left. The Uffizi Gallery is visible just behind the **Loggia della Signoria** (Loggia dei Lanzi) with a sculpture collection, including Giambologna's *Rape of the Sabines* and Benvenuto Cellini's *Perseus holding the head of Medusa*. A copy of Michelangelo's *David* stands at the entrance to the palazzo. A pavement marker near the *Neptune Fountain* of Bartolomeo Ammannati marks the spot where Savonarola was executed in 1498. Continue into Piazzale degli Uffizi that is lined with statues of famous artists and authors in the niches for the entrance to the **Galleria degli Uffizi** (Tour 3). Treasures include paintings from Giotto to the Mannerists, including works by Michelangelo, Botticelli, and Caravaggio. The arches at the end of the piazzale overlook the Arno River. Walk to the end of the piazzale and turn right to cross the Ponte Vecchio.

For an optional tour of the Museo Galileo, the Bargello and church of Santa Croce (1.25 km), before proceeding to the Ponte Vecchio, turn left at the arches at the end of the piazza and continue to the end of the block to the **Museo Galileo** (Museo di Storia della Scienza) in Piazza de' Giudici. Walk up Via de' Castellani past the exit of the Uffizi when the name changes to Via dei Leoni behind the Palazzo Vecchio. Turn right on Borgo de' Greci to proceed immediately to the church of Santa Croce in Piazza Santa Croce or continue through Piazza S. Firenze (the Tribunale di Firenze is to your right) to first visit the **Bargello** (Museo Nazionale del Bargello, Tour 4) at the end of the piazza. The museum includes an important collection of sculpture by Donatello, Michelangelo and others, including Baccio Bandinelli, Bartolomeo Ammannati, and Giambologna. Look up to see the campanile of **Badia Fiorentina** that is across the street from the Bargello.

To proceed to the church of Santa Croce, turn right on Via della Vigna Vecchia then right on Via dell' Acqua. At the end of the block, turn left on Via dell' Anguillara and follow into the Piazza Santa Croce. Along the way, look to your left at Via Torta and right at Via de' Bentaccordi for the curve of buildings that preserve the outline of the ancient **Roman Amphitheatre**. The church of **Santa Croce** (Tour 4) is straight ahead. Inside the church are frescoes by Giotto, early Renaissance funerary monuments and Michelangelo's tomb designed by Giorgio Vasari. The complex includes a museum and the Pazzi Chapel designed by Filippo Brunelleschi and completed by others after

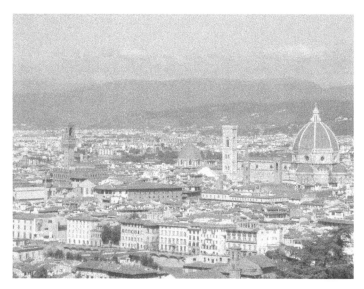

1. Panoramic view of Florence taken from S. Miniato al Monte

his death in 1446. Exit the piazza by the left side (with the facade of the church behind you) onto Borgo de' Greci and follow through to return to Piazza della Signoria. Walk through the piazza with the Loggia della Signoria to your left and exit just beyond it onto Via Vacchereccia. Turn left onto Via Por S. Maria (look to your right to see the Mercato Nuovo) and the Ponte Vecchio.

Cross to the other side of the **Ponte Vecchio** (Tour 9) that is lined with jewellery shops to the area known as Oltrarno 'the other side of the Arno' (Tours 7, 8 and 9) and continue on Via de' Guicciardini passing the church of Santa Felicità (Tour 8) to your left and the home of Niccolò Machiavelli (1469–1527) to your right at No. 18 through to Piazza de' Pitti. The **Palazzo Pitti** (Tour 8) was given to Cosimo I de' Medici Grand Duke of Tuscany as a wedding present by his wife Eleonora of Toledo. The various museums include the **Galleria Palatina** with an important art collection displayed in the former apartments of the Medici and Lorraine Grand Dukes and the House of Savoy. Behind the palace are the **Boboli Gardens** with charming areas to stroll and take in panoramic views of the Duomo.

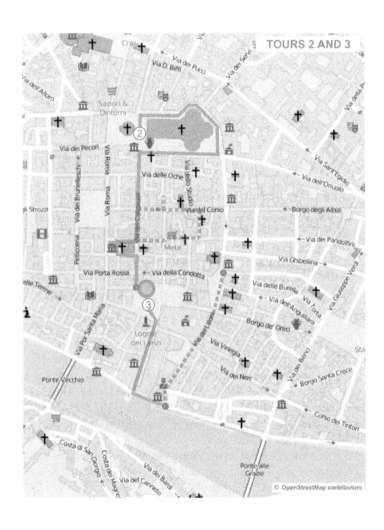

Sites: The Duomo (S. Maria del Fiore), Campanile, Baptistery (Battistero di S. Giovanni), Museo dell' Opera del Duomo, Via dei Calzaiuoli, S. Margherita, Casa di Dante, S. Martino del Vescovo, Orsanmichele

Distance: 1.25 km

The Duomo Area, Dante's Florence and Orsanmichele

Stroll around the area of Piazza del Duomo (S. Maria del Fiore) with Brunelleschi's dome towering above. Visitors taking in sweeping views of the city from the lantern are barely visible from street level. This is the spiritual heart of medieval Florence of the poet Dante Alighieri where the Black Death struck in 1348 killing half the inhabitants and more in later outbreaks. The city slowly recovered into the 15th century when a brilliant generation of artists and humanists were laying the foundations of the Renaissance in Florence. Fierce political contests for control of the city government were dominated by Guelph and Ghilbelline factions and then, under the Signoria, powerful guilds and the Medici family led by Cosimo the Elder. His grandson Lorenzo the Magnificent brought the family closer to the powerful papacy in Rome with his marriage to Clarice Orsini. A reinvigorated Medici family under Grand Duke Cosimo I de' Medici in the 16th century asserted the importance of Tuscany for generations of Florentines and Royal Houses across Europe. Continue your tour of 15th- and 16th-century Florence along Via dei Calzaiuoli into Piazza della Signoria, the civic heart of the city.

The Basilica of **Santa Maria del Fiore** ('St. Mary of the Flower') with Cathedral status (Duomo) was built over the ruins of an earlier basilica dedicated to **S. Reparata**, a Palestinian girl who was martyred (*c.*249) under the reign of Decius. The relics of S. Zenobio (St. Zenobius), the first bishop of Florence (337–417) were discovered in the basilica of S. Reparata during construction of S. Maria del Fiore. The footprint of the earlier church was about half the length of the current nave and

was built on the site of ancient Roman ruins. A **column** erected in the piazza behind the Baptistery in the 14th century marks the spot where an elm tree flowered at the time of the translation of the Saint's relics in the 7th century from S. Lorenzo to the new church of S. Reparata that was interpreted as his approval of the move. The **Palazzo Archivescovile**, Palace of the Archbishop that was remodelled from 1893 to 1895 by Felice Franciolini, faces the back of the Baptistery in Piazza S. Giovanni.

Arnolfo di Cambio (*c.*1245–1302) designed the Gothic basilica in 1294, the sculptor and architect who also designed Palazzo Vecchio (Tour 3) and the church of Santa Croce (Tour 4). Work on the basilica began two years later in 1296 under Arnolfo di Cambio who continued work, including the design of the octagonal drum of the dome, until his death. **Giotto** assumed the title of *capomaestro* in 1331 when construction was under the supervision of the powerful **Arte di Calimala** guild of cloth merchants. Various architects including Neri di Fioravante, Francesco Talenti and Orcagna (Andrea di Cione) continued work on the basilica in the 14th century and the drum of the dome was complete by 1417. The following year, **Filippo Brunelleschi** (1377–1446) and **Lorenzo Ghiberti** (1378–1455) received a joint appointment to design the **dome** but, after several years of rivalry, Brunelleschi was granted sole control in 1426.

When Brunelleschi lost the competition for the Baptistery doors to his rival Lorenzo Ghiberti, he went to Rome (1402–1404) with the sculptor **Donatello** (Donato de' Bardi, *c.*1386–1466) and studied ancient architecture, especially the Pantheon. The two would be pivotal in setting the artistic course of the Renaissance in 15th-century Florence. The octagonal dome, although inspired by the Pantheon is of distinct design, neither Classical nor medieval. It was constructed from 1420 to 1436 and is the first dome since Classical antiquity, with an internal diameter of 41.98m compared to the Pantheon's diameter of 43.3m. The height soars at 114.36m. In a daring feat of engineering, Brunelleschi used vertical stone chains and interior rows of horizontal rings between the outer and inner shells of the dome to relieve the stress of gravity on the structure. Bricks laid in a herringbone pattern that allowed them to be held in place as they set as the vertical axis changed, lighten the weight that is also carried by the stone ribs and arches hidden in the masonry. Machines used in the dome's construction

2. The Duomo (S. Maria del Fiore) with a view of Brunelleschi's Dome

are on display in an area viewed from the stairs leading down from the dome. The decoration of the dome's base was begun by Baccio d'Agnolo, to designs by Antonio da Sangallo the Elder but work was halted due to Michelangelo's criticism that the balcony looked like a cricket's cage.

Brunelleschi won the competition for the lantern (his original design is in the Museo dell' Opera del Duomo) in 1436 but construction only began in 1446 and was completed in 1461. **Andrea del Verrocchio** (1435–1488), Leonardo da Vinci's teacher, designed the ball and cross in 1469 but it was replaced in 1600 after it was struck by lightning. Pope Eugenius IV consecrated the basilica, complete to the base of the dome's lantern, on the Feast of the Assumption, 25 March 1436. A seated statue of the Pope sits in the tabernacle niche of the facade to the upper left of the right portal.

The vibrant neo-Gothic facade with white, green, and red marble was completed in 1887 by Emilio De Fabris. It replaced the facade begun in the 14th century by Arnolfo di Cambio but was still incomplete by 1420 and demolished in 1587/1588 by architect

Bernardo Buontalenti (1531–1608) who proposed a more modern design. The original sculpture is now in the Museo dell' Opera del Duomo. The front of the basilica is the site of the annual festival of the *Scoppio del Carro* ('explosion of the cart') named for the cart filled with fireworks (*brindellone*) on Easter Sunday that meets a procession from the church of Santi Apostoli with the sacred flint brought to Florence by Pazzino de' Pazzi who received it as a reward for being the first to scale the walls of Jerusalem in the First Crusade. At the west doors of the Duomo, the Bishop blesses the carriage and during Easter service, a rocket-shaped dove (*colombina*) on a wire flies out of the church to light the fireworks.

The **Porta della Mandorla** (1391–1397) on the left outside flank of the basilica when facing the facade is named for the almond-shaped aureole with a high relief of the *Annunciation of the Virgin* by Nanni di Banco (*c.*1414–1421). The sculpture of the *Prophet* to the left is by Nanni di Banco and the *Prophet* on the right is attributed to Donatello. Original sculpture is displayed in the Museo dell' Opera del Duomo, including a relief of *Hercules* (1406–1408) midway on the right hand side of the door attributed to Nanni di Banco or Jacopo della Quercia but possibly by Donatello following his return from Rome. The *Hercules* is one of the earliest sculptures that shows the influence of the subject matter and style of Classical art. This is an early date for the use of pagan imagery in church decoration since, like the ancient obelisks and triumphal columns in Rome, Classical sculpture carried associations of idolatry until the end of the 16th century even though some of the great aristocratic collections of ancient sculpture were assembled in Rome beginning from the early 15th century. The mosaic in the lunette *Annunciation* is by Domenico and Davide Ghirlandaio (1491). This is the current entrance for visits to the dome.

The vast interior is on a Latin cross plan with the altar at the liturgical east end. It is the third largest church in Italy after St. Peter's Basilica in Rome and Milan Cathedral. The sparseness of the interior decoration is surprising compared to the exuberant appearance of the exterior. The stained glass windows that date from 1434 to 1445 add colour to the otherwise dark interior. The pavement dates from 1526 to 1660.

On the **north side** near the current entrance door is a portrait bust of Emilio Dc Fabris by Vincenzo Consani (1887). Against the first pilaster is a tabernacle with *St. Zenobius* by Giovanni del Biondo. In

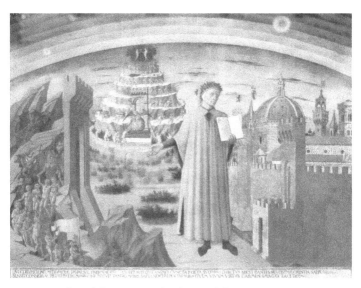

3. Domenico di Michelino, *Dante Before the City of Florence*. Duomo

the aedicule is a sculpture of the *Prophet Joshua* attributed to Donatello perhaps based on the portrait of the humanist Poggio Bracciolini, a friend of Cosimo the Elder. Beyond the *Portrait bust of Arnolfo di Cambio* by Ulisse Cambi (1843) the *Portrait bust of organist Antonio Squarcialupi* is by Benedetto da Maiano (1490). Midway are two frescoes of **Equestrian Monuments** of *condottieri*. The monument painted by **Andrea del Castagno** (1456) against a green-black background is to *Niccolò da Tolentino* who led the Florentine forces against Siena in the Battle of San Romano (1432). *Sir John Hawkwood* (Florentines gave him the name of Giovanni Acuto), painted by **Paolo Uccello** against a porphyry background (1436) replaced an earlier fresco in honour of the Englishman who led the Florentine army (after 1380) and was given a public funeral in 1394. The painting *Saints Cosmas and Damian* in a gilt tabernacle by Bicci di Lorenzo commemorates the patron saints of the Medici. Beyond the aedicule with *King David* is a painting that commemorates the poet Dante: *Dante Before the City of Florence* by Domenico di Michelino (1465) holding his *Divine Comedy*. The poet's cenotaph is in Santa Croce (Tour 4). At the end of the nave is the

entrance to the dome through the Porta della Mandorla but it is only accessible from outside the church.

The height of the **interior dome** above the drum is 91 metres high. The fresco of the *Last Judgement* (1572–1579) is by Giorgio Vasari (1511–1574) painter and architect to Grand Duke Cosimo I and Federico Zuccari in which the damned seem to fall into the church are best viewed from the interior level of the drum since the east end of the church is often closed to visitors without prior permission. The stained glass windows in the roundels (1443–1445) are after designs by Lorenzo Ghiberti (*Ascension, Prayer in the Garden*, and *Presentation in the Temple*), Donatello (*Coronation of the Virgin*), Paolo Uccello (*Nativity* and *Resurrection*), and Andrea del Castagno (*Deposition*).

Around the base of the drum are three **Tribunes** each with five chapels with windows designed by Lorenzo Ghiberti. The area is usually closed to visitors. A statue of *David* was commissioned for a niche in the north tribune by the Opera del Duomo but the project lagged under Agostino di Duccio (1464) and Antonio Rossellino (1475) until it was completed by Michelangelo (1502–1504) and placed in Piazza della Signoria (Tour 3). In the pavement of the north apse is a gnomon by Paolo dal Pozzo Toscanelli (*c.*1450). Next to it is the **North Sacristy** with a terracotta lunette of the *Resurrection* by Luca della Robbia (*c.*1442–1444) over the entrance whose bronze doors he also designed (1446–1467) with the assistance of Michelozzo and Maso di Bartolomeo. Lorenzo the Magnificent took refuge here following the assassination of his brother Giuliano by members of the Pazzi Conspiracy with the consent of Pope Sixtus IV della Rovere during Easter service in the Duomo on 26 April 1478. In the central apse are the relics of St. Zenobius in an urn designed by Lorenzo Ghiberti (1432) with *Angels* by Luca della Robbia (*c.*1450). Over the South Sacristy entrance is a terracotta lunette of the *Ascension* by Luca della Robbia (*c.*1450).

In the south apse, the marble chorus in the **Sanctuary** under the dome was begun by Baccio Bandinelli (1547) for Cosimo I de' Medici and completed to an altered design under Giovanni Bandini (1572). It replaced an earlier wooden chorus but the monumental design was never fully executed. Bandinelli's fully nude *Adam and Eve* (1551), now in the Bargello (Tour 4), was removed in 1722. Other elements of his original design are in Santa Croce and the Museo dell' Opera del

Duomo. At the end of the nave are statues of *St. Matthew* by Vincenzo de' Rossi and *St. James the Greater* by Jacopo Sansovino.

On the **south side**, at the end of the nave is the **Porta dei Canonici**. To the right of the door is Andrea Ferrucci's *portrait of Marsilio Ficino* (1433–1499), the humanist philosopher and priest. He first received the patronage of Cosimo the Elder and later he was hired by Lorenzo the Magnificent for his Plato (Florentine) Academy that was attended by Michelangelo (Tour 5). He was the first to translate the complete works of Plato from ancient Greek into Latin. He was ordained in 1473 and later became a Canon of the Duomo. The Medallion *Portrait of Giotto* is by Benedetto da Maiano (1490) and inscription by Agnolo (Angelo) Poliziano. To either side of the aedicule with a statue of the *Prophet Isaiah* are the painted tombs of Pietro Corsini the Archbishop of Florence by Bicci di Lorenzo (*c.*1422) and Fra' Luigi Marsili (1439). The *St. Bartholomew Enthroned* is by Rossello di Jacopo Franchi (1408). In the aedicule is a statue of the *Prophet Isaiah* or *Daniel* by Nanni di Banco. Against the first pillaster, the *Sant' Antonino* by Francesco Morandini hangs above a 14th-century lavabo (the original is in the Museo dell' Opera del Duomo). The medallion *Portrait of Brunelleschi* by his adopted son Andrea Cavalcanti also known as Buggiano (1446) is next to the facade door on the west wall with windows designed by Lorenzo Ghiberti.

The distinctive **clock** on the **west wall** displays the time according to the *hora italia* by which the twenty-fourth hour of the day ends at sunset. The decoration and the *Prophets* are by Paolo Uccello (1443) and the *Angel Musicians* by Santi di Tito. To the right of the central doors when facing the west wall is the **Tomb of Antonio d'Orso**, the Bishop of Florence (died 1321) by Tino di Camaino (*c.*1280–1337). Gaddo Gaddi's *Coronation of the Virgin* (*c.*1290) may have been made for the church of S. Reparata whose crypt is accessed from the museum entrance staircase in the nave that also includes earlier Roman structures and architectural elements. Here is also the slab **Tomb of Brunelleschi** with the inscription: *corpus magni ingenii viri Philippi Brunelleschi fiorentini* ('Here lies the body of the man of great talent Filippo Brunelleschi the Florentine').

The Gothic **Campanile** (84.7 metres high and 14.45 metres wide) was designed by Giotto (Giotto di Bondone, *c.*1266/7–1337) who worked on it from 1334 until his death when Andrea Pisano assumed

the appointment of *capomaestro*. Giotto, more popularly known as a painter of frescoes than as an architect, took inspiration for the multi-coloured design from the Baptistery. Francesco Talenti, Pisano's successor, completed Giotto's freestanding tower from 1348 to 1359 with some decoration by Luca della Robbia. The original sculptural decoration by Giotto on the first level and Andrea Pisano on the upper levels is now in the Museo dell' Opera del Duomo with the original statues by Donatello and Nanni di Bartolo.

The **Baptistery (Battistero di S. Giovanni)**, named after St. John the Baptist, the patron Saint of Florence, is one of the oldest buildings in Florence built on the foundations of an earlier 4th- or 5th-century Baptistery (a basilica that predated the basilica of S. Reparata). A section of the wall from the Roman colony ran along a road with a necropolis between the Baptistery and the Duomo. A fragment from an ancient Roman sarcophagus is built into the exterior to the left of the doors to the south entrance. Later, a 12th-century cemetery occupied the area around the Baptistery. The octagonal shape of the building is derived from the Baptistery of S. Giovanni in Laterano in Rome. Its Florentine Romanesque style decorated in geometric patterns with white Carrara marble and green marble from Prato inspired the facade of S. Miniato al Monte (Tour 9). The current building was consecrated by Pope Nicholas II on 6 November 1059 and served as an important religious centre of the city where many famous Florentines were baptized including the Medici and the poet Dante Alighieri. Florentines assembled here to pray in times of plague and the carriage that led the Florentine army to battle was stored here.

The **East Doors** called the 'Gate of Paradise' by Michelangelo are by Lorenzo Ghiberti (1425–1452) with Old Testament scenes created with the assistance of Michelozzo, Benozzo Gozzoli and others. Earlier, Ghiberti won the competition sponsored by the Arte di Calimala to design the doors (1403–1424) now at the north entrance in 1401 with reliefs within quatrefoil shapes in imitation of the original doors. The contest was based on a panel depicting the *Sacrifice of Isaac* and Ghiberti's design was preferred to Brunelleschi's after extensive deliberations that had not advanced Donatello's design to the final two finalists. Both of the competition entries are on display at the Bargello (Tour 4) and highlight the importance of the guilds of Florence as patrons of art and architecture. *Ghiberti's portrait* looks

out of a tondo along the left door's central decoration (fourth from top) when facing the doors. The doors replaced the original doors (1330–1336) designed by Andrea Pisano on the recommendation of Giotto. These doors with reliefs in quatrefoil shapes were moved to the south entrance in 1452.

The current doors (1990) are copies of the originals that were damaged in the flood of 1966 now in the Museo dell' Opera del Duomo. Also in the museum are the original sculpture groups of the *Baptism of Christ* by Andrea Sansovino (1505) with *Angel* by Innocenzo Spinazzi (1792) from above the east doors and the *Beheading of St. John the Baptist* by Vincenzo Danti (1569–1571) from above the south doors. The *Preaching of St. John the Baptist* from above the north doors are by Giovan Francesco Rustici (1506–1511) perhaps with the collaboration of Leonardo da Vinci who had left Florence by the end of 1509 never to return. The porphyry columns from Majorca were given as a gift to Florence by Pisa (1114) for protecting them against Lucca as they plundered the island.

The interior (25.6 m in diameter) shines overhead with (13th–14th century) beautiful mosaic decoration in the dome with saints, angels, and scenes from the Old and New Testament. Over the high altar is an 8 metre high figure of Christ above scenes of the *Last Judgement*. The artists who designed the mosaics are unknown. They were formerly attributed to Cimabue (Cenni di Pepo, *c.*1240–1302), Giotto's teacher and the first Renaissance artist in Florence to introduce naturalism to Byzantine iconic art. His *Crucifixions* are in many churches in Florence including Ognissanti (Tour 6) and Santa Croce (Tour 4) that was damaged by the flood of 1966.

In the centre of the Baptistery is the hexagonal-shaped outline of the old Baptismal Font mentioned in Dante's *Inferno* (Canto XIX) that was demolished in 1576 on the occasion of the baptism of Filippo de' Medici the son of Grand Duke Francesco I and Joanna of Austria who lived to only the age of 4. Of their seven children, only two survived to adulthood, Marie de Médicis who married King Henry IV of France and Eleonora de' Medici who married Vincenzo I Gonzaga, the Duke of Mantua. Their respective descendants included King Louis XVI of France and Marie Antoinette of Austria who were married in 1770. Eleonora was baptized here by Cardinal Innocenzo Ciocchi del Monte, the adopted nephew and infamous lover of Pope Julius III. The current

Baptismal Font is attributed to a follower of Andrea Pisano (1371). The pavement with inlaid (intarsia) marble in a geometric pattern is contemporaneous with the nave floor mosaics in S. Miniato completed in 1207. Until damaged by the flood of 1966, Donatello's *Mary Magdalene* (1453–1445) was displayed inside the Baptistery. It is now displayed in the Museo dell' Opera del Duomo.

White marble panels within black frames line the walls. The granite columns with golden Corinthian capitals and the two marble columns with a green pattern named *cipollino* based on its resemblance to a sliced onion are reused from an unknown Roman structure, some of the few surviving architectural elements from the ancient Roman town. Above is a *matroneum* the gallery originally reserved for women. The vault mosaics in the apse contain the only mosaic cycle in Florence. A monk named Jacopo signed the earliest sections (*c.*1225) above the altar.

To the left of the High Altar (13th century) are two Roman sarcophagi that were reused. One with scenes from the Roman festival of the Floralia for Giovanni da Velletri the Bishop of Florence (*c.*1205–1230), and the other, with a scene of the Calydonian Boar Hunt for Guccio de' Medici, Gonfaloniere of Florence in 1299 whose Medici family crest and the crest of the Arte della Lana appear on the lid made to match the chest. In between is a statue of *St. John the Baptist* by Giuseppe Piamontini (*c.*1688) that was given by Grand Duke Cosimo III. To the right is the monumental **Tomb of the Antipope John XXIII** (Baldassarre Cossa) once the tallest structure in Florence. It was created by Donatello and Michelozzo (1422–1428) on behalf of the Medici and with the Arte di Calimala's consent. Cossa was one of three concurrently reigning popes during the Western Schism (1378–1418). His claim was supported by the Medici whose bank he appointed as the bank of the papacy. Pope Martin V whose election ended the schism visited the tomb and he did not approve of the designation of Cossa as 'John the former pope' (*IOAN[N]ES QUO[N]DAM PAPA*) in the monument's inscription. Cossa donated the reliquary with the right index finger of St. John the Baptist to the Baptistery.

To continue on the tour, walk around the Duomo to view the Porta della Mandorla and continue to the apse area for the entrance to the **Museo dell' Opera del Duomo** on Via del Proconsolo. The museum

displays original sculpture and artwork associated with the various construction phases of the Duomo, Baptistery, and the Campanile commissioned by the Opera di S. Maria del Fiore that was founded in 1331. Among the artistic treasures in the museum that opened in 1891 from the Duomo are Arnolfo di Cambio's sculpture from the original unfinished facade and various models and designs from competitions for the facade of the church and balustrade of the dome's drum. A display area with tools and building materials reconstructs the worksite of Brunelleschi's dome and includes a wooden model of the lantern, likely his competition entry from 1436. The display area also includes the death mask of Filippo Brunelleschi. Sculpture from the interior of the Duomo includes Baccio Bandinelli's reliefs for the unfinished choir (1555) and the *cantorie* (1430s) by Luca della Robbia and Donatello (1433–1439) for the areas above the Sacristy doors.

Michelangelo's dramatic *Deposition* also known as *The Florentine Pietà* was made when he was almost 80 years old with a self-portrait in the figure of Nicodemus according to Giorgio Vasari. Tiberio Calcagni completed the figure of Mary Magdalene and restored the arm and left leg of Christ that Michelangelo had destroyed in frustration with its creation. It was intended by the artist for his tomb in S. Maria Maggiore in Rome. He died in Rome and following his funeral in the church of Ss. Apostoli, his body was secretly brought to Florence in a roll of fabric. The sculpture remained in Rome in the gardens of Francesco Bandini (who bought it from the Buonarroti) until it followed him to Florence where Grand Duke Cosimo III intended it for the crypt of S. Lorenzo (1674). The artist and sculpture were not reunited. Michelangelo was buried in Santa Croce (Tour 4) in a tomb designed by Vasari and the sculpture was displayed in the Duomo from 1721 until 1980 when it was moved to the museum.

From the Baptistery are Ghiberti's original *East Doors* and the three original sculpture groups from above the doors by Giovan Francesco Rustici: The *Preaching of St. John the Baptist* (1506–1511), and Vincenzo Danti: *Beheading of St. John the Baptist* (1569–1570) and *Baptism of Christ* that was begun by Andrea Sansovino (1505). The *Angel* is by Innocenzo Spinazzi (1792). From the interior come Donatello's *Mary Magdalene* (*c.*1454) and the *Altar of St. John the Baptist* (mid-14th to 15th century) with needlework panels with scenes designed by Antonio Pollaiolo (also known as Antonio del Pollaiuolo)

for the Arte di Calimala (1466–1487). Original sculpture from the Campanile includes Andrea Pisano's statues of *Prophets* and *Sybils* (from 1337) and Donatello's *Jeremiah, Habakkuk* and *Abraham and Isaac*. Exterior sculpture also includes the bas-relief panels from the lower two registers that were designed by Giotto. From the lower row are reliefs by Andrea Pisano (early 14th century) and Luca della Robbia (1437–1439). The reliefs from the higher row are by Pisano and his workshop.

Continue around the east end of the Duomo with three domed tribunes at the base of the octagonal drum of the dome. A short distance up Via dell' Oriuolo at Via Folco Portinari named for the father of Dante's Beatrice Portinari who commissioned the construction of **Santa Maria Nuova Hospital** in 1288 (in the piazza at the end of the street) is the **Biblioteca comunale centrale** in the former Convent of the Oblate (the main entrance is on Via Sant' Egidio No. 21), a secular order, that was built across from the hospital for convalescing women. Next to it is the **Museo di Firenze come' era** at No. 24 that traces the history of the city from its foundation as Florentia.

To your left as you round the south apse of the Duomo, is Via dello Studio with the stonemason's workshop **La Bottega dell' Opera del Duomo** (low building to your right at No. 23A) where copies of stone sculptures from the Duomo are made. According to legend, in Piazza delle Pallottole to your left is the **Sasso di Dante** ('Dante's Stone') once used as a footrest by the poet when a medieval canopy with a stone bench was located here. Opposite the Duomo's Porta dei Canonici, whose 14th-century exterior facade has a lunette by Niccolò di Pietro Lamberti or Lorenzo di Giovanni, is the monument with two seated figures to your left along **Palazzo dei Canonici** (1826 by Gaetano Baccani) that commemorates two of Florence's important architects. Arnolfo di Cambio is the figure on the left. Brunelleschi, the figure on the right, both by Luigi Pampaloni (1830), a student of Lorenzo Bartolini, gazes up at his dome. From this approach is a good view of the campanile.

Between the Duomo and the Baptistery is the start of **Via dei Calzaiuoli**. At the corner is **Loggia del Bigallo** (now a tourist information point) attributed to Alberto Arnoldi (1352–1358) and built for the Confraternity of the Misericordia that later merged with

the Confraternity of the Bigallo for the care of orphans and lost children who were displayed in the loggia for three days before being available for adoption. The **Museo del Bigallo** includes sculpture by Alberto Arnoldi and art by Bernardo Daddi and Ridolfo del Ghirlandaio.

Via dei Calzaiuoli is the main thoroughfare to Piazza della Signoria and is usually bustling with locals and tourists. At the top of the street to your right at No. 13 is the **Torre degli Adimari** (13th century). To your right at Via degli Speziali is a view of the triumphal arch in Piazza della Repubblica (Tour 7). The name changes to Via del Corso to your left. At the corner of Via Orsanmichele, is the church of Orsanmichele.

For an optional stroll in the area of medieval Florence associated with the poet Dante Alighieri before exploring Orsanmichele, turn left on Via dei Tavolini and continue past Via de' Cerchi through Piazza de' Cimatori when the name changes to Via Dante Alighieri. In Piazza S. Martino to your right is the oratory of **S. Martino del Vescovo** in Piazza S. Martino. The current church occupies part of the site of the parish church (10th century) of the Alighieri and Donati families. It was home to the Compagnia dei Buonomini di San Martino devoted to St. Martin of Tours that was founded in 1441 by S. Antoninus Pierozzi. The frescoes in the lunettes (15th century) are by the workshop of Domenico Ghirlandaio and depict the *Good Men Performing the Seven Acts of Mercy* in contemporary Florence. Opposite the oratory is the **Torre della Castagna** at No. 1 that was the seat of the Priorato delle Arti (from 1282), the Signoria, prior to the construction of Palazzo Vecchio in Piazza della Signoria.

Continue on Via Dante Alighieri. The **Casa di Dante** museum, just ahead to your left at the corner of Via di S. Margherita is dedicated to **Dante Alighieri** (1265–1321) the poet of the *Divine Comedy*. This is not the poet's house but a reconstruction of it by Giuseppe Castelucci (1910) in parts of a house owned by the Giuochi family. Dante's family was a member of the White faction of the Guelph party of wealthy merchants (versus the Black faction of the Florentine aristocracy) supporters of the Pope who fought for power in 12th- and 13th-century Italy with the Ghibellines who supported the Holy Roman Emperor. After the Guelphs defeated the Ghilbellines in 1289, the two Guelph factions fought with each other for political power. Dante was exiled from Florence in 1302 after the Black faction

took control of the city. At the time, he was on a mission to Rome on behalf of the White faction during the Jubilee of 1300 proclaimed by Pope Boniface VIII. He never returned to Florence and after living in various cities, died in Ravenna in 1321. The museum commemorates the life of Dante and 14th-century Florence.

Look for the arch on Via di S. Margherita next to the church of **S. Margherita de' Cerchi** that is known as the 'Church of Dante'. Inside the small church is the tomb of Beatrice Portinari, the poet's love in the *Divine Comedy*, whom he first saw at the age of 13. Today, lovers leave letters in the basket at the foot of the altar. Opposite is the tomb of her nurse with a funerary effigy. Walk through the arch and turn left on Via del Corso to see the **Torre dei Donati** (12th/13th century) at No. 31, once owned by the Donati family of Dante's wife Gemma. Continue on Via del Corso facing Piazza della Repubblica (Tour 7). At the corner of Via S. Elisabetta to your right is another property owned by the Donati, the **Torre dei Donati** (12th/13th century) later called the **Torre dei Ricci**. Turn right on Via S. Elisabetta to enter Piazza S. Elisabetta to view the **Torre della Pagliazza** ('Straw Tower') the oldest surviving structure in Florence (6th/7th century) built into an ancient Roman bath complex (Tour 7) that was converted into a prison for women who slept on straw mattresses. It is now the entrance to the Hotel Brunelleschi. Retrace your steps to Via del Corso and turn right to return to Via dei Calzaiuoli. Turn left to retrace your steps to Orsanmichele.

Walk along the facade of **Orsanmichele** ('St. Michael in the Orchard (*orto*)') begun by Neri di Fioravante that is opposite the church of **S. Carlo dei Lombardi** (completed in 1404 by Simone Talenti). The entrance of Orsanmichele is on the opposite side of the building on Via dell' Arte della Lana and accessible by either Via dei Tavolini or Via de' Lamberti. The church is associated with the city's powerful guilds that controlled the government of the city. They funded the statues of their patron saints in the facade's niches that are now copies of the originals. Walking around the building gives a visual lesson in the development of Renaissance sculpture in Florence.

Across the facade facing Via dei Calzaiuoli from left to right: *St. John the Baptist* and Tabernacle by Lorenzo Ghiberti (1413–1416) for the Arte della Calimala. This is the first life-sized statue cast in bronze in the Renaissance that still shows signs of Gothic influence. *The Incredulity*

of St. Thomas is by Andrea del Verrocchio (1473–1483) Leonardo da Vinci's teacher that was made for the Tribunale di Mercanzia (Merchant's Court). St. Thomas' foot extends beyond the tabernacle space adding spatial depth to the composition. The bronze sculpture group replaced Donatello's *St. Louis of Toulouse* now in the Museo dell' Opera di Santa Croce (Tour 4) when the Guelph party sold the niche. Look up to see the round terracotta *stemma* of the guild by Luca della Robbia (1463). The Tabernacle by Niccolò di Piero Lamberti (1403–1406) for the Giudici e Notai (judges and notaries) has a bronze statue of *St. Luke* by Giambologna (1583–1601) that replaced an earlier version by Lamberti.

Walking to the entrance along Via Orsanmichele, the *St. Peter* is of uncertain attribution but is perhaps by Brunelleschi (*c.*1425) for the Arte dei Beccai (butchers). The *stemma* above the tabernacle dates to 1858. Next, the *St. Philip* and Tabernacle is by Nanni di Banco (*c.*1410–1412) for the Calzaiuoli (shoemakers). The *Quattro Santi Coronati* and Tabernacle are also by Nanni di Banco (*c.*1409–1416/17) for the Maestri di Pietra e di Legname (stonemasons and carpenters). The Four Crowned Saints (Claudius, Castor, Symphorian and Nicostratus) were sculptors martyred under the emperor Diocletian for refusing to make a statue of the god Aesculepius. An alternate tradition confused them for Christian soldiers who refused to venerate the emperor. In the relief below, stonemasons carve a statue. The *stemma* above is by Luca della Robbia. The *St. George* with a confident pose is by Donatello (*c.*1415–1417) for the Armaiuoli (armourers) or Corazzai e Spadai (armourers and swordmakers). The original statue and bas-relief panel of *St. George and the Dragon* are in the Bargello (Tour 4). At No. 4 Via Orsanmichele is the **Palazzo dell' Arte dei Beccai** the butchers' guild (14th century) that is today the seat of the Accademia delle Arti del Disegno founded by Cosimo I de' Medici in 1563.

Via dell' Arte della Lana is named for the powerful guild that was based in the **Palazzo dell' Arte della Lana** (1308) opposite the current entrance that is connected to the church by an overhead walkway. It corners Via Calimala that was lined with manufacturers and merchants in the wool and textile guilds (Tour 7). The Museo di Orsanmichele provides access to the upper level of Orsanmichele where most of the original exterior statues are displayed. In the niches along the entrance facade are the *St. Matthew* and Tabernacle by Lorenzo Ghiberti (1419–1422) for the Cambio (bankers), the bronze *St. Stephen* also by Ghiberti

(1428) for the Lanaiuoli (wool manufacturers and clothiers), and the *St. Eligius* (*c.*1417–1421) by Nanni di Banco for the Maniscalchi (farriers) depicted in the relief below the niche. At the corner of Via dell' Arte della Lana and Via de' Lamberti was the first headquarters of the Medici Bank established by Giovanni di Bicci de' Medici, the father of Cosimo the Elder.

The interior reveals how the building designed by Francesco Talenti (1304) was originally a loggia that served as a grain market. Look for the chutes for the distribution of grain along the piers of the north wall. This market replaced an earlier building by Arnolfo di Cambio (1290) that was destroyed by fire. When the building was later converted into a two-storey oratory (1367–1380), tall Gothic windows were installed in the arcades and it was given two naves. Meetings of the market took place upstairs combining both secular and religious functions. On the ceiling are 14th-century frescoes with Old and New Testament figures by several artists including Lorenzo di Bicci and Niccolò di Pietro Gerini who also designed the stained glass windows (1395–1405). The right-side nave ends with the tabernacle by Andrea di Cione known as Orcagna (*c.*1308–1368) who was a student of Andrea Pisano and Giotto. It was commissioned as an ex-voto after the Black Death in 1348 but completed years later (1355–1359). The *Madonna delle Grazie* by Bernardo Daddi (1347) replaced an earlier image that was destroyed in the fire.

At the end of the left-side nave is the votive altar dedicated to St. Anne that was commissioned by the Signoria (1379). On the altar is a marble sculpture group, *St. Anne, Madonna and Child* by Francesco da Sangallo (*c.*1526). St. Anne whose feast day is celebrated on 26 July is the Protectoress of Florence and in the ceiling fresco above the altar by Mariotto di Nardo (14th century), St. Anne embraces a representation of the city. It was on the feast day of St. Anne that the Duke of Athens, Gualtiero di Brienne (Walter VI, Count of Brienne) connected to the Angevins of Naples, was overthrown by popular uprising (1343). Elite Guelph merchants had invited the Duke to rule Florence in 1342 as a result of the political impasse caused by the financial collapse of the Bardi and Peruzzi banks (Tours 4 and 9). A fresco by Orcagna (1343) originally painted for the tabernacle at the entrance to the Carcere delle Stinche prison demolished in 1833 depicts the *Expulsion of the Duke of Athens* as St. Anne protects Palazzo Vecchio. It is now on display in

Palazzo Vecchio.

Along Via de' Lamberti is *St. Mark* by Donatello (1411–1413) for the Linaiuoli, Rigattieri e Sarti (linen merchants and scrap cloth dealers). The *St. James the Greater* and bas-relief of his beheading are attributed to Niccolò di Piero Lamberti (*c*.1422) for the Pellicciai (furriers). The *Madonna della Rosa* is attributed to Pietro di Giovanni Tedesco (*c*.1400) and Tabernacle attributed to Simone Talenti (1399) for the Medici e Speziali (physicians and apothecaries). The *stemma* above is by Luca dell' Robbia. In the tabernacle by Andrea Pisano (1340) is the bronze *St. John the Evangelist* by Baccio da Montelupo (1515) for the Setaiuoli e degli Orafi (silk weavers and goldsmiths). The *stemma* above is by Lucca della Robbia.

Continue on Via dei Calzaiuoli the short distance into Piazza della Signoria to begin Tour 3. The **Palazzo della Compagnia di Orsanmichele** also called the Compagnia dei Laudesi (look up to see the *stemmi* at the corner with OSM) is attached to **Palazzo dei Cavalcanti**, at the corner of Via de' Lamberti and Via dei Calzaiuoli (13th century) and the row of palazzi on both sides of the street towards the piazza preserve the original width of the street prior to the widening of it from 1841 to 1844 towards the Duomo. The palazzo shows traces of the original arcade now enclosed and the family crest and a marble plaque with a verse from Dante's *Divine Comedy* (*Inferno*, X. 58-63 that references Guido Cavalcanti). Opposite at No. 4 is the **Palazzo dei Buonaguisi**.

On the right side of the street beyond Via Porta Rossa is **Palazzo dell' Arte dei Mercatini or di Calimala** with tondi across the facade with the guild's crest of an eagle holding a bundle of cloth. The street level preserves the 14th-century arcade. Across from it is **Palazzo Bombicci** (18th century) that corners Piazza della Signoria with a medieval arcade on the ground floor. The facade along the side facing the piazza was reconstructed following the demolition of the adjacent church of S. Remolo in 1786 in the suppression of the uprisings under Grand Duke Peter Leopold also known as Leopold II Holy Roman Emperor and Grand Duke of Tuscany, the brother of Marie-Antoinette, Queen of France and Navarre. Across Palazzo Vecchio at No. 4 is the Neo-Renaissance **Palazzo delle Assicurazione Generali** also known as **Palazzo del Leone** (1871) named after the logo of the General Insurance Company. The early basilica of S. Cecilia (5th century) and the medieval Loggia dei Pisani formerly occupied the site.

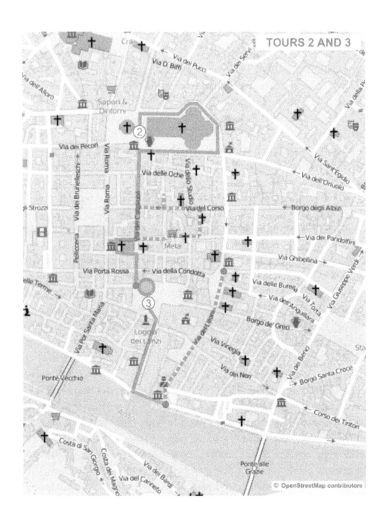

Sites: Piazza della Signoria, Palazzo Vecchio, Loggia della Signoria, the Uffizi, Commemorative site of the 1993 bomb, Museo Galileo.
Distance: .70 km

Piazza della Signoria, Galleria degli Uffizi and Museo Galileo

Piazza della Signoria is the civic heart of medieval and Renaissance Florence with Palazzo Vecchio seat of the governing Priorato delle Arti and the Signoria under the Florentine Republic and later from where the Medici first ruled the city as Dukes of Florence and then the whole of Tuscany as Grand Dukes. The palazzo remains at the civic core of the city symbolized by Michelangelo's *David*, now replaced with a copy, and is the current home of the Municipality of Florence that often stages ceremonial pageants in the piazza. The vast piazza was the location of key episodes from Florence's proud history including the punishment of the Pazzi conspirators and the execution of Savonarola on the spot of his Bonfire of the Vanities. Statues in the piazza and the Loggia della Signoria advertised the shifting power struggles of the Republic and the Medici. At the edge of the piazza is the Uffizi (Galleria degli Uffizi) built as offices but now a world famous museum with must-see artistic treasures. After a visit to the commemorative site of the 27 May 1993 bomb just outside the Piazzale degli Uffizi, the tour ends at the Museo Galileo to highlight the studies and advances of scientists in Florence through the patronage of the Grand Dukes of Tuscany that advanced contemporaneously with the visual and liberal arts.

Piazza della Signoria, filled night and day with locals and tourists taking their turn on the Grand Tour of the city, is dominated by the imposing Palazzo Vecchio. The piazza (originally called Piazza del Popolo in 1307) was built over the ruins of an ancient Roman Bath

complex (*Thermae Maximae*) with an adjacent Fullery (*fulonica*), a public latrine, and part of the Roman Theatre whose ruins are visible under Palazzo Vecchio. The walls of the Roman city ran from the exterior wall of the theatre stage (*scaena*) along the current Via del Proconsolo. In the Middle Ages, the area for tiered theatre seating (*cavea*) fell into ruin and the rubble diminished the steep change in elevation of the piazza still evident on Via de' Gondi that declines along the side of Palazzo Vecchio. A minor tributary of the Arno flowed along the wall and was later used by the guilds for the washing and dyeing of fabric and leather goods. Vasari complained of the marshy area when designing the Uffizi.

Before the conversion of the Uffizi into a gallery displaying ancient and contemporary artistic treasures belonging to the Medici, the Republic of Florence displayed signs of its power over neighbouring rivals, such as Pisa through sculpture in the piazza and the Loggia della Signoria. The male statues with heroic physiques strike dominant and triumphant poses, with the exception of *David* but viewers already know the victorious outcome of his battle against Goliath. The statues were also a commentary and witness of political theatre in the piazza as the Republic and the Medici fought for control of the state and neighbouring territory.

The **Fontana del Nettuno** (Fountain of Neptune) at the corner of Palazzo Vecchio by Bartolomeo Ammannati (1563–1575) is an allegory of Cosimo I de' Medici's power. In 1558, Ammannati's mentor Baccio Bandinelli first received the commission for the fountain sculpture from Cosimo I de' Medici to celebrate the opening of a new aqueduct that brought water to the city centre but Bandinelli died shortly after selecting the marble. The portrait of Cosimo I de' Medici as Neptune is an allegory of his political power and the towering figure has earned it the nickname of *il Biancone* ('White Giant'). Michelangelo criticized the statue by saying that Ammannati had ruined a beautiful piece of marble. Earlier, Michelangelo had praised statues that Ammannati sculpted of relatives of Pope Julius III in the church of S. Pietro in Montorio in Rome. The bronze maritime figures around the basin are reproductions by Francesco Pozzi (1831) of the bronze originals by Ammannati and Giambologna that are now lost.

Cosimo I's rise to power was through cunning and courage. Following the restoration of the Medici in 1530, Alessandro de' Medici

(believed to be the illegitimate son of Pope Clement VII de' Medici) was appointed the first Duke of Florence. He was assassinated by his cousin Lorenzino ('Lorenzaccio') in 1537 with support from Filippo Strozzi (allied with France) and replaced as Duke by his other cousin Cosimo I (allied with Spain) from the branch of the family descended from Cosimo de' Medici the Elder's younger brother Lorenzo (known as Lorenzo the Elder), who served as Duke of Florence (1537–1569) until becoming Grand Duke of Tuscany (1569–1574). He rejuvenated the family fortune and political influence that Pope Leo X and Pope Clement VII had squandered. Cosimo I's marriage to Eleonora of Toledo (1565) elevated the status of his branch of the Medici to European royalty and their son Francesco I married Joanna of Austria, daughter of the Holy Roman Emperor Ferdinand I. They were the parents of Marie de Médicis who as Queen of France and Navarre extended the influence of the Bourbon dynasty in Europe. Her daughter Henrietta Maria married Charles I of England. The Medici ruled Tuscany as Grand Dukes until the childless Gian Gastone de' Medici's death in 1737 when power passed to Francis I, the Holy Roman Emperor who founded the Habsburg-Lorraine dynasty with his wife Maria Theresa.

Immediately in front of the Neptune Fountain is a disc in the pavement marking the spot where the outspoken Dominican Friar **Girolamo Savonarola** (1452–1498) was executed on 23 May 1498 with two of his followers Fra Domenico and Fra Silvestro Maruffi. Savonarola had ruled in Florence after the expulsion of the Medici in 1494. After being hanged, the bodies were burned and their ashes were thrown into the Arno River from a spot near Ponte Vecchio. The place for his execution also marks the earlier location of one of his 'Bonfire of the Vanities' on 7 February 1497. Pope Alexander VI Borgia excommunicated Savonarola the year before his execution for heresy and false prophecy following years of criticisms of the Church (he sided with King Charles VIII of France against the Papacy) and the tyranny of the Medici in Florence who were expelled under his influence but returned in 1512. Machiavelli criticized Savonarola in *The Prince* (Chapter VI) for not having the force of arms to retain power over his followers. Savonarola's cell is preserved in the Convent of S. Marco (Tour 5).

To the left of Palazzo Vecchio is the **Equestrian Statue of Cosimo I de' Medici** by Giambologna (1594–1598). It evokes the equestrian

statue of the Roman emperor Marcus Aurelius now in Piazza del Campidoglio, Rome and presents Cosimo I as a modern-day emperor. The statue of *Gattamalata* (Erasmo da Narni) in Padua by Donatello (1453), influenced by the Marcus Aurelius statue, was the first full equestrian bronze statue since antiquity. The now odd shape of this part of the piazza is due to the demolition of two palazzi in the 13th century belonging to the Cavalcanti and Uberti. The Uberti were members of the Ghibelline faction of Florentine aristocrats allied with the Holy Roman Emperor and his supporters across Europe. The Cavalcanti were members of the Guelph faction allied with the Pope and his supporters across Europe but Cavalcante de' Cavalcanti, friend of Dante Alighieri, married his son Guido to the daughter of Farinata degli Uberti (1266) a prominent Ghibelline at a time when the Ghibellines were dominant in Florentine politics. When their political fortunes shifted, the Guelphs demolished the palaces in retaliation for the Ghibelline destruction of their towers and palaces. The area was considered unlucky and nothing was constructed here before the erection of the statue. On the opposite side of the statue is **Palazzo Ugaccioni** by Mariotto di Zanobi Folfi (1549) with a portrait bust of Cosimo I. Next to it on the other corner of Via de' Cerchi is **Palazzo Guiducci** with a meridian on the side facing the piazza. Behind the statue is **Palazzo della Mercanzia** (1359) established as a civil court for the commerical guilds that is now the **Museo Gucci**. Beyond the piazza, when facing the front of the statue, the tower of the Bargello and the slender tower with a pointed top of the Badia Fiorentina rise above the rooftops diagonally to the left.

Across the front of the palazzo, is a copy of Donatello's *Lion* known as the ***Marzocco*** (1418–1420), the heraldic symbol of Florence holding the coat of arms of the city with the *giglio*, a fleur-de-lys with a visible stamen. An earlier version of the statue was originally attached to a speaker's platform (*ringhiera*) set up in the piazza for the governing signoria but it was demolished in 1812 at which point this version was moved to its current location. Donatello's original is now on display in the Bargello (Tour 4). The name Marzocco may be connected to an ancient Roman statue of Mars, the god of War also connected to the protection of agriculture, that was displayed in the piazza until it was carried off by flooding of the Arno (Dante, *Inf.* XIII. 146; *Purg* XXXI.58) but, like the name of the 'talking statue' *Marforio* in Rome, any linguistic connections to Mars is unclear.

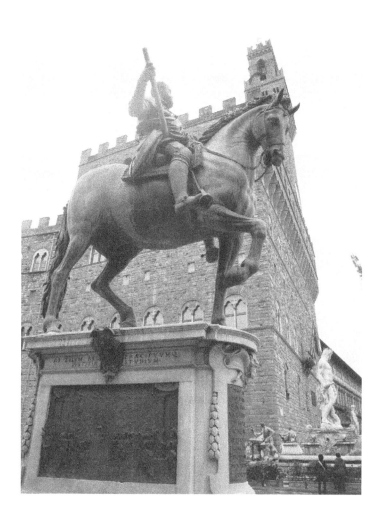

4. Giambologna, *Equestrian statue of Grand Duke Cosimo I*. Piazza della Signoria

The *Judith and Holofernes* is a copy of one of Donatello's last works (*c.*1455–1460) now on display in Palazzo Vecchio. Originally commissioned by Cosimo the Elder as a fountain for Palazzo Medici-Riccardi (Tour 6), as a metaphor for the just rule of the Medici as defenders of Florence's liberty, it was confiscated by the Republic in 1495 following their expulsion and displayed alternately outside the entrance and inside the courtyard of Palazzo Vecchio until moving to the Loggia della Signoria as a warning against the tyrants. It was placed in front of the palazzo in 1919.

In front of the palazzo entrance, is a copy of Michelangelo's *David* placed here in 1910. The original, now in the Galleria dell' Accademia (Tour 5), stood here, remarkably, until 1873. *David* was erected here in 1504 during the 18-year exile of the Medici as a symbol of republicanism over tyranny. Flanking the other side of the entrance is the *Hercules and Cacus* by Baccio Bandinelli (1534). A marble group was intended as an anti-Medici monument to complement the statue of *David,* when Michelangelo first received the commission under the Republic. Upon the restoration of the Medici, Pope Clement VII de' Medici awarded the project to Bandinelli intending the myth to allude to the Medici's return to power over their Republican rivals in 1512 and 1530. It was criticized by Michelangelo's supporters and Bandinelli's rivals Giorgio Vasari and the goldsmith Benvenuto Cellini who apparently criticized it in the presence of Bandinelli's patron Cosimo I de' Medici. A charming urban legend improbably assigns the graffito of a man's portrait on the facade of Palazzo Vecchio behind the statue to Michelangelo. Called the *l'Importuno di Michelangelo* after an importunate man who constantly interrupted the artist's work by engaging in idle conversation.

The **Herms** by Baccio Bandinelli and his student Vincenzo de' Rossi evoke the *grottesche* decoration of Nero's Golden House in Rome that was widely imitated in the Renaissance, including the interior decoration of Palazzo Vecchio. The celebrated statue of *Laocoön* was discovered in excavations of the Golden House in 1506 and restored by Michelangelo. The copy of the statue by Bandinelli is in the Uffizi visible between Palazzo Vecchio and the Loggia della Signoria.

The **Loggia della Signoria** also called the **Loggia dei Lanzi** is attached to **Palazzo della Zecca** (the former Mint that produced Florence's currency the Florin). The loggia with tall rounded arches

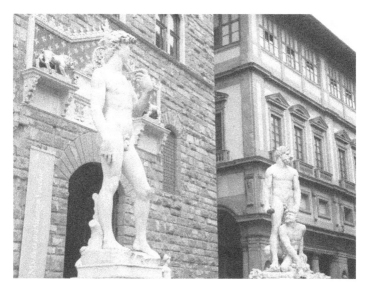

5. Copy of Michelangelo's *David* and Baccio Bandinelli's *Hercules and Cacus* at the entrance to Palazzo Vecchio

more Classical than Gothic in inspiration, was built by Benci di Cione and Simone Talenti for outdoor assemblies and ceremonies. It was built from 1376 to 1382 perhaps to an earlier design by Orcagna (Andrea di Cione) but similarity of surnames may be the source of the alternate name of Loggia di Orcagna. Between the arches are Gothic trefoils (1384–1390) with the seated *Virtues* of Prudence, Justice, Temperance and Fortitude to designs by Agnolo Gaddi. Architect Bernardo Buontalenti altered the design of the roof for the Medici to view spectacle entertainments in the piazza. Today, it is the terrace of the Uffizi café.

The alternate name of Loggia dei Lanzi refers to the pikes or lances of the German mercenaries Landsknechts (Lansquenets in French) whose Italian name Lanzichenecchi was shortened to Lanzi organized under the Holy Roman Emperor Charles V who were stationed here by Cosimo I de' Medici as protectors of his power. Under the Holy Roman Emperor, Spanish mercenaries were added to the force that sacked Rome in 1527 to retaliate for not being paid for defeating the

French in Italy on behalf of Pope Clement VII de' Medici. For the triumphal entry of Charles V into Rome (1536), Pope Paul III Farnese commissioned Michelangelo to redesign Piazza del Campidoglio to receive the emperor on the Capitoline Hill in the style of ancient Roman generals and emperors. For his entry into Florence, the same year, the artist known as Il Tribolo designed triumphal arches and tableaux to mark the occasion.

As a civic focal point, sculpture communicated the political power of Florence over rivals Pisa and Siena and the political struggle between the Republic and the Medici. The ancient Roman *Medici Lion* to the right side of the entrance is flanked by a matching lion to the left made by Flaminio Vacca (1600) for the Villa Medici on the Pincian Hill in Rome that was also the origin of much of the ancient sculpture now in the Uffizi. Vacca used marble from a surviving capital of a column from the Temple of Jupiter Optimus Maximus on the Capitoline Hill in Rome. The statues were transferred to Florence in 1780.

To the far left is Benvenuto Cellini's bronze *Perseus holding the head of Medusa* (1545–1554) commissioned by Cosimo I. Daunted by the task of the project and of competing with Donatello's *Judith* and Michelangelo's *David*, Cellini struggled with the project yet ultimately cast the statue in a single mould. The original of the base that depicts statuettes of *Jupiter*, *Minerva*, *Mercury* and Perseus' mother *Danaë* is in the Bargello (Tour 4) with the bas-relief of *Perseus freeing Andromeda*. Cellini is commemorated with a portrait bust on the Ponte Vecchio (Tour 9). The *Rape of Polyxena* carved from a single block of marble and the only modern work in the loggia is by Pio Fedi (1866). In the sculpture group, Pyrrhus carries off Polyxena, the daughter of Priam and Hecuba, over the body of her brother Polites. In Classical mythology, after the Fall of Troy, Polyxena, was sacrificed on the grave of Achilles, Pyrrhus' father.

In the centre is the ancient Roman group of *Menelaus with the Body of Patroclus* that is a copy of a Greek original (3rd century BCE). It was purchased by Cosimo I in 1570 after its discovery in Rome outside the area of Porta Portese and heavily restored in the 16th and 17th centuries. It was displayed for a time in the 19th century on the Ponte Vecchio. Another group of the same theme but identified as Ajax was purportedly excavated in the Mausoleum of Augustus in Rome by Paolo Antonio Soderini whose heirs gave it to Cosimo I in 1570. It is

now in Palazzo Pitti (Tour 8). The figure of Menelaus gives a sense of how the famous talking statue *Pasquino* near Piazza Navona in Rome originally looked. The six ancient Roman statues of women lining the back wall of the loggia were transferred from the Villa Medici at the same time as the *Medici Lions* in 1780.

To the far right, Giambologna's *Rape of the Sabines* (1582) was commissioned by Grand Duke Francesco I for this location. Giambologna did not have a particular subject in mind for the dynamic three-figure group with no fixed focal point that was carved from a single block of marble so one was assigned after its installation. The gesso model is in the Galleria dell' Accademia (Tour 5). The sculpture group inspired Gian Lorenzo Bernini's *Daphne and Apollo* and *Rape of Proserpina* in the Galleria Borghese in Rome. Behind it is Giambologna's lesser-known *Hercules and the Centaur Nessus* (1599). In Classical mythology, the centaur tried to rape Hercules' wife Deianeira and the demigod exacts his revenge but the centaur's blood causes Hercules to burn until his death and apotheosis into the pantheon of Olympian gods. A Latin inscription on the right wall from 1750 records the adoption of the Roman calendar in Florence in 1749 in which the year begins 1 January instead of 25 March according to the Florentine calendar.

Palazzo Vecchio was designed by Arnolfo di Cambio (1299) who also built the Duomo (Tour 2) and the church of Santa Croce (Tour 4). It was first called Palazzo dei Priori but its name changed to Palazzo della Signoria in the 15th century after the governing body of Florence following the factional strife of the Guelph and Ghibelline parties. The guilds controlled political power over the Signoria until the rise of the Medici who, after several attempts by the Republic to reduce their power, became Dukes of Florence and then Grand Dukes of Tuscany. Cosimo the Elder moved his residence here where, for a time, he was also imprisoned in the **tower** (1433). The tower, incorporating the Tower of the Foraboschi (1310) that was already on the site, is one of the oldest parts of the palace soaring 95 m. The tower figured prominently at key moments in Florence's history – the Pazzi Conspirators were hung from it following the assassination of his brother Giuliano in the Duomo in 1478 and Savonarola was imprisoned in it (1498) prior to his execution in the piazza. The oldest of the three bells in the tower dates from the 13th century and the one-handed **clock** (1667) is a replica of the original from 1353 by Nicolò

Bernardo. The double Gothic windows with trefoils have a *giglio* in the spandrel added by Michelozzo.

The palazzo was expanded by Giorgio Vasari for Cosimo I de' Medici when he moved his residence here from Palazzo Medici-Riccardi (Tour 6) with further additions towards Via dei Leoni by Giovanni Battista del Tasso (1549–1555) and Bernardo Buontalenti (1588–1596). The name changed to Palazzo Ducale (1540–1565) until the Medici moved to Palazzo Pitti on the other side of the Arno (Tour 8). Afterwards, the name of the palazzo was changed to Palazzo Vecchio but the piazza's name remained Piazza della Signoria. Cosimo I commissioned Giorgio Vasari to build a corridor (**Corridoio Vasariano**) to connect Palazzo Pitti to Palazzo Vecchio over the Ponte Vecchio and through the Uffizi that he built to house the government offices. When Florence was the capital of the provisional government of the Kingdom of Italy (1865–1871), the palace served as the official seat. Since 1872, it has served as a museum and the seat of the municipality of Florence and the offices of the Mayor. The popularly called **Renzi's Fountain** on the side facing Via de' Gondi is named after former mayor Matteo Renzi. It was installed in 2011 as one of 16 new fountains to reduce the cost of water and the use of plastic in the city and dispenses both *acqua frizzante* and *acqua normale*.

The palazzo was built over the foundations of medieval structures that were built over the ruins of a **Roman Theatre** dating to the 1st century CE and a second phase under the reign of the emperor Hadrian with a seating capacity of around 5,000 spectators. A section of the *vomitorium* (central entry point to the orchestra area from below the seating area (*cavea*)) and orchestra pit of the theatre survive and are shown on the **scavi** (excavation) tour of the palazzo. From the 6th century CE, as with other Roman cities, including Rome, burials became intramural and the decaying Imperial monuments, including the theatre, became the site of a necropolis. The theatre was fortified during the Byzantine occupation and later in the Middle Ages, was used as a jail. In 1885, architect and archaeologist Corinto Corinti made plans and a reconstruction of the ancient Roman ruins in the area, including the theatre, the *cavea* of which he excavated. The Roman theatre survives in remarkable condition in Fiesole (Tour 10). The public entertainment district continued to the east towards the church of Santa Croce with the Amphitheatre and Roman Port (Tour 4).

Above the entrance between the statues of *David* and *Hercules and Cacus*, is a Gothic frontispiece (1345) with facing gilded *Lions* and a Latin motto dedicated to Christ the King (*Cristo Re*) below the *Monogram of Christ* (1551): *Rex Regum et Dominus Dominantium* (King of Kings, Lord of Lords). Even if not entering the museum, walk into the first courtyard designed by Michelozzo (1453) to see a copy of Andrea del Verrocchio's *Putto with Dolphin* fountain (1476). The original is upstairs in the museum. *Grottesche* stucco and fresco decoration enliven the interior of the courtyard that is lined with topographic maps displaying the territorial possessions of Florence. The entrance to the museums is through a second courtyard beyond a monumental staircase by Vasari (1561–1571) that leads to the Salone dei Cinquecento.

On the **first floor**, the vast **Hall of the Five Hundred** (Salone dei Cinquecento) was built by architects Simone del Pollaiolo, known as Il Cronaca, ('the Chronicle') and Francesco di Domenico (1494) for Savonarola during the Medici exile and is named for his newly created Grand Council of 500 members. The original decoration commissioned by Piero Soderini as *Gonfaloniere* of Justice for life (1502), included Michelangelo's cartoon of the *Battle of Cascina* and Leonardo da Vinci's fresco of the *Battle of Anghiari* (1503), left incomplete due to his failed experiment with paint but is known from a copy by Peter Paul Rubens, that were lost when Cosimo I commissioned Vasari (and his assistants) to enlarge and decorate the hall for ceremonies of court. The frescoes with dynamic battle scenes were much copied and exemplify the rivalry between the two towering figures of the Renaissance who frequently traded insults. Vasari's frescoes (1555–1572) commemorate famous battles and victories of Florence against Pisa and Siena. On the **ceiling**, is the *Apotheosis of Cosimo I* by Vasari surrounded by panels illustrating episodes from his life.

Michelangelo's *Genius of Victory* statue (1533–1534) was intended for the unfinished *Tomb of Pope Julius II della Rovere* and was given to Cosimo I by Michelangelo's nephew Leonardo Buonarroti. Other marble statues made for the tomb include the *Prisoners* or *Slaves* in the Galleria dell' Accademia (Tour 5), the figures of *Moses*, *Rachel* and *Leah* in S. Pietro in Vincoli in Rome and two completed figures in the Louvre known as the *Dying Slave* and *Rebellious Slave*. The original of Giambologna's gesso *Florence triumphing over Pisa* is in the Bargello.

The six statues of the *Labours of Hercules* are by Vincenzo de' Rossi who assisted his mentor Baccio Bandinelli in the sculpting of the statues of Medici family members in the niches. Bandinelli with Guiliano di Baccio d'Agnolo (1542–1543) also created the **tribune** (Udienza) on the north side of the hall where Cosimo I received dignitaries.

The small **Studiolo of Francesco I** was designed and executed by Vasari and assistants (1570–1575) as part of the Grand Duke's private quarters. It is in the Renaissance tradition of the famous Studiolo of Federico da Montefeltro (1473–1476) in the Palazzo Ducale in Urbino as a place of retreat but also as the repository of precious collections and heirlooms that anticipates antiquarian *Cabinets of Curiosities*. The frescoes on each wall depict the *Four Elements* and the scholar Vincenzo Borghini assisted in categorizing the objects in the cabinets along each wall according to the element and iconographic significance.

The series of apartments off of the Salone dedicated to various illustrious members of the Medici (Cosimo the Elder, Lorenzo the Magnificent, Leo X, Giovanni dalle Bande Nere, Clement VII and Cosimo I) are called the **Apartments of Leo X** that Tasso and Vasari designed for Cosimo I (1555–1562). The **Chapel** connects the patriarchs of both branches of the family with paintings by Vasari depicting Cosimo the Elder as St. Cosmas and Cosimo I as St. Damian, the patron saints of the Medici. Pope Leo X de' Medici was appointed Cardinal at the age of 13 and became the first Florentine Pope at the age of 37. His mother, Clarice was a member of the powerful noble Orsini family in Rome that had produced 3 popes and 34 cardinals. He visited Florence in 1515 and artists collaborated on the sumptuous decorations for his entrance into the city and Palazzo Medici (Tour 6). **Pope Clement VII de' Medici** (born Giulio) was the nephew and later the adopted son of Lorenzo following the assassination of his father Giuliano in the Pazzi Conspiracy. Pope Clement VII presided over pivotal events with enormous consequences: the Sack of Rome in 1527 by the mercenary forces of Charles V the Holy Roman Emperor and King of Spain and his refusal to grant Henry VIII of England a divorce from Catherine of Aragon, the aunt of the Holy Roman Emperor. Charles V later supported the restoration of the Medici to Florence in 1530.

The two Medici popes were successful in marrying their niece Catherine de' Medici, daughter of Lorenzo II de' Medici, Duke of Urbino, to King Francis I of France's son Henry II, but the King

famously lamented that she arrived in France broke. Mary Queen of Scots called her mother-in-law a *marchande Florentine* ('Florentine shopkeeper') even though Catherine's mother Madeleine de La Tour d'Auvergne was a French princess and they shared royal blood through her mother's older sister Anne de La Tour d'Auvergne, wife of John Stewart, Duke of Albany and Beatrice Plantagenet. Both Medici popes are buried in the Florentine church of S. Maria sopra Minerva in Rome. Two more members of the Medici family were subsequently elected pope: Pope Pius IV (1559–1564), a distant cousin of Cosimo I de' Medici whose branch of the family was based in Milan and Pope Leo XI who only reigned from 1 to 27 April 1605. Both are buried in Rome, S. Maria degli Angeli e dei Martiri and St. Peter's Basilica respectively. The next Florentine pope, Urban VIII Barberini's rise to the papacy was meteoric.

On the **second floor**, above the Apartments of Leo X in the palace extension built by Tasso and Vasari for Cosimo I, are the **Apartments of the Elements** with celestial and Classical mythological allegories that connects the rooms with those directly below dedicated to family members of the Medici. The **Room of the Elements** is above the Apartment of Leo X as allegory of his role in laying the foundations of the Medici Duchy in Florence; the **Room of Ceres** and **Study of Calliope** with a ceiling fresco of the Muse of epic poetry by Vasari was Cosimo I's place of refuge and is above the Apartment of Cosimo the Elder; the **Room of Opis** is above the Apartment of Lorenzo the Magnificent; the **Room of Jupiter** with a ceiling fresco by Vasari is above the Apartment of Cosimo I; the **Terrace of Juno** (closed off in the 16th century) was dedicated to Eleonora of Toledo and had a loggia. The ceiling fresco is by Vasari. On display here is the original *Putto with Dolphin* (1476) by Andrea del Verrocchio for the Medici villa at Careggi. The **Room of Hercules** is above the Apartment of Cosimo I's father Giovanni dalle Bande Nere; and the **Terrace of Saturn** and the **Study of Minerva** are above the Apartment of Clement VII.

The **Apartments of Eleonora of Toledo** are in the original 13th/14th-century part of the palace that were renovated for Cosimo I by Tasso and then Vasari who completed the decoration of the rooms in 1562, the same year that Eleonora died of malaria at the age of 40. The **Green Room** was painted by Ridolfo del Ghirlandaio (1540–1542) with parrots and birds against a *grottesche* backdrop. Off of the

room is **Eleonora's Study** with more *grottesche* decoration (1545–1548) by Francesco Salviati (born Francesco de' Rossi but also known as *Il Salviati*). The **Chapel of Eleonora** was painted (1540–1565) by the important Mannerist painter **Bronzino** (Agnolo di Cosimo) with iconography and scenes from the Old and New Testament that allude to the Medici dynasty. The **Room of the Sabines** begins decoration by Vasari and Giovanni Stradano that continues into the **Room of Penelope** with heroines from Classical mythology whose virtues equalled those of men. The **Room of Esther** in between these two rooms contains a copy of Leonardo da Vinci's *Battle of Anghiari*. The **Room of Gualdrada** celebrates a Florentine girl whose refusal to let the Emperor Otto IV kiss her symbolizes Florence's virtue and independence.

The **Apartments of the Priors** are also in the original part of the palace that originally housed the *Gonfaloniere* of Justice and the Guild Priors that Cosimo I left mostly intact. The **Chapel of the Priors** was built by Baccio d'Agnolo for *Gonfaloniere* Piero Soderini and painted by Ridolfo del Ghirlandaio (1511–1514) in the first Republic during the Medici exile and continued work upon their return. The **Audience Chamber** was first decorated by Benedetto da Maiano (1470–1474) but Cosimo I commissioned Francesco Salviati to paint *Scenes from the Life of Marcus Furius Camillus* (1543–1545), the Roman general who liberated Rome from the Gauls in 390 BCE to allude to the family's return from exile. The marquetry door with *Dante and Petrarch* is to a design by Botticelli (1480).

The **Hall of Lilies** originally part of the Audience Chamber before the room was divided into two, was decorated by Benedetto da Maiano (1470–1472) and is named for the Angevin Fleurs-de-Lys painted by Bernardo di Stefano Roselli (1490) that honour the ties between France and Florence. In 1482, the Signoria had intended a fresco cycle on all four walls celebrating *Illustrious Men* by leading painters, including Botticelli, Ghirlandaio, and Perugino newly returned from painting the Sistine Chapel in Rome but only one wall was completed by Ghirlandaio. The original of Donatello's *Judith and Holofernes* is on display here. The **Old Chancellery** connected the Hall of Lilies to the Hall of the Five Hundred. Niccolò Machiavelli, author of *The Prince*, served as secretary to the Second Chancellery. Cosimo I commissioned Vasari to design the **Hall of Geographic Maps** or **Wardrobe** to the

existing apartments (1561–1565) and features 53 *Maps* of the then known world by the Dominican friar Egnazio Danti (1564–1575) and Stefano Bonsignori (1575–1586). The *Terrestrial Globe* is by Danti (1564–1571). On the **Mezzanine** level, is the collection of medieval and Renaissance art and furnishings of the **Loeser Bequest**.

Exit Piazza della Signoria and enter into the adjacent Piazzale degli Uffizi that is lined with the galleries of the Uffizi. In the niches are statues of illustrious Florentines. The entrance to the Uffizi is to your left.

If not entering the Uffizi, there are two options to continue with the tour. Walk to the end of Piazzale degli Uffizi (through the arches) and turn left to walk to the end of the block into Piazza de' Giudici. The entrance to the Museo Galileo is just to your left. Or, to see the **Commemoration site of the bomb explosion of 27 May 1993** en route to the Museo Galileo, at the mid-point of the piazzale, turn right on Via Lambertesca then left on Via dei Georgofili. At the corner is an olive tree that survived the explosion. Along the facade of Palazzo dei Georgofili, are plaques including one commemorating the life of a young poetess killed in the explosion at the age of 9. The blast also caused damage to the buildings in the area, including the Uffizi and the nearby church of Santo Stefano al Ponte. Retrace steps through Piazzale degli Uffizi then turn right to walk across the end of the piazzale to the Museo Galileo or continue to sites beyond the Uffizi to begin Tour 4. If you would like to explore the sites in Oltrarno, such as Palazzo Pitti at this time, turn right at the end of Via dei Georgofili and walk across the Ponte Vecchio to begin Tour 9 for San Miniato al Monte or follow directions in Tour 1 to Palazzo Pitti to begin Tour 8.

The Uffizi (Galleria degli Uffizi) is a world famous museum with a collection of painting and sculpture that attracts over a million visitors annually. As former offices (*uffizi*), the Palazzo degli Uffizi was built by Vasari who demolished medieval buildings on the site including the church of San Pier Scheraggio (11th–13th century), then by Alfonso Parigi the Elder and Bernardo Buontalenti for Cosimo I (1560–1574) to supplement the office space available in the Palazzo Vecchio. An area of the building was later converted into an art gallery (Tribune) for Francesco I by Buontalenti. The Medici collection of scientific instruments formerly displayed in Palazzo Vecchio were relocated to the Uffizi. Vasari's Corridor (Corridoio Vasariano) that connects the

Uffizi with Palazzo Pitti contains a collection of artist self-portraits begun by Cardinal Leopold de' Medici installed here beginning in the early 20th century.

The Medici art collection was assembled from gifts, purchases, and dowries. Cosimo I de' Medici acquired ancient Roman sculpture and architectural materials such as columns that Florence lacked from his kinsman Pope Pius IV de' Medici. The Medici sculpture collection in Rome was displayed at the Villa Medici on the Pincian Hill in Rome at the top of the Spanish Steps purchased by Cardinal Ferdinando de' Medici in 1576. The Cardinal later became Grand Duke of Tuscany Ferdinando I and married Christina of Lorraine in 1589. Their wedding was celebrated in the Uffizi and included intermezzi that influenced Baroque performances and stage design.

The Medici had acquired the ancient sculpture collection of Cardinal Andrea della Valle in 1584 and displayed it at the villa until transferring much of the collection to Florence. Other pieces of the collection passed to the Farnese family of Pope Paul III via Alessandro de' Medici who married Margaret of Parma, the illegitimate daughter of Holy Roman Emperor Charles V but after Alessandro's assassination, she married Ottavio Farnese taking with her some of the Medici sculpture that was later displayed in Palazzo Farnese in Rome and then in Naples. Through Ferdinando II's marriage to his cousin Vittoria della Rovere (1634), the painting collection of her grandfather Francesco Maria della Rovere, Duke of Urbino, including work from Piero della Francesca, Raphael, and Titian entered the Medici collection displayed in the Uffizi and the Palazzo Pitti. In the tradition of Catherine de' Medici who left her art collection to the people of Paris, the last Medici heir, Anna Maria Luisa left the Medici collection to the people of Florence in 1737. The art collection was subsequently divided among museums in Florence: the Uffizi, the Bargello and the Museo Archeologico (Archaeological Museum).

In the **vestibule** of the U-shaped second floor where the gallery displays begin along the East Corridor, are ancient Roman statues, sarcophagi and Medici portrait busts. The **East Corridor** is lined with painted portraits commissioned by the Medici (1552–1589) and more ancient Roman sculpture, including Imperial portraits and the *Borghese Ares*. Pope Sixtus IV della Rovere, founder of the Capitoline Museums in Rome (1471) gave the portraits of *Augustus* and *Marcus Agrippa*

to Lorenzo the Magnificent for Palazzo Medici-Riccardi. The Pope would later be Lorenzo's enemy and he supported the Pazzi Conspiracy against the Medici. The *grottesche* decoration is by Alessandro Allori (1581). The display of art in the series of rooms open to the corridor follows a chronological order of artists interspersed with rooms filled with more ancient sculpture. The large crowds can make the visit an overwhelming experience in rooms that were not designed for the display of art but a stroll through the rooms is an education in the history of Renaissance and Mannerist art. The location of artwork is subject to change as new gallery space is opened and more pieces are introduced from storage. Highlights include:

In **Room** 1 to the right of the stairs are paintings from the end of the 12th century to the 13th century. In **Room 2** are *Maestà* altarpieces (tempera on wood) depicting the Enthroned Madonna and Christ Child of the Florentines **Cimabue** and **Giotto** and the Sienese **Duccio** that show an increasing naturalism and humanism in painting over stylized Byzantine and Gothic iconography. Cimabue's *Santa Trìnita Madonna* (*c*.1280–1290) shows an awareness of spatial depth that his student Giotto further explores with an increasing naturalism in his *Ognisanti Madonna* (*c*.1310). His master-work is the series of frescoes on the *Life of the Virgin*, the *Life of Christ* and *Last Judgement* for the Scrovegni Chapel (1305) in Padua and the Bardi and Pazzi Chapels in Santa Croce (Tour 4). The *Rucellai Madonna* (1285) of Duccio (di Buoninsegna) is named after the Rucellai Chapel in Santa Maria Novella (Tour 6). His famous *Maestà* altarpiece in Siena (1308–1311) shows traditional late Gothic features but the reverse panels with the *Life of the Virgin* and the *Life of Christ* reveal experiments in space and naturalism. Not represented here is another important painter of the 13th/14th century, Pietro Cavallini who was active in Rome, Naples, and possibly Assisi.

Off of the room are smaller rooms devoted to painting representing 14th century Siena (**Room 3**) with Simone Martini's *Annunciation* (1333) and work by Pietro and Ambrogio Lorenzetti; Florence (**Room 4**) and International Gothic (**Rooms 5–6**) with altarpieces by Lorenzo Monaco. Gentile da Fabriano's *Adoration of the Magi* (1423) (**Room 7**) that anticipates Benozzo Gozzoli's famous fresco in the Chapel of the Magi (1459–1461) in Palazzo Medici-Riccardi (Tour 6). In **Room 8**, the *Virgin with Child and St. Anne* (*c*.1424) of **Masaccio and**

Masolino shows the influence of ancient Roman sculpture in depiction of the figures. Their frescoes in the Brancacci Chapel in Santa Maria del Carmine (Tour 8) offer an opportunity to compare their styles. Domenico Veneziano's *Santa Lucia de' Magnoli* (1445–1447) is the first altarpiece painted without a gold background and has innovative use of light. Paolo Uccello's *Battle of San Romano* (*c.*1438) with mathematical perspective was displayed with two other panels now in the National Gallery, London and the Louvre in Lorenzo the Magnificent's bedroom in Palazzo Medici-Riccardi. Also here is **Filippo Lippi's** masterpiece *Madonna with Child and Angels* (*c.*1465). In **Room 9** is the altarpiece of *Sts. Vincent, James, and Eustace* by Antonio Pollaiolo with his brother Piero (1466–1468) for the Chapel of the Portuguese Cardinal in San Miniato al Monte (Tour 9). In the centre is **Piero della Francesca's** diptych of Federico da Montefeltro, the Duke of Urbino and Duchess Battista Sforza (*c.*1465).

A large hall is devoted to Sandro **Botticelli** (**Rooms 10–14**) where crowds gather in front of his *Primavera* (*c.*1478–1482) based on Ovid's *Metamorphoses* and the *Birth of Venus* (*c.*1484) one of the most famous paintings in the world perhaps commissioned by Lorenzo di Pierfrancesco de' Medici a cousin of Lorenzo the Magnificent that hung in the Medici Villa at Castello with the *Primavera* and *Pallas and the Centaur* (by late 15th century). According to Classical mythology, Venus was born from the blood of the severed genitals of Kronos and arose from the sea on the shore of the island of Cythera. The myth was popularized by Agnolo (Angelo) Poliziano, the poet of Lorenzo the Magnificent to whom the laurel tree in the painting may allude. The nude figure of Venus may be based on the *Medici Venus* that Botticelli may have seen in Rome when he was there painting the walls of the Sistine Chapel. It is of the ancient *Venus Pudica* type ('modest Venus') but the pose shows Gothic influence. Zephyr and a female figure gently blow the goddess ashore where a female figure, perhaps one of the *Horae*, extends arms with clothing to her. In addition to other works by Botticelli, including Madonna tondi in **Room 15** are the immense *Portinari Triptych* by Flemish artist Hugo van der Goes (1476–1478), the *Lamentation of Christ* by Rogier van der Weyden (*c.*1450) and works by Hans Memling.

The octagonal **Tribune** (**Room 18**) was designed by Bernardo Buontalenti for Francesco I (1584) to display the prize pieces of the

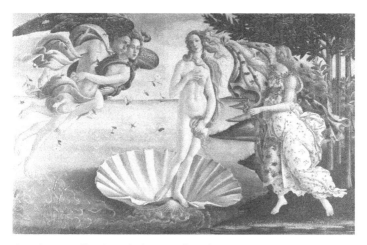

6. Sandro Botticelli, *The Birth of Venus*. Galleria degli Uffizi

Medici Classical sculpture collection. The much-admired *Medici Venus* (1st century BCE) signed by the sculptor Cleomenes, son of Apollodorus, is an Aphrodite of Cnidos statue type like the famous *Capitoline Venus* in the Capitoline Museums, Rome. The *Medici Venus* with arms restored by Ercole Ferrata (1675) was acquired by Cardinal Ferdinando de' Medici for the Villa Medici in Rome and brought to Florence by Cosimo III and was a must-see attraction of the Grand Tour. The statue was taken to Paris by the French in 1802 among other ancient statues and artworks from Italy but returned to Florence in 1816. Ludovico I, King of Etruria commissioned Antonio Canova to make the *Venus Italica* now in Palazzo Pitti as a replacement (Tour 8). Following the discovery of the *Venus de Milo* (1820) both the *Medici Venus* and the *Capitoline Venus* faded from popular acclaim. The *Wrestlers* is a Roman copy of the Greek bronze original from the 3rd or 2nd century BCE as is the so-called *Arrotino* ('knife grinder') that may depict a Scythian assisting Apollo flay the satyr Marsyas for challenging him in a music contest. The *Dancing Faun* playing musical instruments is a Roman copy of a 3rd century BCE original. The *Young Apollo* is based on an original by Praxiteles.

The paintings on display since 1589, are the *Young St. John the Baptist in the Desert* by Raphael and assistants; *A Girl with a Book of*

Petrarch by Andrea del Sarto; and *Madonna and Child with the Young St. John the Baptist* by Pontormo (1527–1528). The *Portrait of Eleonora of Toledo with son Giovanni* (1545) is by **Bronzino** (Agnolo di Cosimo) the court painter of Cosimo I de' Medici. Bronzino was the student of Pontormo Jacopo Carucci and is among the leading Mannerist painters. Other portraits by Bronzino: *Cosimo I in Armour* (1545), a portrait of the young *Giovanni holding a finch*; the portrait of Cosimo I's other son and successor *Francesco I* (1551); the young girl *Bia*, the illegitimate daughter of Cosimo I, his friend and representative in France *Bartolomeo Panciatichi* (1541) and Panciatichi's wife *Lucrezia di Gismondo Pucci* (1545) and a portrait of Cosimo I's granddaughter *Marie de Médicis* (1551). Bronzino also painted the two-sided painting (1552) of the naked dwarf *Morgante* (Braccio di Bartolo) who served as Cosimo I's court jester. In the Boboli Gardens (Tour 8), there is a statue of Morgante riding a tortoise, the family device of the Medici. The portraits of Cosimo I's precursors, include *Lorenzo the Magnificent* by Vasari (1533–1534), the portrait of *Cosimo the Elder* by Pontormo; and *Alessandro de' Medici* by Bronzino (1555–1565).

Rooms 19–23 called the *Salette* with *grottesche* ceiling decoration by Lodovico Buti (1588) and once home to the Medici armoury, include art from the early 15th century. In **Room 19** is Vecchietta (Lorenzo di Pietro)'s *Madonna Enthroned with Saints* (1457). **Room 20** is dedicated to **Andrea Mantegna** (*Madonna of the Cave*), **Giovanni Bellini** and **Antonello da Messina** (*Madonna and Child* and *St. John the Evangelist*). Albrecht Dürer's *Adoration of the Magi* (1504) and *Adam and Eve* (1504) and Lucas Cranach the Elder's portraits of *Martin Luther,* formerly in Room 20, will move to new rooms. **Room 21** with painters from the 15th-century Venetian school was damaged by German bombs in World War II and was restored with a fresco of Florence dated August 1944. **Room 22** is dedicated to painters from Emilia Romagna and **Room 23** from Lombardy. In **Room 24** is the Cabinet of Miniatures.

At the end of the corridor, beyond a statue group of *Venus and Mars* (2nd century CE), is the ***Doryphoros*** (Spear-bearer), an ancient Roman marble copy (1st century CE) of a Greek bronze by Polyclitus (*c.*440 BCE) with restorations. Another famous copy is in the National Archaeological Museum, Naples. The statue type was the inspiration for *Augustus Prima Porta* in the Vatican Museums. The *Sleeping*

Cupid in black marble was one of the earliest pieces of the collection belonging to Lorenzo the Magnificent (1477). More ancient Roman statues line the **South Corridor** with views of the Arno and Piazzale degli Uffizi, including a *Demeter*; *Apollo*; *Venus*; and *Cupid and Psyche*, after a Hellenistic original. In the centre of the corridor is a porphyry torso of a *She-Wolf* (2nd century CE). At the end of the corridor beyond the *Pothos* based on an original by Skopas (mid-4th century BCE) is a colossal head of a *Triton* (3rd–2nd century BCE) once considered a portrait of Alexander the Great, was purchased by Cosimo I. From here, there is an excellent view of the Ponte Vecchio.

At the start of the **West Corridor** is a pair of statues (based on a 3rd–2nd century BCE original group that included Apollo and an *Arrotino* figure like the one in the Tribune), depicting the *Flaying of Marsyas*. The statue on the left made from red marble to simulate the satyr's flayed flesh was displayed in Palazzo Medici-Riccardi by Cosimo the Elder. Restoration to the upper part of the statue is attributed to Donatello (according to Vasari). The statue on the right was acquired by Grand Duke Ferdinando I as Cardinal. After Room 25 is a staircase leading to Vasari's Corridor.

The recently renovated Rooms 25–32 are dedicated to 15th-century art by the teachers of the Great Masters of the Renaissance. In **Room 25** are paintings by Michelangelo's teacher Domenico Ghirlandaio, including his *Adoration of the Magi* (1487) for the Tornabuoni family and by Alesso Baldovinetti. **Room 26** with paintings by Cosimo Rosselli, like Room 29, features art displayed for the first time in the permanent collection taken from the Uffizi deposits after new rooms opened on the first floor. **Room 27** is dedicated to Raphael's teacher Perugino (Pietro Vanucci); **Room 28** to Filippino Lippi with his monumental *Adoration of the Magi* (1496) and Piero di Cosimo with his *Perseus Freeing Andromeda* (1513); and **Room 29** Lorenzo di Credi. In **Room 30** is a fragment of the torso from an ancient basalt copy of the *Doryphoros*. **Rooms 31** and **32** are dedicated to Luca Signorelli with his Holy Family (*c.*1485–1490) and the dramatic *Crucifixion* with Mary Magdalene (*c.*1502–1505). In **Rooms 33** and **34** are Classical sculptures, including portraits, funerary art, and plaster cast reliefs such as a panel from the *Ara Pacis Augustae* in Rome once displayed in the Villa Medici in Rome and the garden of the Casino Mediceo di San Marco in Florence (Tour 5) where Michelangelo first came into contact with them.

Room 35 traces the development from high Renaissance to Mannerism in Florence. **Michelangelo**'s *Doni Tondo* (*c*.1505–1506) of the Holy Family was painted for the wedding of Agnolo Doni and Maddalena Strozzi (1504) and later bought by the Medici (1594) for display in the Tribune. The original frame is by Domenico del Tasso. The serpentine pose of the Madonna may owe inspiration to the recently discovered statue group of *Laocoön* discovered in Rome in 1506 and restored by Michelangelo. The pose also anticipates Mannerism's break from the restraint of the high Renaissance while the nude figures in the background anticipate the *Ignudi* of the Sistine Chapel ceiling begun in 1508 whose recent restoration was guided by the colours in the painting. The room also features work by Andrea del Sarto, Fra Bartolomeo and Francesco Granaci. In the centre of the room is the ancient Roman *Sleeping Ariadne* (2nd century CE).

Beyond the Hall with ancient inscriptions and another cast of the *Ara Pacis Augustae* with the so-called figure of *Tellus* (**Rooms 36–37**) is the Room of the Hermaphrodite (**Room 38**) with a Roman copy of a *Hermaphrodite* after a Greek Hellenistic original (mid-2nd century BCE) and the erotic *Portrait of Gabrielle d'Estrées and One of her Sisters* from the School of Fontainebleu (late 16th century) that depicts, like a more erotic version in the Louvre, the mistress of King Henry IV of France during his first marriage to the equally unfaithful Margaret of Valois, the daughter of Catherine de' Medici and Henry II of France. After the annulment of their marriage, he next married her relative Marie de Médicis and continued having public affairs that produced numerous children. In **Room 41** are 15th-century paintings from Northern Europe.

The **Niobe Room** (**Room 42**) is named after the ancient Roman Niobid statue group (after a 3rd–2nd century BCE Greek original) depicting Niobe and her children being slain. They were found in Rome in 1583 on the Esquiline Hill in the ancient Garden of the Lamiani and were formerly displayed in the garden of the Villa Medici when they were acquired by Ferdinando I de' Medici. In Classical mythology, Niobe had bragged that she was more fertile than Leto the mother of Apollo and Diana, so the goddess sent her children to exact revenge for the insult. Some of Niobe's children in the Niobid Group are unaware that Apollo and Diana have already started to aim their arrows against their brothers and sisters. The dramatic action

set in an outdoor setting made the myth a popular garden theme in ancient Rome. The room and statues were restored following damage caused by the 1993 bomb explosion. During the restoration, the room was returned to its original 1780 design. Also here are a Roman sarcophagus (2nd century CE) with the *Virtues of the Roman Consul*, the *Rape of Proserpina* is by Giuseppe Grisoni (1734) and the *Triumphal Entry of Henry IV into Paris* by **Peter Paul Rubens** (1627–1630). The final three rooms, **Rooms 43–45**, are currently dedicated to temporary exhibition space with Lucas Cranach's *The Judgement of Paris* (*c*.1515–1525) and his *Portrait of Martin Luther and his wife Katharina Von Bora* (1529).

At the end of the corridor is **Baccio Bandinelli's** copy of *Laocoön* in the Cortile del Belvedere in the Vatican Museums for Cardinal Giulio de' Medici whose cousin and adopted brother Pope Leo X de' Medici intended it as a gift to King Francis I of France. When Cardinal Giulio became Pope Clement VII de' Medici, however, he sent the statue to Florence for display in Palazzo Medici-Riccardi (Tour 6). When the Palazzo was sold to the Riccardi, the statue was moved to the Casino Mediceo di San Marco (Tour 5) and then transferred to the Uffizi. In the corner is the ancient statue of a **Boar** that served as the model for Pietro Tacca's *Porcellino* statue now copied in the Loggia del Mercato Nuovo (Tour 7). There is an excellent view of Palazzo Vecchio and Brunelleschi's Dome from the **Terrace** on top of the Loggia della Signoria that is accessed from the café.

On the **first floor**, **Rooms 46–55** are dedicated to foreign painters from the Spanish, Dutch, French, and Flemish schools from the 16th to 18th centuries. In **Room 49** are **Rembrandt**'s *Self-Portrait*, *Self-Portrait as an Old Man*, and *Portrait of an Old Man* with works in **Room 55** by **Rubens** and **Van Dyck**. In **Room 56** dedicated to ancient Hellenistic Art is the *Hercules Farnese*, a Roman copy (2nd century CE) of the famous statue now in the National Archaeological Museum in Naples. **Rooms 57** and **58** are dedicated to **Andrea del Sarto** whose work such as the *Madonna of the Harpies* (1517) named for the reliefs on the Madonna's pedestal represents the transition between the high Renaissance represented by Michelangelo and Raphael and Mannerism represented in Florence by Pontormo and Vasari. Daniele da Volterra who worked with Michelangelo typifies Mannerism in Rome. **Room 60** is dedicated to **Rosso Fiorentino**

with portraits and his *Madonna and Saints*. Fiorentino left Florence to work for Francis I at Fontainebleau; **Room 61** to **Pontormo** that includes his portrait of *Maria Salviati*. He is famous for his frescoes in the church of Santa Felicità (Tour 8); **Room 62** to **Giorgio Vasari**; and **Rooms 64** and **65** to **Bronzino** and the Medici.

Room 66 is dedicated to **Raphael** (Raffaello Sanzio) who was in Florence between 1504 and 1508 when he left for Rome to paint the Papal Apartments (known as the *Raphael Rooms*) for Pope Julius II della Rovere and Pope Leo X de' Medici. The pyramidal composition of the *Madonna of the Goldfinch* (*c*.1505–1506) owes much to Leonardo da Vinci. It survives the landslide of Via de' Bardi that destroyed the Palazzo Nasi (Tour 9). Raphael's portraits include: *Portrait of a Young Man* (1503–1504); his *Self-Portrait* (1506); and *Portrait of Pope Leo X with Cardinals Giulio de' Medici (future Pope Clement VII) and Luigi de' Rossi* (1518). Other paintings by Raphael are in Palazzo Pitti (Tour 8).

The following rooms are dedicated to Modern Mannerism. In **Room 68** are paintings from artists working in Rome during the first half of the 16th century. **Rooms 68–71** are dedicated to Correggio and his followers. In **Room 74**, Parmigianino's popularly known *Madonna of the Long Neck* (1535–1540) famously exemplifies Mannerist art with the serpentine pose and long neck of the Madonna that distort reality. **Room 75** has works by Giorgione and Sebastiano del Piombo. In **Room 79**, are examples of **Leonardo da Vinci**'s early works in Florence including the angel in his mentor Andrea del Verrocchio's *Baptism of Christ* (*c*.1470–1474) that shows his attention to detail evident in his *Annunciation* (1472). His *Adoration of the Magi* is incomplete and dates to 1482 when he left Florence for Milan. **Room 83** is dedicated to the Venetian painter **Titian** (Tiziano Vecellio) and includes portraits, the *Venus of Urbino* (1538) and *Flora* (*c*.1515–1517). After rooms dedicated to temporary exhibitions, works from painters from Lombardy are in **Room 88**.

Currently, in the **Verone Sull'Arno** (Balcony Room) is Bartolomeo Ammannati's bronze *Mars Gradivus* (1559) and Jacopo del Duca's *Silenus with the Young Bacchus* (1571–1574) both of which were once displayed in the loggia of the Villa Medici in Rome with the marble *Medici Vase*, in the centre of the room, from the 1st century BCE. **Rooms 90–93** are dedicated to **Caravaggio** (Michelangelo Merisi da Caravaggio) and Caravaggesque Baroque art. In **Room 90** is the

famous *Bacchus* of Caravaggio painted in Rome (1596–1597) for his patron Cardinal Francesco Maria del Monte as a gift to Grand Duke Ferdinando I to whom he also gave the *Shield with the Head of Medusa* (1597) for the Medici armour collection. The *Sacrifice of Isaac* (*c*.1603) was commissioned by Cardinal Maffeo Barberini, the future Pope Urban VIII whose portrait Caravaggio had painted (*c*.1598). The *Judith and Holofernes* (1612–1613) is by **Artemisia Gentileschi**, the daughter of Caravaggio's follower Orazio Gentileschi. She was the first woman accepted into the Accademia delle Arti del Disegno in Florence and joined her father at the Court of Charles I and Henrietta Maria in England (1638–1642). She returned to Italy and possibly died of plague in Naples (1656).

Rooms 95–100 are dedicated to Florentine and Sienese painters from the 17th century. **Room 101** is dedicated to Guido Reni. The **Contini Bonacossi Collection** that includes works by Cimabue, Paolo Uccello, Andrea del Castagno and Gian Lorenzo Bernini's *St. Lawrence Martyred on a Gridiron* is housed on Via Lambertesca and is closed to the public.

On the **ground floor** is the Book and Gift Shop. The exit is onto Via de' Castellani. Excavations under the Reading Room of the **Uffizi Library** next to Piazza del Grano have revealed 60 skeletons from the 5th–6th centuries CE in an area outside the Roman walls of the city close to the Arno prone to frequent flooding. The burials show signs of haste suggesting an epidemic, perhaps plague, as the cause of death. Turn right and walk into Piazza de' Giudici to Museo Galileo just ahead. A gnomon casts a shadow on the zodiac that is embedded into the sidewalk in front of the museum.

The **Museo Galileo** (Museo di Storia della Scienza) in Palazzo Castellani (formerly called Palazzo de' Giudici) is dedicated to Galileo Galilei (1564–1642) who was appointed Professor of Mathematics at the University of Pisa by Cardinal Ferdinando de' Medici and later taught at the University of Padua (1592–1610). He was tried and found guilty of heresy during the Inquisition under Pope Urban VIII Barberini in 1633 for advocating the heliocentrism of Copernicus versus the Aristotelian geocentrism that was the position adopted by the Catholic Church. According to legend, he muttered '*Eppur si muove*' 'And yet it moves' after recanting his views on heliocentrism. Galileo avoided imprisonment through the intercession of Grand

Duke Ferdinando II de' Medici and was placed under house arrest for the rest of his life at his Villa Il Gioiello in Arcetri near Florence where he died 8 January 1642. He is buried in the church of Santa Croce (Tour 4). The Florence house of Galileo is on the other side of the Arno (Tour 9). The museum contains two telescopes made by Galileo and displays the collection of scientific instruments of both branches of the Medici dynasty whose patronage of the sciences was as important as their patronage of the humanities and arts.

On the first floor is the **Medici Collection** (16th–18th centuries) begun by Cosimo I. **Rooms I** and **II** dedicated to astronomy and the measurement of time contain astrolabes (including an Arab astrolabe from the 10th century) and celestial globes. In **Room III** is the Ptolemaic armillary sphere (1588–1593) of Antonio Santucci for Ferdinand I. **Room IV** contains four globes made for Louis XIV of France by the Venetian Vincenzo Coronelli. Room V is devoted to the maritime ambitions of the Medici who developed the port of Livorno (Leghorn) for commerce that included trade treaties with the English court. The room contains the nautical instruments and gauges of English Admiral Sir Robert Dudley (1574–1649) who was in the service of Ferdinando I's fleet and an important figure in the Medicean study of nautical sciences and map-making. **Room VI** displays instruments in the science of warfare first displayed in Palazzo Vecchio and then in the Uffizi. **Room VII** is devoted to Galileo and contains two telescopes made by him (1609–1610) and the objective lens that he used to observe the four largest moons of Jupiter. In the centre of the room are reliquaries one with Galileo's middle finger from his right hand and the other with his index finger and thumb from his right hand, and tooth. Grand Duke Cosimo III commissioned Carlo Marcellini to make the bust of Galileo (1674). **Room VIII** commemorates the Accademia del Cimento (1657) founded by Ferdinando II and Europe's first academy of sciences. Improvements in the microscope on display in **Room IX** led to discoveries in meteorology and the founding of the biological and entomological sciences.

On the second floor starts (**Room X**) the **Lorraine Collection** (18th–19th centuries) begun by Grand Duke Peter Leopold (1747–1792) who moved the Medici collection from the Uffizi to Palazzo Torrigiani near Palazzo Pitti that houses La Specola (Tour 8). On display here are his remarkable chemistry cabinet, terracotta

obstetrical models (1770–1775) and obstetrical instruments. **Room XI** contextualizes science as entertainment in 18th-century salons. **Rooms XII** and **XIII** are devoted to educational instruments used to teach sciences and **Room XIV** to the precision instrument industry. **Rooms XV** and **XVI** are devoted to the measurement of natural phenomena: atmosphere, light, electricity and electromagnetism. **Room XVII** traces the importance of chemistry from alchemy to experimental chemistry. In **Room XVIII** is a collection of 18th-century scientific instruments designed for home use and displays.

Exit the museum and turn left on Via de' Castellani past the exit to the Uffizi. Continue on it when the name changes to Via dei Leoni at the **Loggia del Grano** the former granary built by Giulio Parigi (1619) for Grand Duke Cosimo II at the corner of Via dei Neri. The **Fontana del Mascherone** (1764) is by Chiarissimo Fancelli who also sculpted the *Portrait of Cosimo II*. Beyond Palazzo Vecchio to your left at the corner of Via de' Gondi is **Palazzo Gondi** that was begun by Giuliano da Sangallo in 1490 and was influential to the designs of other palazzi, including Palazzo Medici-Riccardi (Tour 6), Palazzo Rucellai (Tour 6) and Palazzo Pitti (Tour 8). To continue to Tour 4, walk through Piazza S. Firenze with the Baroque **Tribunale di Firenze** to your right. It was formerly the church complex of S. Firenze for the Filippini (Oratorians), followers of S. Filippo Neri who were given the property by Pope Urban VIII Barberini. The complex was originally designed by Pietro da Cortona (1645) who designed the Chiesa Nuova for the Order in Rome but it was redesigned on a smaller scale by Pier Francesco Silvani (1668). At the end of the piazza to your right is the tower of the Bargello. In the pavement in front are markers indicating the location of a section of the ancient Roman walls. Across the street from the Bargello is the campanile of Badia Fiorentina.

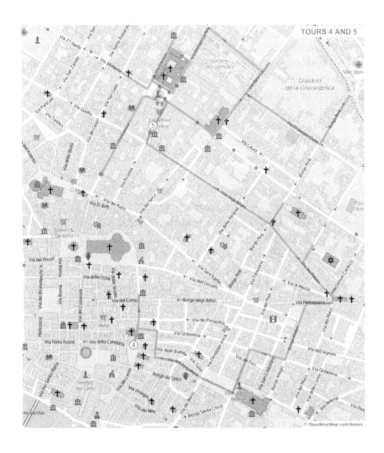

Sites: The Bargello, Badia Fiorentina, Palazzo Nonfinito, Palazzo Borghese, Palazzo Barberini, Santa Croce, Casa Morra; Museo Horne, Casa Buonarroti, Piazza dei Ciompi, Sant' Ambrogio, Mercato di Sant' Ambrogio, Synagogue (Tempio Israelitico) and Jewish Museum, S. Maria Maddalena dei Pazzi, Palazzo Giugni, Brunelleschi's Rotondo di S. Maria degli Angeli, Opificio delle Pietre Dure. Distance: 3.4 km

Tour 4

The Bargello, Santa Croce, Synagogue and Jewish Museum

From the Bargello filled with sculptural masterpieces from the early to the later Renaissance including Brunelleschi and Ghiberti's panels for the Baptistery door competition, versions of *David* by Donatello and Andrea del Verrocchio and sculpture by Michelangelo, Baccio Bandinelli, Bartolomeo Ammannati, and Giambologna, this itinerary takes you to the historic church of Santa Croce with frescoes by Giotto, architecture by Brunelleschi, and tombs of famous Florentines, including Giorgio Vasari's tomb for Michelangelo. The church was built in the area of the Roman Amphitheatre and Roman Port that was gradually transformed into the strongholds and palaces of the wealthy banking families, the Bardi and Peruzzi that later attracted the papal families of the Barberini and Corsini. Around Piazza dei Ciompi were the homes and workshops of famous artists Vasari, Michelangelo, Cimabue and Ghiberti. The itinerary includes strolls through outdoor markets to reach the Synagogue relocated following the demolition of the medieval area around the former Jewish Ghetto in the 19th century to create Piazza della Repubblica (Tour 7). The tour ends at the Galleria dell' Accademia with Michelangelo's *David* at the start of Tour 5.

The **Bargello** (Museo Nazionale del Bargello) with its menacing tower and medieval crenelations is a must-see museum filled with an important collection of stone and bronze sculpture, maiolica, reliquaries, and other artworks originally part of the Medici collection displayed in the Uffizi and relocated here in 1874. Sculpture on display, from Donatello to the Mannerists, shows the influence of humanism earlier

than painting: secular subjects and less iconic treatment of religious figures that defined the Renaissance in Florence. The oldest part of the palazzo begun in 1255 is attributed to a certain Lapo the maestro of Arnolfo di Cambio to serve as headquarters for the Capitano del Popolo but in 1261 the palace was occupied by a magistrate called the Podestà. The palazzo was enlarged by Neri di Fioravante (*c.*1340) and acquired the name Bargello after the office of police chief instituted by the Medici in 1574. It is the oldest public building in Florence. Francesco Mazzei restored the palazzo to its 14th-century appearance (1858–1865), including the opening of the *verone* on the first floor facing the courtyard that was enclosed when the palace served as a prison (until 1849). The crests of prominent families line the courtyard.

In the **courtyard** where executions took place until abolished by Grand Duke Peter Leopold (1786) are sculpture from the Medici collections mostly originating from the Boboli Gardens (Tour 8) or the Villa Medici di Castello, including 14th-century pieces: Benedetto da Maiano's *Coronation of Ferdinand of Aragon and Six Musicians* and statues of the *Madonna and Child*, and *Saints Peter and Paul* from the Porta Romana by Paolo di Giovanni (1322). The statue of *Cosimo I* as a Roman emperor is by Vincenzo Danti. Bartolomeo Ammannati's allegorical *Juno fountain* (1556–1561) with Juno flanked by peacocks for the Salone dei Cinquecento in Palazzo Vecchio (Tour 3) that was commissioned by Cosimo I de' Medici in 1555. His wife, Eleonora of Toledo's symbol was the peacock, the bird of the ancient goddess Juno, sister and wife of Jupiter. In 1588 the monumental fountain was moved to Palazzo Pitti and installed in the location of the current *Fontana del Carciofo* before being dismantled and individual pieces were displayed throughout the gardens. Ammannati also sculpted the other allegorical figures, including the rivers *Arno* and *Arbia*, near Siena associated with the Spring of Mount Parnassus symbolized by Pegasus. The marble *Oceanus* by Giambologna made for the Isolotto in the Boboli Gardens was later replaced with the current copy. The *Bronze Cannon* (17th century) by Cosimo Cenni with St. Paul and the Medici coat of arms was commissioned by Ferdinand II for Livorno Castle (1620).

On the **ground floor**, the large room in the original part of the palace is dedicated to **Michelangelo and Sculpture from the 16th Century**. **Michelangelo** studied sculpture under Bertoldo di Giovanni,

a student of Donatello and was one of the first students enrolled in Lorenzo the Magnificent's humanist Platonic Academy (also called the Florentine Academy) that met in the garden of the Casino Mediceo in Piazza San Marco (Tour 5) and the Villa Medici in Fiesole (Tour 10). Michelangelo's marble statue of the drunken **Bacchus** (*c*.1497) was made in Rome for Cardinal Raffaele Riario, the nephew of Pope Sixtus IV della Rovere but it was rejected by him and bought by the banker Jacopo Galli who displayed it in his garden. It was later acquired by the Medici and transferred to Florence. Michelangelo's next commission in Rome was his iconic *Pietà* in St. Peter's Basilica for Cardinal Jean de Bilhères. The **Pitti Tondo** (*c*.1503–1505) with the Madonna and Child with the Infant St. John the Baptist was commissioned by Bartolomeo Pitti (*c*.1503–1505) and displays his shallow relief carving technique (*schiacciato*). The other tondo with the *Madonna and Child with the Infant St. John the Baptist* is by Giovan Francesco Rustici.

Work by Michelangelo made a few decades after his colossal statue of *David* (Tour 5): *Day* and *Aurora bozzetti* (small scale models) for the Medici Tombs (1526–1531) in the Cappelle Medicee in San Lorenzo (Tour 6); the *Apollo/David* (1530–1534) for Baccio Vallori but left unfinished when Michelangelo was summoned to Rome by Pope Clement VII de' Medici in 1534 to paint the altar wall of the Sistine Chapel but the *Last Judgement* was started after Clement VII's death for Pope Paul III Farnese (1536–1541). The unfinished bust of *Brutus* (1540s) the famous Liberator of the Roman Republic, for Cardinal Niccolò Ridolfi, a grandson of Lorenzo the Magnificent, evokes Classical portraits (the toga was added by Michelangelo's student Tiberio Calcagni) but is distinct from them with its sharp turn of the head. The bust is associated with Florentine republicanism following the assassination of Duke Alessandro de' Medici. Daniele da Volterra's bronze portrait bust of *Michelangelo* is a tribute to his mentor and friend. He was present at Michelangelo's death and gave another version of the portrait to his nephew Leonardo Buonarroti that is on display at Casa Buonarroti. Not represented in the room is work by Raffaello da Montelupo, Michelangelo's student who assisted him in the Cappelle Medicee (Tour 6). He was active in Rome and is best known for the original statue of *St. Michael* on Castel Sant' Angelo (*c*.1536) but his *Angels* for Ponte Sant' Angelo for Pope Paul III Farnese were replaced by Bernini's.

The sculpture in the other half of the room captures the influence of Michelangelo's rival **Baccio Bandinelli** (1493–1560) and the work of his students and other Mannerist contemporaries. Bandinelli was a student of Giovan Francesco Rustici who, in turn, mentored his own students whose works are represented in the gallery (but the influence of Michelangelo on them is evident): Bartolomeo Ammannati, Vincenzo de' Rossi, and Giambologna. Bandinelli is popularly known in Florence for his statue group of *Hercules and Cacus* at the entrance of Palazzo Vecchio and copy of *Laocoön* in the Uffizi. Bandinelli accompanied the Medici to Rome in their exile (1527) and later designed the funerary monument to Pope Leo X de' Medici in the church of S. Maria sopra Minerva in Rome with the assistance of Raffaello da Montelupo. The marble *Adam and Eve* (1551) by Bandinelli was commissioned by Cosimo I for the chorus of the Duomo (Tour 2) but the statue group was removed in 1722 because of the nudity of the figures. His marble portrait of *Cosimo I* (1539–1540) offers an opportunity to compare it to Cellini's bronze version in the room.

The *funerary monument to Mario Nari* (1540–1542) by **Bartolomeo Ammannati** (1511–1592) depicts the deceased as a recumbent Roman soldier with an accompanying figure of *Victory*. The statue apparently aroused the envy of his mentor Bandinelli and it was never displayed in the Nari chapel in the church of SS. Annunziata (Tour 5). Other works by Ammannati give further evidence of his talent, including his *Moses* and *Leda and the Swan* that is after a lost painting by Michelangelo. Ammannati is popularly known for the *Neptune fountain* in Piazza della Signoria. The *Dying Adonis* (*c.*1570) is by **Vincenzo de' Rossi** (1525–1587) who depicts the mythological lover of Venus naked in a recumbent pose. The hand of Adonis shows the influence of Michelangelo's *David*. Another student, **Vincenzo Danti** (1530–1575) from Perugia was also influenced by Michelangelo and his work is less popularly known than that of his contemporaries Ammannati and Giambologna. Danti's bronze low relief of *Moses and the Brazen Serpent* (1557) anticipates the dynamism of his marble *Honour triumphs over Falsehood* (1561) carved from a single block of marble for Sforza Almeni, the cupbearer (cappiere) of Cosimo I de' Medici. A sense of drama extends to his bronze *The Beheading of St. John the Baptist* (1567) group over the south doors of the Baptistery (Tour 2).

The iconic bronze statue of *Flying Mercury* (1580) by **Giambologna** the Flemish sculptor born Jean Boulogne (1529–1608) elegantly captures Jupiter's messenger in flight atop the breath of Zephyr. It was designed for a fountain in the Villa Medici in Rome. His bronze *Bacchus*, formerly part of a fountain on Borgo San Jacopo in Oltrarno (Tour 8), is now replaced with a copy. *Venus Emerging from her Bath* (*c.*1570) was originally displayed in the Grotta Grande of the Boboli Gardens (Tour 8). The marble *Florence Victorious over Pisa* (1575) recalls Michelangelo's *Genius of Victory* in Palazzo Vecchio. **Benvenuto Cellini**'s marble *Ganymede* (1545–1547) depicts the Trojan youth nude with the eagle, the form in which Jupiter snatched him up to Olympus to serve as his wine server. On display is his original marble and bronze pedestal of *Perseus holding the head of Medusa* (1545–1554) for the Loggia della Signoria where a copy is now displayed (Tour 3). His bronze *Portrait of Cosimo I* (1545–1547) is the goldsmith's first work in bronze. The marble *Bacchus* (1510) is by **Jacopo Sansovino** born Jacopo Tatti (1486–1570) who studied under Andrea Sansovino who apprenticed under Antonio Pollaiolo. Sansovino also sculpted the polychrome high relief *Madonna and Child*.

The stone stairs lead up to the **first floor** to the **Verone** (Loggia) with Giambologna's marble allegory of *Architecture* (*c.*1570). The bronze birds by Giambologna and others, including Ammannati were made for the grotto at Villa Medici di Castello that also included Botticelli's paintings of *Primavera* and *Birth of Venus* now in the Uffizi gallery (Tour 3). Rooms on the first and second floors progress around the courtyard.

The Gothic **Consiglio Hall** designed by Neri di Fioravante and restored in the 19th century is dedicated to Donatello (1386–1466) and important early Florentine Renaissance sculpture. In the centre is Donatello's original *Marzocco* (1418–1420), the heraldic symbol of Florence that was moved here from Piazza della Signoria in 1812 (Tour 3).

The three statues of the biblical figure of David allow for a study of the development of Florentine Renaissance sculpture. **Donatello** came into contact with Classical art during his visit to Rome (1402–1404) with Brunelleschi and it had a profound impact on his work and the history of Renaissance sculpture. Donatello's *David* in marble (*c.*1408) was his first major work upon his return from Rome and there are hints

of Classical influences but the overall effect is still Gothic. His bronze *Putto* (1430s), however, reveals the influence of ancient putti figures on ancient Roman reliefs. Donatello's *David with the Head of Goliath* in bronze (*c.*1439–1443) was commissioned by Cosimo the Elder for Palazzo Medici-Riccardi (Tour 6) and is the first freestanding nude male statue since Classical antiquity. After the expulsion of the Medici in 1495, it was moved to the first courtyard of Palazzo Vecchio. The Medici recovered the palazzo after their return and Cardinal Giulio de' Medici (future Pope Clement VII) commissioned Giovan Francesco Rustici to make a terracotta replacement copy of Donatello's *David* for the courtyard but it was never completed. Unlike his first version, an effeminate David stands nude except for his helmet in a sensuous pose over the head of Goliath whose helmet feather touches David's inner thigh. Classical influences dominate Donatello's work in this period and the *Equestrian statue of Marcus Aurelius* inspired his *Equestrian statue of Gattamelata* (1453) in Padua, the first full scale equestrian statue since antiquity.

Andrea del Verrocchio's bronze *David* (*c.*1468–1469), formerly displayed on the second floor, was made for Piero de' Medici but it was purchased by the Signoria by 1476. The statue is less sensual than Donatello's bronze version and the proud angular stance exudes a confidence that confronts the viewer. The attention to detail that is also present in his paintings influenced his student Leonardo da Vinci. Later in the 15th century, Tullio Lombardo's *Adam* (*c.*1490) for the Tomb of Doge Andrea Vendramin in the church of Ss. Giovanni e Paolo, Venice, now in the Metropolitan Museum of Art, New York, was also inspired by Classical art in the Venice area and was the first life size nude marble statue of the Renaissance. His *Portrait of Christ* (1520) is in the Bargello collection. Unlike these previous versions, Michelangelo's monumental nude *David* (1502–1540) in the Galleria dell' Accademia (Tour 5) depicts the hero prior to his battle with Goliath.

Against the wall is Donatello's *Stemma Martelli*. It is the crest of the Martelli, the family of Grand Duke Cosimo I's second wife Camilla whom he married after his retirement whereupon his son Francesco I succeeded him as Grand Duke. Following his father's death Francesco committed Camilla to the Convent of Santa Monica. She was allowed to leave for the wedding of her daughter with Cosimo I, Virginia to

Cesare d'Este, son of Alfonso I d'Este, Duke of Ferrara. The dramatic turn of the head characterizes Donatello's polychrome terracotta *Portrait of Niccolò da Uzzano* (1430s) the Gonfaloniere of Justice who led the opposition with the Albizzi family against the Medici even though earlier, he had served as the executor of the will of Medici ally Antipope John XXIII in 1410. It is considered the first portrait bust of the Renaissance. A sense of movement is also implied in Donatello's marble *St. George* (*c*.1415–1417) in the tabernacle from Orsanmichele (Tour 2) that depicts the Saint gazing into the distance and stepping out of the niche. Like his statue of *David* in marble, the overall effect, however, is more Gothic than Classical. The low relief panel of *St. George and the Dragon* casts the scene anticipated by the statue above against a spatial background achieved through perspective.

The Baptistery door contest panels (Tour 2) of Donatello's teacher **Lorenzo Ghiberti** and **Filippo Brunelleschi** with the scene of the *Sacrifice of Isaac* (1403) show the influence of perspective and classical sources for the depiction of religious subjects. Both reliefs are set in a quatrefoil frame but Ghiberti uses gold to highlight the spatial depth of the composition that is more dramatic than Brunelleschi's multi-figure scene that revolves around the figure of Isaac. Ghiberti also made the bronze *reliquary urn of Saints Protus, Hyacinth, and Nemesius* (1428). Among other treasures of the early Florentine Renaissance in the room are: four glazed and enamelled terracotta works of the *Madonna and Child* by **Luca della Robbia**.

Through the Tower and Podestà Halls with Islamic and metal arts and the Carrand Collection of early religious icons and art is the **Chapel** built after 1280 but later divided into two stories when the Medici converted the palace into a prison and had the walls plastered to conceal the frescoes. Restoration by Antonio Marini (1840) revealed the fresco cycle by the School of Giotto (1340) with scenes of *Paradise* with a portrait of *Dante* (in profile in the group to the right), *Hell* on the west wall, the *Flight into Egypt*, and the *Lives of Mary Magdalene* and *St. John the Baptist*. The wooden *Crucifix* is attributed to Michelangelo (*c*.1495). At the church of Santo Spirito (Tour 8) he dissected corpses for anatomical studies under the protection of Prior Niccolò Bicchielli and his polychrome wood *Crucifix* (1492) on display there depicts Christ nude. The displays in the next halls include ivories and Carolingian and Byzantine era icons and art. The **Maiolica**

Room contains an important collection of maiolica and ceramics from the Medici collections, including utility wares and ornamental pieces from Urbino, Deruta, and Faenza with mythological and historical subjects, and *grottesche* decorations designed for sideboard display in banquet halls.

On the **second floor**, are rooms dedicated to enamelled terracotta by **Giovanni della Robbia** and his father **Andrea della Robbia** (the nephew of Luca della Robbia) and others of portraits and religious works that were originally produced for convents and monasteries but became highly collectible. In the **Andrea del Verrocchio Room** is his marble bust of a *Lady with a Bouquet of Flowers* (1472–1480) associated with Lorenzo the Magnificent's mistress Lucrezia Donati, portraits and reliefs, including the *Death of Francesca Tornabuoni-Pitti*. Other portraits are by Antonio Pollaiolo and Antonio Rossellino. The **Small Bronzes Room** displays an excellent collection of Renaissance bronze begun by Lorenzo the Magnificent, particularly statuettes on mythological subjects, including Antonio Pollaiolo's *Hercules and Antaeus* (*c.*1492); and works by Baccio Bandinelli, Giambologna, Benvenuto Cellini and others. Bronzes from the Carrand Collection are also displayed here. Other metal objects are in the Medals and Armoury Rooms with an important collection of arms and armour assembled by the Medici.

Among the Baroque treasures on the second floor is **Gian Lorenzo Bernini**'s remarkable *Portrait of Costanza Bonarelli* (1636–1637), the wife of one of his assistants Matteo Bonarelli for whom Bernini fell in love. Pope Urban VIII Barberini intervened and according to the Pope's advice, Bernini married Caterina Tezio. The marriage lasted 34 years and the couple had 11 children. The portrait anticipates 18th-century portraiture. The only other Bernini sculpture in Florence, *St. Lawrence on the Grid Iron* is in the Uffizi collection but rarely on public view. The exit is onto Via Ghibellina.

Directly across the street from the Bargello on Via del Proconsolo is the **Badia Fiorentina** (S. Maria Assunta della Badia Fiorentina) with its distinctive half Gothic, half Romanesque campanile. The current church perhaps by Arnolfo di Cambio (1285) was built on the site of the original 10th-century Romanesque Benedictine abbey and church founded by Willa in memory of her husband Uberto, Margrave of Tuscany when Florence was part of the Frankish empire. Part of

the newly rebuilt abbey complex was demolished in 1307 when the monks failed to pay taxes. The entrance onto Via del Proconsolo is by Benedetto da Rovezzano (1495) with the Pandolfini family emblem of the dolphin. At the same time, Rovezzano reworked the 10th-century church of Santo Stefano within the complex where Boccaccio had delivered his lectures on Dante's *Divine Comedy* (1373). The Gothic church plan was again altered in the Baroque reconstruction of Matteo Segaloni (1627) who remodelled it on a Greek cross design and changed the main entrance of the complex to Via Dante Alighieri. The *Signori di Otto di Guardia e di Balia* enforced quiet and no ball playing in the streets around the Badia under the threat of severe penalty. A plaque with the prohibitions survives behind the Badia at the corner of Via Dante Alighieri and Via dei Magazzini.

Inside the entrance of the church to the left is Filippino Lippi's *Apparition of the Madonna to St. Bernard* (*c*.1485) and to the right is the altarpiece of the *Madonna with Saints Leonard and Lawrence* by Mino da Fiesole (1464–1470). Just beyond is his funerary *Monument to Bernardo Giugni* (died 1460) with an effigy of the deceased and the figure of *Justice*. The Baroque Chapel of St. Mauro is by Vincenzo Meucci (1717). Accessed from the area to the right is the *Cloister of the Oranges* designed by the important early Renaissance architect Bernardo Rossellino (1432–1438) with a 15th-century fresco cycle on the *Life of St. Benedict*. On the north side of the nave with 17th-century works, is Giovanni Battista Naldini's *Way to Calvary*. Fragments from a fresco cycle on the *Passion of Christ* by Nardo di Cione from the 10th-century church with a scene of Judas' suicide are displayed in the next chapel. Below the choir loft is Mino da Fiesole's funerary *Monument to Ugo* (son of Uberto and Willa), Margrave of Tuscany who died in 1001. Above it is the *Ascension with Two Saints* by Giorgio Vasari (1568). Vespers are sung by the Fraternity of Jerusalem that also operates a shop selling devotional items and natural products from various monasteries in Italy.

Continuing along Via del Proconsolo a short distance, walk past **Palazzo Pazzi-Quaratesi** at No. 10 (1458–1469) designed by Giuliano da Maiano that is also known as the Palace of the Conspiracy after Jacopo de' Pazzi who was complicit in the conspiracy against the Medici in 1478. Cross Borgo degli Albizi, a street with beautiful palazzi including **Palazzo Albizi** at No. 12 and **Palazzo Ramirez de Montalvo**

at No. 26 with contributions by Bartolomeo Ammannati and Giorgio Vasari. At the end of Via degli Albizzi is the facade of the former church S. Pier Maggiore redesigned by Matteo Nigetti (1638) that contained Francesco Botticini's Palmieri Altarpiece *Visions of Paradise* (1497) now in the National Gallery, London. Buried there were famous artists Luca della Robbia, Piero di Cosimo, Mariotto Albertinelli and the poetess and Greek scholar Alessandra Scala. The church was demolished in 1784 by order Grand Duke Peter Leopold and the contents moved to the Spedale degli Innocenti and the church of S. Michele Visdomani.

The entrance to the **Palazzo Nonfinito** ('Unfinished Palazzo') at No. 12 Via del Proconsolo formerly belonged to the Strozzi family. The palazzo was designed by Bernardo Buontalenti who redesigned the facade of the Duomo for Cosimo I de' Medici but left it unfinished. The state acquired the palace for administrative use including the period when Florence was the capital of Italy. It has since housed Italy's first **Museum of Anthropology and Ethnology** (1869) now part of the Museum of Natural History of Florence.

Retrace steps to Via Ghibellina. Turn left to walk along the exit side of the Bargello to the corner of Via dell' Acqua with **Palazzo Borghese** remodelled by Gaetano Baccani (1822) for Camillo Borghese, descendant of Pope Paul V Borghese and the husband of Paolina Bonaparte. Camillo's mother Maria belonged to the Salviati family of Florence also linked to the Medici (Pope Leo XI de' Medici was the son of Francesca Salviati, the daughter of Giacomo Salviati and Lucrezia de' Medici) that owned the palazzo since the 13th century. She moved to Rome to marry Marcantonio IV Borghese and her fortune contributed to the renovation of Villa Borghese in Rome. Camillo sold the bulk of the famous Borghese ancient sculpture collection to Napoleon that is now displayed in the Louvre.

Turn right on Via dell' Acqua. At the end of the block, turn left on Via dell' Anguillara. Look to your left at Via Torta (formerly called Via Torcicoda 'twisted tail') and to your right at Via de' Bentaccordi for the elliptical curve of the building facades that preserves the outline of the ancient **Roman Amphitheatre**. The amphitheatre, like the other monuments of ancient Florence survives in the foundations under the modern city. Originally outside the ancient walls beyond the Roman theatre in modern-day Piazza della Signoria, it was built between 124 to 130 CE during the reign of the emperor Hadrian. It had a seating

capacity of approximately 20,000, however, the scale of the bloodlust of the Colosseum in Rome was unmatched anywhere in the ancient world. The ruins of the amphitheatre were gradually incorporated into the medieval structures including those of the Peruzzi family in Piazza de' Peruzzi (see below).

Follow Via dell' Anguillara into Piazza Santa Croce where the 12th-century wall once ran along the west side of the piazza with an entrance gate called Porta San Simone.

Piazza Santa Croce from the medieval era on was the hub of the lucrative textile and leather industries whose various activities of washing and dyeing gave the area of the piazza a foul stench. Borgo de' Greci leading to Palazzo Vecchio preserves the history of the area's dark streets and leather factories. Street names reveal the former activities and trades associated with them in the area around the piazza that was formerly in the vicinity of the ancient **Roman Port** at the bend formed by Via dei Neri and Via della Mosca to the west of Ponte alle Grazie: Via delle Conce (Tanners) and Via dei Conciatori (Tanners) and around Piazza Mentana towards the Arno: Via dei Tintori (Dyers); Via dei Saponai (Fullers); Via del Vagellai (Dyers). The **Scuola del Cuoio**, a school for leather making and a retail showroom occupy the former dormitory of Santa Croce accessed from the church or directly on Via S. Giuseppe, No. 5 red, on the left side of the church.

For centuries, the piazza has been the site of spectacle entertainment, including the iconic **Calcio Storico Fiorentino**. Florentines pack the temporary bleachers leading up to the feast day of S. Giovanni (24 June) set up for the ferocious football (soccer) matches first played in the 16th century between teams representing the four historic *Quartieri* of the city: Santa Croce (blue); San Giovanni (green); Santa Maria Novella (red) and Santo Spirito (white). Other special events held here include the German Christmas Fair (Mercato Tedesco di Natale) with traditional German handicrafts and foods.

On the south side to your right are *sporti,* wooden houses with second stories that project over the ground level. Midway in the piazza is the medieval **Palazzo dell' Antella** that was later enlarged and decorated with a polychrome facade by several artists including Domenico Cresti (Il Passignano), Matteo Rosselli, and Ottavio Vannini (1619–1620). A bust of Grand Duke Cosimo II de' Medici is set above the main entrance. On the west side of the piazza facing

the church is **Palazzo Cocchi-Serristori** (1485–1490) attributed to Giuliano da Sangallo that was built on the site of an earlier palazzo belonging to the Peruzzi family. It currently serves as the Headquarters for the 1st Quartiere of Florence. The street in front of the palazzo continues outside the piazza as Via Giuseppe Verdi with the **Teatro Verdi** named for the composer.

On the north side of the piazza to your left is Via Giovanni da Verrazzano named after the navigator who explored the Atlantic coast of North America for King Francis I of France. A plaque on the house at No. 20 (the last house on the right at the end of the block) identifies it as his birthplace. Rival claims based on the identity of his parents place his birth in Greve in Chianti in Tuscany and Lyon, France.

At the corner of Via Giovanni da Verrazzano facing the piazza is a palace attributed as **Palazzo Barberini** (Piazza Santa Croce, 5) the in-town residence of the Barberini during the childhood of Maffeo Barberini, the future Pope Urban VIII (1568–1644). The future pope was born in Barberino di Mugello north of Florence where the noble Barberini owned estates in the Mugello Valley. The palace symbolizes the meteoric rise of the Barberini to the papacy: Maffeo moved to Rome and lived with his uncle Cardinal Francesco Barberini and began his clerical studies and career that quickly took him through the ranks to become pope in 1623. He dedicated St. Peter's Basilica in 1626 and began construction of his Palazzo Barberini in Rome the following year in 1627 with architects Francesco Borromini, Gian Lorenzo Bernini and Pietro da Cortona. Ownership of this Florentine palazzo passed to the Corsini, the family of Pope Clement XII (1730–1740) popularly associated with commissioning the Trevi Fountain in Rome. The Corsini built the monumental Palazzo Corsini on the banks of the Arno (Tour 6).

The entrance to the Basilica of **Santa Croce** (Holy Cross) is on the left side past the monumental statue of *Dante* on Largo Piero Bargellini. The statue by Enrico Pazzi (1865) was relocated here from the other end of the piazza following the devastating flood of 4 November 1966 that damaged the church and its art. Volunteers in the international effort to clean up the interior of the church and other historic sites were called 'Mud Angels'. The Gothic church designed by **Arnolfo di Cambio** in 1294 and remodelled by Giorgio Vasari (1560) is the world's largest Franciscan church that contains the tombs and funerary monuments of illustrious artists and Florentines. The English Francis

Joseph Sloane paid for the colourful marble neo-Gothic facade (1857–1863) by Niccolò Matas (1798–1872), a Jewish architect who is buried under the front steps. Pope Pius IX laid the foundation stone in 1857 with Grand Duke Leopold II. The first church of the Holy Cross was founded in Rome in the 4th century CE by the Emperor Constantine's mother, St. Helena.

Along both sides of the nave are altarpieces by Vasari and contemporaries including Bronzino that alternate between funerary monuments. To your immediate left upon entering on the **north side** is Desiderio da Settignano's funerary **Monument to Carlo Marsuppini** (died 1453), humanist scholar and the associate and ally of the Medici who wrote the epitaph for Leonardo Bruni on the opposite side of the nave who preceded him as Chancellor of the Republic. The fine funerary monument takes its design cues from Bernardo Rossellino's tomb for Bruni that set the standard for Renaissance funerary monuments inspired by Classical art and architecture.

In the north transept is **Donatello**'s wood *Crucifix* (1412–1415) that his friend Brunelleschi criticized for having a peasant's body so he carved one himself that is now in the church of S. Maria Novella (Tour 6) to show Donatello how to depict Christ's body. At the end of the nave opposite is the monument to **Leon Battista Alberti** by Lorenzo Bartolini (1850) who died in Rome. There are five chapels to the left of the high altar. In the chapel to the far left is the fresco cycle, *Scenes from the Life of St. Sylvester and Constantine* by Maso di Banco (*c.*1367) who was a follower of Giotto as was Bernardo Daddi who painted the *Scenes from the Lives of St. Stephen and St. Lawrence* in the next chapel.

The area of the High Altar and sanctuary is painted with Agnolo Gaddi's frescoes of *Christ, the Evangelists, St. Francis and the Legend of the Cross* (*c.*1380). Baccio Bandinelli's *Dead Christ and God* sculpture group was removed from the sanctuary area of the Duomo and relocated here but was separated in the 19th century for display in the garden and cloister. Above the altar is a polyptych comprised of several panels of 14th-century works assembled in 1869, including works by Lorenzo Monaco and the Master of Figline who was active in the first half of the 14th century.

There are five chapels to the right of the high altar in the south transept with works by Giotto and other 14th-century painters (*trecento*) influenced by him. In the first, the **Bardi Chapel**, are frescoes

7. Giotto, Detail of the *Death and Ascension of St. Francis*. Bardi Chapel, Santa Croce

on *Scenes from the Life of St. Francis* designed by **Giotto** and completed with the help of assistants (1317–1319). After the publication of St. Bonaventure's *Biography of St. Francis* (1266), interest in episodes from the life of the Saint spreads and frescoes are commissioned soon after. Giotto was in Rome for the Jubilee proclaimed by Pope Boniface VIII (1300) and Pietro Cavallini's fresco cycle on *Scenes from the Life of St. Francis* in the church of S. Francesco a Ripa that are now lost may have influenced Giotto's painting here and possibly the earlier fresco cycle for the Upper Basilica of St. Francis in Assisi. Unlike the Peruzzi Chapel, the perspective of the fresco architecture is based on the chapel. The altarpiece (13th century) is comprised of painted panels with *Scenes from the Life of St. Francis*. The Bardi were a powerful family of noble lineage that acquired the Bardi Chapel in Santa Maria Novella in 1334 (Tour 6). The collapse of the family bank in 1344, due to defaulted loans to King Edward III of England for his war against France, greatly diminished their wealth and that of their associates the Peruzzi. Both families controlled the commercially important area around Santa Croce and Via de' Benci.

In the next, the **Peruzzi Chapel**, commissioned by the wealthy Peruzzi banking family and associates of the Bardi who lived in the

area of the church, are the damaged mural paintings by **Giotto** that were painted almost 20 years later with *Scenes from the Life of St. John the Evangelist* and *Scenes from the Life of St. John the Baptist* (1334–1337) following his return from Padua where he painted the Scrovegni Chapel. The figures occupy settings with Classical architectural references that Michelangelo studied in a drawing he made that is now in the Louvre of the two male figures to the left of the *Ascension*. The altarpiece *Madonna and Saints* is by Agnolo's father **Taddeo Gaddi**, a student of Giotto.

In the Giugni Chapel to the right of the Peruzzi Chapel is the tomb of Charlotte Bonaparte (died 1839), Napoleon's niece. Her father Joseph was King of Naples (1806) and King of Spain (1808). In the next chapel is the tomb of the Blessed Umiliana de' Cerchi (died 1246) with a 14th-century silver reliquary. The last chapel contains frescoes on the *Life of the Archangel St. Michael* (early 14th century) by a follower of Cimabue. On the south wall of the transept is the **Baroncelli Chapel** with Taddeo Gaddi's fresco cycle on the *Life of the Virgin* (1332–1338) and *Madonna and Child* in the lunette. The altarpiece with the *Coronation of the Virgin* is by **Giotto**. The statue of the *Madonna and Child* is by Vicenzo Danti (*c.*1568) and the fresco of the *Madonna of the Girdle* is by Bastiano Mainardi, the brother-in-law and student of Domenico Ghirlandaio. The frescoes in the **Castellani Chapel** to the right are by Agnolo Gaddi. Also here is the monument to Louise, Countess of Albany (died 1824), the wife of Charles Edward Stuart, the Young Pretender. They lived in Palazzo di San Clemente (Tour 5) until their estrangement and her relationship with poet Count Vittorio Alfieri whose monument is in the nave.

From the south transept there is access to the **Sacristy** with frescoes by Spinello Aretino and Niccolò di Pietro Gerini (14th century) and access to the Rinuccini Chapel (14th century) with frescoes by Giovanni da Milano (1365) and altarpiece by Giovanni del Biondo. At the end of the **Michelozzo Corridor** lined with historic photographs of the flood and Monument to the sculptor **Lorenzo Bartolini** (died 1850) is the **Medici Chapel of the Novici.** The chapel designed by Michelozzo (1434) has an altarpiece of the *Madonna and Child with Angels* by Andrea della Robbia (*c.*1480). The Leather Workshops of the **Scuola del Cuoio** are accessed from the **Room of the Well**.

On the **south side** walking towards the front entrance of the church, are the monuments to the Italian poet Ugo Foscolo (1778–1827) and composer Gioachino Rossini (1792–1868) who is buried in Père Lachaise cemetery in Paris. The **Tomb of Leonardo Bruni** (died 1444) the humanist scholar and historian whose effigy lies in state wearing a laurel crown is by **Bernardo Rossellino** (*c*.1446–1447). Bruni translated Aristotle into Latin and wrote *Twelve Books on the History of the Florentine People* that he is holding and the history *In Praise of Florence* (*c*.1401). He also served as the Chancellor of the Republic (appointed 1410–1411; 1427–1444). The epitaph is by Carlo Marsuppini whose funerary monument is across the nave. The tomb is an early Renaissance masterpiece inspired by Brunelleschi's use of Classical architectural elements such as the triumphal arch. Rossellino was the contemporary of architect Leon Battista Alberti with whom he is associated on many buildings in Rome, Pienza, and Florence, including Palazzo Rucellai (Tour 6).

Just beyond the exit to the cloister is the **Cavalcanti Tabernacle** with a high relief of the *Annunciation* and *putti figures* by **Donatello** (*c*.1440) for the now relocated Cavalcanti Chapel. Opposite in the nave is the pavement **Tomb of John Catterick**. The **Tomb of Niccolò Machiavelli** (1469–1527) statesman and author of *The Prince* is by Innocenzo Spinazzi (1787). The monument to the poet Count **Vittorio Alfieri** (1749–1803) by the Neoclassical sculptor Antonio Canova was commissioned by Louise Countess of Albany, the wife of Charles Edward Stuart. Opposite is the **pulpit** with scenes from the *Life of St. Francis* and five *Virtues* by Benedetto da Maiano (1472–1476). The **Cenotaph of Dante Alighieri** by Stefano Ricci (1829) honours the iconic poet of Florence who is buried in Ravenna where he died in exile in 1321. The **Tomb of Michelangelo** is by Giorgio Vasari. The artist's body was secretly taken out of Rome and brought to Florence. Michelangelo worked on the *Deposition* now in the Museo dell' Opera del Duomo (Tour 2) days before his death intending it for his own funerary monument. Opposite on the pier is the *Madonna del Latte* by Antonio Rossellino (1478) above the **Tomb of Francesco Nori** who died in the Pazzi Conspiracy while protecting Lorenzo the Magnificent.

Along the **west wall** with a marker indicating the flood level of the Arno is the funerary **Monument to Giovanni Battista Niccolini** the playwright with **Pio Fedi**'s *Statue of Liberty* (1883) that is also

known as the *Liberty of Poetry*. The statue was first modelled in plaster in 1870 when Frédéric Auguste Bartholdi was in Florence and it may have influenced his design for his *Statue of Liberty* (1883) in New York Harbor after his failed attempt to design a colossal statue of an Arab Egyptian peasant woman for the Suez Canal in 1869. Fedi's *Rape of Polyxena* is the only modern sculpture in the Loggia della Signoria (Tour 3). In front of the main doors is the pavement tomb of an ancestor of Galileo who was a physician.

At the beginning of the **north side** is the **Monument to Galileo Galilei**. He was originally denied a Christian burial so he was buried under the campanile but his relics were moved to the nave in 1737 and placed in the monument that was commissioned by Grand Duke Gian Gastone. The pavement **Tomb of Lorenzo Ghiberti** (died 1455) is in front of the Tomb of Giovanni Battista della Fonte with the *Pietà* by **Bronzino** (1569). Ghiberti's contemporary and rival Filippo Brunelleschi (died 1446) is buried in the Duomo (Tour 2).

From the exit on the south side, descend into the area of the first cloister (14th century) with **Baccio Bandinelli**'s statue of *God*. Immediately to your left is a marker indicating the 1966 flood level of the Arno. The **Gallery of Romantic Graves** (Galleria dei Sepolcri Romantici) below ground level along the south wall of the church is lined with Neoclassical funerary monuments. The area survives from the earlier cemetery Chiostro dei Morti demolished in 1969. A memorial to **Florence Nightingale** (1820–1910) who was born in Florence and named after the city is located under the colonnade near the exit.

The **Pazzi Chapel** is an early Renaissance masterpiece by Brunelleschi that was commissioned by Andrea de' Pazzi (*c*.1430) husband of the wealthy Caterina Salviati whose son Jacopo was involved in the Pazzi Conspiracy against the Medici and executed in 1478 with his cousins Francesco and Renato. Brunelleschi worked on the chapel from 1442 until 1446 but it was completed after 1470. The portico is attributed to Giuliano da Maiano (1461) who also made the wooden entrance door (1472). Above the door is an enamelled terracotta medallion with *St. Andrew* by Luca della Robbia (*c*.1461) for whom the chapel is dedicated as the patron saint of Andrea de' Pazzi. The classically proportioned interior, lit by the oculi in the dome, is defined by *pietra serena* stone and white plaster and is reminiscent of the interplay between squares and circles in Brunelleschi's earlier design

for the old sacristy of the basilica of San Lorenzo (Tour 6). Colour is introduced by the enamelled terracotta roundels of the *Apostles* by Luca della Robbia (*c.*1442–1452) and the pendentives of the *Evangelists* (*c.*1460).

The **Museo dell' Opera** displays art and funerary monuments removed from the church and Peruzzi Chapel, including the Tomb of Gastone della Torre by Tino di Camaino (*c.*1318). From the museum is access to a **second cloister** (1453) by Brunelleschi that was completed after his death perhaps by Bernardo Rossellino. In the Gothic **Cenacolo** the former refectory, is **Cimabue**'s *Crucifix* damaged in the flood of 1966 and **Donatello**'s bronze *St. Louis of Toulouse* (1424) originally for a tabernacle niche at Orsanmichele for the Guelph party (Tour 2) that was later formerly displayed on the facade of Santa Croce until the construction of the new facade by Niccolò Matas. Bronzino's *Descent of Christ into Limbo* (1552) includes portraits of contemporary figures including Alessandro Allori next to Christ and Pontormo. In the top left is Bronzino's self-portrait. Along the long walls are Andrea Orcagna's frescoes *Triumph of Death, Last Judgement,* and *Hell* that were removed from the nave of the church when Vasari added the side altars. On the short wall at the far end of the room are Taddeo Gaddi's *Last Supper* and *Tree of the Cross* (1333).

To the right of the church (when facing it) is the **Biblioteca Nazionale** in Piazza Cavalleggeri. The library consists of several historic collections, including the Libreria Magliabechiana (1747) named after Antonio Magliabechi the book collector and librarian of the Palatina and Laurentian libraries under Cosimo III; the Biblioteca Palatina-Medicea (1711); and the Library of Ferdinand III (1861). Other collections focus on monastic texts, Dante, and Galileo. The flood of 1966 damaged nearly a third of the collection.

To visit **Casa Morra** the **House of Giorgio Vasari** before continuing on the tour from Piazza Santa Croce, follow Borgo Santa Croce (to your diagonal right when facing the church) the short distance to No. 8. **Palazzo Spinelli** (1460–1470) at No. 10 is by Bernardo Rossellino for Tommaso Spinelli, the treasurer of Pope Paul II. From here, you may return to the piazza or continue on Borgo Santa Croce to Via de' Benci that follows the former course of the 12th-century city walls (1172–1175) into which was built **Palazzo Caccia-Peruzzi** at No.

19–21 Via de' Benci acquired by the Peruzzi in 1286 and enlarged into the walls from 1317 to 1319.

Turn left onto Via de' Benci at **Torre Alberti** (13th century) one of several palaces in the area once owned by the wealthy Alberti family. On the other side of Corso dei Tintori to your left at No. 6 is the **Museo Horne** in Palazzo Corsi (1495–1502) renovated by the English art historian and architect Herbert Percy Horne to house his important collection of 14th- to 16th-century art that he gave to the Italian nation on his death in 1916. Works of art include Giotto's painting of *St. Stephen* and Masaccio's *Scenes from the Legend of St. Julian*. Opposite at No. 9 red is the **Methodist Church** founded in 1861 in a former Catholic church built in the 11th century around the same time as the original nearby church of San Remigio that was rebuilt in 1350.

At No. 5 is **Palazzo Busini-Bardi** also called Palazzo Bardi alle Grazie whose design is attributed to Brunelleshi and built 15 years before Michelozzo built the Palazzo Medici-Riccardi (Tour 6). The palace was bought by Giovanni de' Bardi in 1482 with one of the oldest surviving painted facades in Florence. A plaque commemorates the palace's role in the development of the musical genre of melodrama. At No. 2 is **Palazzo Bardi-Tempi** owned by the Bardi family and remodeled by Matteo Nigetti (1610). The Bardi also owned strongholds and palaces in the area of the other bridgehead of Ponte alle Grazie on the other side of the Arno and towards Ponte Vecchio. To stroll along the other side of the Arno, at this time, in the area formerly controlled by the Bardi, cross the bridge and join Tour 9 in Piazza de' Mozzi.

To continue on the tour, return to Piazza Santa Croce by following Via de' Benci back into the piazza. Along the way, look for the arch on your left that leads into **Piazza de' Peruzzi** for a view of the curve of buildings that preserve the outline of the Roman Amphitheatre. The entrances to No. 7 and No. 12 red are built into the arches of the amphitheatre. The main facade of **Palazzo Peruzzi** (13th century) is on Borgo de' Greci No. 3. In addition to the ruins of the amphitheatre, the palace was built into the medieval walls of the city. Famous guests included Robert of Anjou, King of Naples and leader of the Italian Guelph party, in 1310. With their associates, the Bardi, the family went bankrupt in 1344 due to unpaid loans to King Edward III of

England. When the Peruzzi sold the palace to the Bourbon del Monte family in 1772, they moved to Borgo de' Greci No. 12.

At the statue of Dante in Piazza Santa Croce, take Via de' Pepi and proceed to Via Ghibellina. The Gherardini, the family of the famous **Mona Lisa** purported to be the sitter for Leonardo da Vinci's *Mona Lisa*, lived on Via de' Pepi in 1494 but moved a year later to Via della Stufa. According to Giorgio Vasari, *La Gioconda* refers to Lisa del Giocondo, the wife of Ser Francesco del Giocondo whom she married in 1495 at the age of 16. They resided on Via della Stufa next to the house her parents had occupied. The Giocondo family lived on Via Ghibellina opposite the house of Leonardo da Vinci's father Ser Piero da Vinci. Lisa del Giocondo, the mother of five children, died in the Convent of Sant'Orsola in 1542 at the age of 63.

Turn right and the **Casa Buonarroti** is on the other side of the street at No. 70 at the corner of Via Michelangelo Buonarroti. The house occupies the site where Michelangelo owned three properties that he bought in 1508 and lived from 1516 to 1525 upon his return from Rome after painting the Sistine Chapel (1505–1512). He moved permanently to Rome in 1534. In Rome, the house and studio he occupied for decades near S. Maria di Loreto fared less well – it was relocated next to his Cordonata leading to Piazza del Campidoglio during the construction of present-day Piazza Venezia. It was demolished a second time and its facade was moved to the Janiculum Hill near Porta di S. Pancrazio and now fronts a cistern. Michelangelo's nephew Leonardo inherited the three properties and connected them following plans drawn by Michelangelo. Leonardo's son Michelangelo the Younger created a gallery in 1612 to honour his great-uncle.

The house and collection were founded as a museum by the last Buonarroti in 1858. In addition to art created or inspired by Michelangelo and ancient Roman and Etruscan artifacts acquired by the Buonarroti family, the museum collection displays two of Michelangelo's earliest works, the *Madonna of the Steps* (1490–1492) and a relief of *Lapiths and Centaurs* (*c*.1492). It also contains his wood model for the facade of San Lorenzo. Daniele da Volterra's *Portrait bust of Michelangelo* commissioned by Leonardo Buonarroti (1564–1566) was modelled after the artist's death mask. Leading 17th-century artists contributed to the painted decoration of the **Galleria** celebrating the

Life and Apotheosis of Michelangelo including Artemisia Gentileschi and Domenico Cresti (Il Passignano).

Continue on Via Ghibellina (look at the Campanile of Santa Croce to your right on Via S. Cristoforo as you walk past) to Borgo Allegri where the painter **Cimabue** lived. Giorgio Vasari writes that the street was named Allegri ('Joyous') after his painting the *Rucellai Madonna* (1285) for the Rucellai Chapel in S. Maria Novella since a procession accompanied the painting when it left his studio but the altarpiece is now attributed to Duccio. Turn left on Borgo Allegri and continue past Via dell' Agnolo until you reach Piazza dei Ciompi in an area cleared in the Fascist era. The dome of the Synagogue rises above the market to your left.

Piazza dei Ciompi is dedicated to the wool-carders (*ciompi*) and other paid labourers, including artisans and craftsmen who lived and worked in the area in the medieval era and famously staged a revolt (tumulto dei ciompi) in 1378 since they were excluded from guilds and access to city governance. The **Loggia del Pesce** was designed by Giorgio Vasari (1568) for the sale of fish (depicted in the terracotta roundels with sea creatures) in the former Mercato Vecchio but it was demolished in 1899 for the construction of Piazza della Repubblica. It was reassembled here in 1951. **Lorenzo Ghiberti**'s home and workshop was at No. 11 from facing the piazza.

Exit the piazza onto Via Pietrapiana, a major street in the Jewish area of Florence, and follow a short distance into Piazza S. Ambrogio where six streets meet. Straight ahead is the church of **Sant' Ambrogio** one of the oldest churches in Florence founded in 988 as part of a Benedictine monastery. It was remodelled in the 13th century in the Gothic style and again in the 15th century. Several prominent artists and architects are buried here. In front of the first altar on the south side is the pavement **Tomb of Simone del Pollaiolo** (1457–1508) the Florentine architect and nephew of Antonio and Piero Pollaiolo known as Il Cronaca ('the Chronicle' after his visit to Rome in 1470). To the left of the high altar is the **Cappella del Miracolo** with a marble tabernacle by Mino da Fiesole (1481) and a chalice that miraculously contained blood instead of wine (1230) that gives the chapel its name. The **Tomb of Mino da Fiesole** is adjacent to the chapel. In front of the fourth chapel on the north side is the **Tomb Andrea del Verrocchio**, Leonardo da Vinci's teacher. The **Tomb of Leonardo del**

Tasso is in front of the niche that contains his wooden statuette of *St. Sebastian*. The *Virgin and Child in Glory* above the third altar is by Cosimo Rosselli (1498–1501). In front of the first chapel is the **Tomb of Francesco Granacci** the painter who assisted Michelangelo in transferring his cartoons onto the ceiling of the Sistine Chapel.

Continue past the church where the name of Via Pietrapiana changes to Borgo La Croce. This is a lively area at night filled with restaurants and wine bars frequented by locals. At Via della Mattonaia, turn right to enter the **Mercato di Sant' Ambrogio** in Piazza Ghiberti opened in 1873 that is a popular market selling baked goods, fresh fruit and vegetables, fish and meat. The other popular food market, the Mercato Centrale (Tour 6) next to the church of San Lorenzo was built at the same time.

Retrace steps to Via Pietrapiana. Turn right to walk across the front of the church of S. Ambrogio (the dome of the Synagogue rises straight ahead) and cross the piazza to Via G. Carducci (look left down Via di Mezzo for a view of the Duomo dome). Cross to the other side of Via G. Carducci to take Via de' Pilastri to Via L. C. Farini. Turn right. The entrance to the Synagogue and the Jewish Museum is to your right at No. 6.

The **Synagogue (Tempio Israelitico)** and **Jewish Museum** with its distinctive copper dome was built in an eclectic Spanish-Moresco style with traditional Florentine horizontal colour stone elements by Marco Treves, Mariano Falcini, and Vincenzo Micheli (1874–1882) on land that was acquired by David Levi (died 1870). The museum collection includes silver and textiles from the 17th to 19th centuries, ceremonial objects and photographs of the Jewish community (19th–20th centuries) that is first attested in the 15th century as moneylenders with the sanction of the Republican government. The Jewish community settled in the Borgo San Jacopo in Oltrarno (Tour 8) in the 15th century. In 1521, after he took up residency in Palazzo Pitti, Cosimo I ordered that Jews be confined into a ghetto north of present-day Piazza della Repubblica that was demolished at the end of the 19th century (Tour 7). The Jewish cemetery is located at Viale Ariosto No. 14 (open the first Sunday of the month from 10 am to 12 pm).

From the Synagogue, retrace steps to Via dei Pilastri. Turn right and continue on the street to Borgo Pinti. Turn right at the former church of **S. Maria di Candeli** and walk the short distance to the

church and former convent of **S. Maria Maddalena dei Pazzi** to your right at No. 58. The church originally dedicated to St. Mary Magdalene was founded in 1257, renovated by Giuliano da Sangallo (1492) and renamed in honour of a mystic Carmelite nun of the Pazzi family Maria Maddalena (1566–1607). Earlier altarpieces by Botticelli, Domenico Ghirlandaio and others were replaced in the 17th–18th centuries. The Baroque high altar is by Ciro Ferri (1675). **Perugino**'s fresco *Crucifixion and Saints* (1493–1496) is in the Chapter House in the cloister accessed from the school entrance at the corner of Borgo Pinti and Via della Colonna.

Retrace steps to Via dei Pilastri and turn right where the name changes to Via degli Alfani beyond Borgo Pinti. At the corner is an aedicule with a *Madonna and Child*. After frequent changes to the street addresses, **Palazzo Giugni** is to your right at No. 48. The Renaissance palace designed by **Bartolomeo Ammannati** (1571) with frescoes by Alessandro Gherardini is occupied by the international Lyceum Club for women (since 1953) that sponsors cultural events. At the end of the block to your left is **Brunelleschi**'s unfinished **Rotondo di S. Maria degli Angeli** (1434) originally part of a monastery complex with a scriptorium that produced manuscripts. Brunelleschi modelled his octagonal rotunda after the so-called Temple of Venus Medica in Rome. The Università degli Studi di Firenze continues the tradition of learning and it is commonly called the Rotondo degli Scolari ('Rotunda of Scholars'). In the former Cenacolo (refectory) is a *Last Supper* by Ridolfo del Ghirlandaio (1543).

Continue on Via degli Alfani and continue past Via dei Servi (look left to see the dome of the Duomo). To your right at No. 78 is the **Opificio delle Pietre Dure** founded by Ferdinand I (1588) for the production of mosaics that is now a museum displaying furniture and a restoration centre of stone artworks. Just beyond the museum is Via Ricasoli. Turn right and the entrance to the Galleria dell' Accademia is to your right midway up the block.

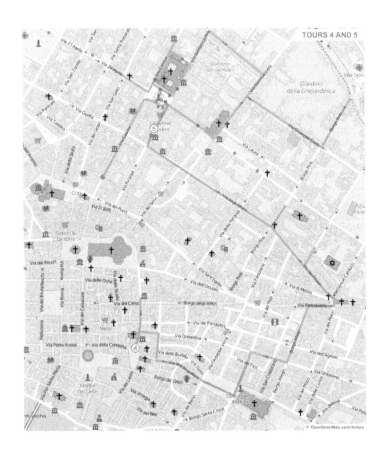

Sites: Galleria dell' Accademia, Piazza San Marco, Casino Mediceo di S. Marco, San Marco, Chiostro dello Scalzo, Cenacolo di Sant' Apollonia, Giardino dei Semplici, Palazzo di San Clemente, Piazzale Donatello, English Cemetery, Piazza della SS. Annunziata, Spedale degli Innocenti, SS. Annunziata; Museo Archeologico, Option from Piazza San Marco: Cenacolo di San Salvi.

Distance: 2.0 km

Galleria dell'Accademia, Piazza San Marco Area and English Cemetery

A tour that begins and ends in Piazza San Marco with masterpieces in painting, sculpture and architecture from the early and high Renaissance that includes visits to the Galleria dell' Accademia with Michelangelo's iconic *David* and early Renaissance sites and artworks in the area, including Fra' Angelico's paintings for the Convent of San Marco where the fiery Savonarola was Prior, Andrea del Castagno's *Last Supper* for the Cenacolo di Sant' Apollonia and Brunelleschi's Spedale degli Innocenti in Piazza della SS. Annunziata. The Basilica of SS. Annunziata by Michelozzo is filled with Renaissance and Mannerist art and the funerary monuments of famous artists. The tour features the high Renaissance artist Andrea del Sarto, immortalized by Robert Browning, including an option to see his famous *Last Supper* for the Cenacolo di San Salvi.

Sites of Jacobite and Grand Tour interest include the Palazzo of the Young Pretender and the English Cemetery. The Museo Archeologico contains a collection of Egyptian and Classical art with masterpieces of Etruscan art from Florence and Tuscany.

The **Galleria dell' Accademia** is part of the Accademia di Belle Arti founded by Grand Duke Peter Leopold in 1784 in the adjoining buildings that used to serve as the Ospedale di S. Matteo and the Convent of S. Niccolò di Cafaggio. The academy incorporated the earlier Accademia e Compagnia delle Arti del Disegno founded by Cosimo I in 1563. Early members included Michelangelo, Giorgio

Vasari, Benevenuto Cellini, Bronzino, Giambologna, Bartolomeo Ammannati, and Artemesia Gentileschi.

The **ground floor** entry is into the **Hall of the Colossus** originally named after the plaster cast of one of the Dioscuri (Castor and Pollux) of Montecavallo, (Piazza del Quirinale in Rome where the original stands). In the centre of the room is Giambologna's plaster model of the *Rape of the Sabines* (1582) that is displayed in the Loggia della Signoria (Tour 3). On the walls hang 15th/16th century Renaissance paintings, including on the entrance wall the *Cassone Adimari* (*c*.1450) a painted panel by the painter Masaccio's younger brother Giovanni di Ser Giovanni Guidi (nicknamed Lo Scheggia) commemorating a wedding procession through the streets of mid-15th-century Florence. In addition to small panels by Botticelli, is the *Scenes from Monastic Life* attributed to Paolo Uccello. On the left wall are the *Trebbio Altarpiece* with a *Holy Conversation* by Botticelli and Domenico Ghirlandaio's *St. Stephen between St. James and St. Peter* (1493). In the centre of the right wall is Perugino's *Assumption of the Virgin* (1500) and to the left is the *Deposition* by Filippino Lippi that was completed (lower half) after Lippi's death by Perugino (1504–1508). From this room is the entrance to the **Museum of Musical Instruments** with 17th- and 18th-century instruments assembled by the Grand Dukes, including the *Viola Medicea* (1690) and *Violin* (1716) by Antonio Stradivari.

Lining the **Hall of the Prisoners** that ends with Michelangelo's *David* are his unfinished sculptures for the Tomb of Pope Julius II della Rovere (1513). The tomb was intended for St. Peter's Basilica with 40 statues but after several revisions it was never completed. A revised version with Michelangelo's *Moses* and the figures of *Rachel* and *Leah* is in the church of S. Pietro in Vincoli in Rome. The *Prisoners* (also known as the *Slave*s and *Captives*): *Awakening Slave* and *Atlas* on the left; and opposite *Young Slave* and *Bearded Slave*. The two completed slaves in the Louvre, the *Dying Slave* and the *Rebellious Slave* give a sense of what these statues would have looked like if completed but their unfinished state appeals to modern aesthetics. The statues were left with the *Genius of Victory* (now in Palazzo Vecchio) in Michelangelo's studio in Florence when he moved permanently to Rome and so passed to his nephew who gave them to Grand Duke Cosimo I. They were incorporated into the Grotto of the Boboli Gardens of Palazzo Pitti

(Tour 8) by Bernardo Buontalenti (1586) and remained there until 1908 and displayed at the gallery in 1909.

The *Saint Matthew* (1505–1506) was commissioned by the Opera del Duomo for a series of the Twelve Apostles for the Tribune of the Duomo. It was in storage there until transferred to the gallery in 1831. The *Pietà di Palestrina* was discovered in the Barberini Chapel of the church of Santa Rosalia and transferred to the gallery in 1939 but its attribution to Michelangelo is not secure.

Other artworks are by artists influenced by Michelangelo. To the left of the entrance are Fra' Bartolomeo's *The Prophet Isaiah* and the *The Prophet Job* (*c*.1515) influenced by Michelangelo's figures in the Sistine Chapel. On the right side: Daniele da Volterra's bronze *Bust of Michelangelo* depicting the artist in old age and Andrea del Sarto's *Christ as the Man of Sorrows*. On the left side: *Venus and Cupid* (*c*.1533) by Pontormo based on a drawing by Michelangelo. To the left is Michele di Ridolfo del Ghirlandaio's *Ideal Head* (*c*.1560–1570) and on the other side his *Ideal Head* known as *Zenobia* (*c*.1560–1570) show the influence of Michelangelo's drawings.

Michelangelo's **David** (1502–1504), one of the most famous statues in the world, stands in the **Tribune** by Emilio de Fabris built for the monumental statue that was moved here in 1873. Previously it was displayed in front of Palazzo Vecchio where a copy now stands (Tour 3). The commission for a statue of *David* initially went to Agostino di Duccio (1464) and then Antonio Rossellino (1475) for a niche in the tribune of the Duomo but the project was abandoned because of imperfections in the marble that subsequently lay in the yard of the Opera del Duomo. Michelangelo used the rejected marble to complete his 14 foot statue with a Classical *contrapposto* pose. A committee was formed to decide on a more suitable location than the tribune and Piazza della Signoria was selected where it stood outside Palazzo Vecchio as a civic symbol for Florence. The statue captures the moment before the battle that a naked and self-confident David has just seen Goliath in the distance. Earlier versions by Ghiberti for the Baptistery Doors and by Verrocchio and Donatello now in the Bargello (Tour 4) depicted an armed triumphant hero after the battle.

On the Tribune walls are 15th-century Mannerist paintings, including to the right of *David:* Francesco Salviati's *Madonna and Child with the Young St. John the Baptist and Angel* (*c*.1543–1548) and to the

left, is Santi di Tito's *Deposition* (*c.*1590). Opposite on the right wall is Bronzino's *Deposition* (*c.*1561) completed with his assistant Alessandro Allori who painted the third painting on the right wall *Annunciation* (1572–1578) and fourth, the *Coronation of the Virgin* (1593). The **Gipsoteca Bartolini** is dedicated to the 19th-century sculpture models and plaster casts of Lorenzo Bartolini and Luigi Pampaloni with an extensive collection of plaster casts of European, Russian and English nobility, including Lord Byron. A small fresco painting by Pontormo (*c.*1514) of a hospital scene references the former use of the room as the women's ward of the former Hospital of St. Matthew.

The **Florentine Gothic Hall** is divided into three rooms. **The 13th and Early 14th-century Room** includes Pacino di Bonaguida's *Tree of Life* (1305–1310). In the **Giottesque Room** are the works of Giotto's students: Bernardo Daddi's *Crucifix* (*c.*1345) and Taddeo Gaddi's trefoil panels *Crucifixion* and *Stigmata of St. Francis*. The **Orcagna Room** is devoted to Andrea di Cione (nicknamed Orcagna 'Archangel') and his brothers Nardo, Matteo and Jacopo di Cione. Orcagna's *Pentecost* (1365) was painted for the high altar of Ss. Apostoli (Tour 7). Works by his brothers include Nardo di Cione's *Trinity* (1365) and Jacopo di Cione's *Coronation of the Virgin* (1370–1380). On the **first floor** are more early Renaissance paintings from Florence between 1370 and 1430; magnificent altarpieces commissioned by the Florentine Guilds between the late 15th and early 16th century, including Giovanni del Biondo's *Annunciation with the Blessing Father* and Lorenzo Monaco's *Annunciation*; and International Gothic works from the early 15th century.

Follow Via Ricasoli (formerly called Via Cocomero) into **Piazza San Marco** a beautiful but noisy piazza because of the bus stops (see option below to visit San Salvi and Tour 10 to visit Fiesole from here). In the centre is a bronze statue of the Italian Unification figure, *General Manfredo Fanti* by Clemente Papi to a design by Pio Fedi (1873). On the east side (to the right as you enter) is the Loggia dell' Ospedale di S. Matteo (1384) that is one of the oldest porticoes in Florence and the **Università degli Studi** in the former stables of the Grand Duke.

On the west side, a plaque outside the garden wall of the **Palazzina della Livia** (built in 1775 and named after Livia Raimondi, the mistress of Grand Duke Peter Leopold) indicates the site of the **Giardino di S. Marco** also known as the **Casino Mediceo di S. Marco** at No. 57. The

Giardino housed Cosimo the Elder's collection of ancient sculpture. Lorenzo the Magnificent introduced Giovan Francesco Rustici to Andrea del Verrocchio whose other pupil was Leonardo da Vinci. Michelangelo joined the school of the sculptor Bertoldo di Giovanni and lived here as a boy. Lorenzo the Magnificent's humanist Platonic Academy met here and at the Villa Medici in Fiesole and Marsilio Ficino was installed as its first head. At the end of the block of Via Cavour is the **Palazzo Pandolfini** designed by **Raphael** in 1516.

The Dominican Basilica of **San Marco** is between Via Cavour to the left and Via Giorgio La Pira to the right. The **church** was built in 1299 for the Benedictine Silvestrine Order but possession passed to the Dominicans from the convent in Fiesole (Tour 10) by Pope Eugenius IV at the request of Cosimo de' Medici the Elder who commissioned **Michelozzo** to remodel the church and convent (1436–1443). **Giambologna** made further modifications to the side altars (1588). The Neoclassical facade is by Giovanni Battista Paladini (1778).

The interior with works by Mannerist artists was once decorated with 14th-century frescoes that survive in part on the west wall with a *Crucifixion* and *Annunciation*. On the south side, the altarpiece in the first chapel is by Santi di Tito (1593) and the *Madonna and Saints* in the second chapel is by Fra' Bartolomeo. In the fourth chapel is a Byzantine mosaic of the *Madonna in Prayer* (*c.* 8th century) possibly from the Old St. Peter's Basilica in Rome. The apse with frescoes by Santi di Tito and Bernardino Poccetti and sacristy were added by Michelozzo. The cupola frescoes are by Alessandro Gherardini (1717) and the high altarpiece *Crucifixion* is by Fra' Angelico (1425–1428). In the sacristy is the **Tomb of St. Antoninus** the prior of the convent and Archbishop of Florence from 1446 until his death in 1459. The humanist Pope Pius II Piccolomini conducted his funeral. The same pope canonized St. Catherine of Siena two years later in 1461.

The **Chapel of St. Antoninus** (also called the Salviati Chapel) is by Giambologna (1588) with an altarpiece by Alessandro Allori (1584) and works by Giovanni Battista Naldini, Francesco Morandini (il Poppi) and dome fresco by Bernardino Poccetti. The two large frescoes of the *Translation and Burial of St. Antoninus* are by Domenico Cresti (Il Passignano) who received commissions from other prominent Florentine families including branches in Rome where he painted panels for the Barberini Chapel in Sant' Andrea della Valle. On the

north side is a statue of Savonarola (19th century) and pavement **Tomb of Giovanni Pico della Mirandola** (1463–1494), the humanist philosopher, and the pavement **Tomb of Agnolo (Angelo) Poliziano** (1454–1494) his friend a humanist, Neoplatonic poet and teacher of Medici children. Both men were members of the Platonic Academy that met in the Giardino di S. Marco and also in the convent next door that held a Library of Classical texts assembled by Lorenzo the Magnificent. Their deaths in the same year are linked to arsenic poisoning. Savonarola delivered the funeral oration. Beneath the second altar is the **Tomb of Giorgio La Pira** (1904–1977), a former mayor of Florence who was beatified in 2005. If you are not entering the museum, follow the directions to the Chiostro dello Scalzo after the description of the museum visit.

The **convent** (Museo Nazionale di San Marco) with an entrance to the right of the church was founded as a museum in 1869 and is devoted to **Fra' Angelico** born Guido di Pietro (*c*.1395–1455) but also known as Fra' Giovanni da Fiesole and the Beato Angelico who was beatified by Pope St. John Paul II in 1982. He is buried in the church of S. Maria sopra Minerva in Rome. One of the most consequential priors of the convent was **Savonarola** who played a pivotal role in Florentine religion and politics in the last decade of the 15th century until his execution for heresy in 1498 (Tour 3).

On the **ground floor** is the Cloister of St. Antoninus by Michelozzo with small frescoes by Fra' Angelico and *Scenes from the Life of St. Antoninus* by Bernardino Poccetti completed by Matteo Rosselli and others. Masterpieces by Fra' Angelico are displayed in the **Pilgrims' Hospice**: *Deposition* (1435–1440) commissioned by Palla Strozzi for the church of Santa Trìnita (Tour 7); *Last Judgement* (1431) from the church of Santa Maria degli Angeli; *Madonna della Stella* reliquary tabernacle for Santa Maria Novella; *Tabernacle of the Linaioli* (1433) for the flax-workers guild with a frame by Lorenzo Ghiberti; and the *Pala di San Marco* (*c*.1438–1440) for Cosimo the Elder with a *Sacred Conversation* and predella with Scenes from the *Lives of Saints Cosmas and Damian*, the patron saints of the Medici. In the **Great Refectory** are the fresco *Miraculous Feast of St. Dominic* by Giovanni Antonio Sogliani (1536) and 16th- and 17th-century paintings, including the *Lamentation with Saints* by **Suor Plautilla Nelli** (1524–1588) a self-taught artist and nun in the adjacent

Dominican Convent of S. Caterina di Siena. She is the first known female painter of the Renaissance.

The **Room with works by Fra' Bartolomeo** includes his famous *Portrait of Savonarola* and *Madonna with St. Anne and Other Saints* (1510) commissioned by the Florentine Republic's last gonfaloniere Piero Soderini for the Hall of the Five Hundred in Palazzo Vecchio during the Medici exile. In the **Chapter House** is Fra' Angelico's dramatic *Crucifixion* (1441–1442). In the **Small Refectory** is a smaller version of Domenico Ghirlandaio's *Last Supper* (1476–1480) and an enamelled terracotta *Lamentation of Christ* by Andrea della Robbia. Along the exit corridor is the **Cloister of St. Dominic** by Michelozzo (1437–1343) and the **Museo di Firenze Antica** in the former guest quarters (*foresteria*) preserves stone architectural elements from the 19th-century demolition of the area of the Mercato Vecchio and Ghetto to create Piazza della Repubblica (Tour 7). Off of the museum is the small **Cloister of the Silvestrines**.

On the **first floor** along three corridors are 44 cells with frescoes on religious themes painted by Fra' Angelico and his assistants and the Library. At the top of the stairs is Fra' Angelico's iconic *Annunciation*. Along the **north corridor** to the right of the stairs are the cells of St. Antoninus (cell 31) and of Cosimo the Elder (cells 38 and 39) that served as his retreat with a fresco of the *Adoration of the Magi* by Benozzo Gozzoli with Fra' Angelico. The **Library** by Michelozzo (1441) was an important centre for humanists with an important collection of Greek and Latin texts that was dispersed in subsequent centuries to the Biblioteca Laurenziana (1571) and the Biblioteca Nazionale. The Sala Greca (1457) at the far end of the library preserves its original appearance.

Along the **east corridor** are more frescoes by Fra' Angelico: *Noli me tangere* (cell 1); **Annunciation** (cell 3); *Crucifixion with St. Dominic* (cell 4); *Nativity* (cell 5); **Transfiguration** (cell 6); *Mocking of Christ in the Presence of the Virgin and St. Dominic* (cell 7); *The Maries at the Sepulchre* (cell 8); *Coronation of the Virgin*, 1440–1441 (cell 9), opposite in the corridor is the *Madonna Enthroned with Saints*; *Presentation in the Temple* and *Madonna and Child with Saints* (Rooms 10 and 11).

The **south corridor** is parallel to Piazza San Marco. In cell 17 are fragments from one of Florence's earliest frescoes (*c*.1290–1300) from the original Silvestrine convent. Preceded by rooms displaying his

standard (cell 16) and cloak (cell 15) is Savonarola's room (cells 12–14) that he occupied as prior from 1482–1487 and 1490–1498. The exit of the museum is on Via della Dogana.

To visit the Chiostro dello Scalzo, turn left from the exit of the museum (or exit Piazza San Marco from the left side when facing the church) to Via Cavour. Cross to the other side of the street and turn right and walk the short distance to the entrance at No. 69.

The **Chiostro dello Scalzo** is a small cloister with beautiful monochrome frescoes by the important painter **Andrea del Sarto** on the *Life of St. John the Baptist* (1507–1526). Two scenes were completed by his assistant Franciabigio when del Sarto was in Paris at the court of Francis I from 1518 to 1519. There he painted a portrait of the Dauphin and a *St. Jerome* that does not survive and the *Charity*, now in the Louvre that shows the influence of Leonardo da Vinci and Raphael. Exit the chiostro and turn right on Via Cavour to return to Piazza San Marco.

The Cenacolo di Santa Apollonia is a short distance from Piazza San Marco. Exit the piazza on Via degli Arazzieri that turns into Via XXVII Aprile. At the corner of Via S. Reparata is the **Cenacolo di Sant' Apollonia** originally part of a convent founded in 1339 and remodelled in 1445. In the former refectory is the fresco of the *Last Supper* by **Andrea del Castagno** (1447). The perspective and exterior view of an interior scene follow Leon Battista Alberti's treatise *Della Pittura* (1435–1436) and the naturalism and ease of the figures shows the influence of Masaccio. The satyr-like Judas on the viewer's side of the table breaks up its linear integrity. Imitation stone panels define the symmetry of the scene and suggest a knowledge of Roman first-style wall painting. Also displayed here are the sinopie of other frescoes by Castagno: *Crucifixion*; *Deposition;* and *Resurrection*. In addition to several *Last Supper* frescoes painted by Domenico Ghirlandaio, including the Cenacolo di Ognisanti in 1480 (Tour 6), other notable versions in Florence are the Cenacolo di Fuligno in the former convent of Sant' Onofrio by Perugino (1493–1496) near Stazione S. Maria Novella (Via Faenza, 40) and the *Last Supper* by Andrea del Sarto in the Cenacolo di San Salvi (below). Leonardo da Vinci painted his iconic *Last Supper* in the Convent of S. Maria delle Grazie, Milan in 1495–1498. Retrace steps to Piazza San Marco.

There are several options from Piazza San Marco. To proceed directly to Piazza della Santissima Annunziata, exit Piazza San Marco

by Via Cesare Battisti and walk the short distance to the piazza. To begin Tour 6, follow Via Cavour south the short distance to Palazzo Medici-Riccardi. To visit the Cenacolo di San Salvi for the *Last Supper* of Andrea del Sarto, follow directions at the end of the tour.

To continue on the tour, exit the piazza on Via Giorgio La Pira, turn left past the entrance to the **Museo Botanico** founded in 1842 and containing the Andrea Cesalpino Herbarium (1563) and plants collected by Charles Darwin on his first voyage on the *H.M.S. Beagle* (admission by appointment) and walk along the fence of the Giardino dei Semplici. Continue to Via Pier Antonio Micheli named for the founder of the first botanical society in Florence and the first in Europe (1716). At the corner is the Chiesa Evangelica Valdese with a tower decorated with statues of saints. Turn right on via Pier Antonio Micheli. The entrance to the Giardino is to your right at No. 3.

The **Giardino dei Semplici** (Orto Botanico di Firenze) the 'Garden of Simples' (meaning medicinal herbs) was founded here by Cosimo I in 1545–1546 just two years after founding one of the first botanical gardens in Pisa (1543). The garden was laid out by Niccolò di Raffaello di Niccolò dei Pericoli (nicknamed Il Tribolo). The oldest trees are the yew (1720); Lebanon cedar (1795); and cork oak (1805). Today, the garden contains over 9,000 plant specimens. In the centre is a fountain with a copy of Andrea del Verrocchio's *Putto with Dolphin* from Palazzo Vecchio.

From the entrance, continue to the end of Via Pier Antonio Micheli. At the corner of Via Gino Capponi to your left is **Palazzo di San Clemente** also known as Palazzo del Pretendente where Charles Edward Stuart known as the Young Pretender (Bonnie Prince Charlie) resided under the title of Count of Albany. He married Princess Louise of Stolberg-Gedern who was 32 years younger. The marriage was not successful and she had a relationship with poet Count Vittorio Alfieri and both are buried in Santa Croce (Tour 4). Charles and Louise did not have any children but he fathered a daughter, Charlotte, with his mistress Clementina Walkinshaw. He later moved to Rome (Palazzo Balestra Muti in Piazza dei Ss. Apostoli where he and his brother Henry were born) and lived there until his death on 31 January 1788. He is buried with his father James Francis Edward Stuart and brother in the Grottoes of St. Peter's Basilica in Rome. The Palazzo later passed to the Duke of San Clemente. It is

currently owned by the University of Florence and is the seat of the Faculty of Architecture.

Turn right on Via Gino Capponi. The **Palazzo Capponi** is to your left at No. 2. To proceed immediately to Piazza della Santissima Annunziata continue on Via Gino Capponi into the piazza. To continue on the tour, turn left on Via Giuseppe Giusti. The building at the corner with a column and Medici seal was the house of **Andrea del Sarto** (No. 22 Via Gino Capponi). To your right at No. 26 is the **Palazzo Zucchari** with a distinctive facade. The German Institute is ahead to your left at No. 44. At the end of the block, turn left on Borgo Pinti with eagle sculptures on the fence posts to your left. At No. 68 is **Palazzo Panciatichi Ximenes** with a facade by Gherardo Silvani (1603) and **Palazzo Salviati** is to your right at No. 80. The **Palazzo Scala della Gherardesca** (No. 99) currently the Four Seasons Hotel with a facade by Antonio Ferri (early 18th century) preserves a courtyard by Giuliano da Sangallo (1470s) and the **Giardino della Gherardesca** once laid out as a Renaissance garden with a limonaia but now an urban sanctuary accessed from Piazzale Donatello with a Neoclassical temple by Giuseppe Cacialli (1842).

Follow Borgo Pinti into **Piazzale Donatello**. The English Cemetery now forms a traffic island in the centre of the piazzale created at the end of the 19th century as part of the Circonvallazione system of roads around the city centre. To enter, turn right to Via Vittorio Alfieri then cross Viale Antonio Gramsci. The entrance is straight ahead.

The **Protestant Cemetery** known as the **English Cemetery** (Cimitero degli Inglesi) was founded in 1828 outside the **Porta a Pinti** that was demolished in 1865. Florence was a late addition to the itinerary of the Grand Tour, bypassed in favour of Siena, and this is reflected in the date of the cemetery. The earliest Protestant cemetery in Italy was in Livorno (Leghorn) the commercial port city that was important to Henry VIII and Queen Elizabeth I. The Protestant cemetery in Rome next to the Pyramid of Cestius also predates this cemetery that closed in 1878 when burials within the city limits were discontinued. Among those buried here are Elizabeth Barrett Browning (1809–1861) whose tomb was designed by Frederic, Lord Leighton; Isa Blagden (1818–1873); Fanny Trollope (1780–1863); and Giovan Pietro Vieusseux (1779–1863).

Retrace steps to Via Gino Capponi and follow towards Piazza della Santissima Annunziata. Just before the arch to your left at No. 4 is the Ex Oratorio di San Pierino part of the former cloister of the Compagnia della Santissima Annunziata with frescoes by Bernardino Poccetti (*c*.1585–1590). The glazed terracotta *Annunciation* in the pediment above the entrance door is by Santi Buglioni. Follow Via Gino Capponi past the Museo Archeologico to your left into **Piazza della Santissima Annunziata**. In the centre of the harmonious piazza is an *Equestrian statue of Grand Duke Ferdinando I*. This is the last work by **Giambologna** who began the statue but after his death it was completed by Pietro Tacca in 1608. Tacca also designed the two bronze fountains. The Basilica of the Santissima Annunziata is to your right and to your left is the Spedale degli Innocenti. Across the piazza from it is the **Loggia dei Serviti** by Antonio da Sangallo the Elder and Baccio d'Agnolo (1516). Opposite the church is **Palazzo Grifoni** by Bartolomeo Ammannati (1563–1574). Via dei Servi connects the piazza to the Duomo and Brunelleschi is said to have viewed his rising dome from the street. The piazza is the setting for the Festa della Riticolona (7 September), the eve of the birth of the Virgin, with children carrying lanterns and the Feast of the Immaculate Conception (Fierucolina dell' Immacolata) on 8 December.

The **Spedale degli Innocenti** (1419–1451) 'Hospital of the Innocents' was the city orphanage from 1445 until 2000. Still intact on the left side of the portico is the *rota* the revolving stone wheel through which unwanted children were left anonymously by mothers who would ring the orphanage bell next to the wheel (1660–1875). The Spedale with the **Loggia degli Innocenti** (1419–1426) for the Arte della Seta (Silk Merchants Guild) was the first architectural commission of Brunelleschi. The colonnade of arches and monolithic columns with Corinthian capitals (the architectural order associated with St. Mary) is the first building in the Renaissance manner inspired by Classical antiquity. Brunelleschi may have based his design of a pilaster between columned arches on the Colosseum that he studied on his trip to Rome with Donatello (1402–1404). The charming roundels in the spandrels of orphans in swaddling clothes are by Andrea della Robbia (1487). The roundels at the ends are copies (1842–1843). The fresco lunettes over the doors at the ends and the vault in front of the main doors are by Bernardino Poccetti.

The entrance to the church of **S. Maria degli Innocenti** (1786 design of Bernardo Fallani) is to the left of the entrance to the cloisters and museum in the centre of the Loggia. The **cloisters** were designed by Brunelleschi: the larger of the two cloisters is the Chiostro degli Uomini (1422–1445). The other cloister, the Chiostro delle Donne (1438) leads to UNICEF offices and the **Museo degli Innocenti** that includes: Domenico Ghirlandaio's *Adoration of the Magi* (1488) with a scene of the *Massacre of the Innocents* commissioned for the high altar of the convent church and a predella by Bartolomeo di Giovanni (1488); Piero di Cosimo painted the *Madonna Enthroned* (1490s); a *Madonna and Child with an Angel* in the style of his teacher Filippo Lippi is attributed to Botticelli; and Luca della Robbia's *Madonna and Child* (*c.*1445–1450) in white glazed terracotta. Items related to the leaving of children are poignant reminders of the hospital's role over the centuries: babies were left between the terracotta crèche figures of *Mary* and *Joseph* before the *rota* was introduced and 19th-century identification tags and tokens that mothers left with their children in the hope of a future reunion. Walk down the steps to a landing for a view of Brunelleschi's original ceiling for the church that was covered by a barrel vault in 1785.

The Basilica of the **Santissima Annunziata** was founded by the Servite Order in 1250 and was the focus of patronage in the 15th century when it was rebuilt by **Michelozzo** (1444) with funds supplied for the church and chapels by numerous families, including the Medici, Servi, and Pucci. Construction continued until 1481 with the addition of the tribune and cupola. The portico facade with a central arch is by Giovanni Battista Caccini (1600) with the faded frescoes of *Faith* and *Charity* (1513–1514) by **Pontormo**. The entrance to the church is through the **Chiostrino dei Voti** with the now-faded frescoes by **Andrea del Sarto**: *Journey of the Magi* (1511) and *Birth of the Virgin* (1514) and his Mannerist students **Pontormo** (*Visitation)* and **Rosso Fiorentino** (*Assumption*). Other frescoes are by Franciabigio (*Marriage of the Virgin*); Alesso Baldovinetti (*Nativity*, 1460–1462); and Cosimo Rosselli (*Calling and Investiture of San Filippo Benizzi*, 1476). The bronze stoups are by Antonio Susini (1615) Giambologna's principal bronze-caster.

Immediately to the left along the west wall is the **Cappella della Santissima Annunziata** filled with ex-votos and the much-revered

painting of the *Virgin* (begun *c*.1252 by an unknown friar with the miraculous assistance of an angel) that is protected in a tempietto designed by Michelozzo and made by Pagno di Lapo Portigiani (1448–1461) for Piero de' Medici (the Gouty), the father of Lorenzo the Magnificent. The bronze grille by Maso di Bartolomeo (1447) is under a Baroque baldacchino that blends with the ornate Baroque stucco and painted decoration in the **nave** by Cosimo Ulivelli, Pier Francesco Silvani and Pier Dandini (*c*.1703). The organ (1509–1521) along the nave by Domenico di Lorenzo da Lucca and Matteo da Prato is the oldest in the city. In the adjoining chapel that was reserved as the **Medici Oratory** is a *Head of Christ* by Andrea del Sarto (*c*.1514).

On the north side, in the Feroni chapel (fourth) by Giovanni Battista Foggini (1692) is **Andrea del Castagno**'s fresco *St. Julian and the Saviour* (1455–1456) behind the altarpiece. The next chapel (third) has another fresco by Andrea del Castagno *Holy Trinity with St. Jerome* (1454) and frescoes by Alessandro Allori who also painted the *Last Judgement* (1560) in the second chapel. The *Assumption* (1506) by **Perugino** (first chapel) was painted for the high altar. The north transept chapel is by Michelozzo (1445–1447) and behind it the Cappella di San Luca for the Accademia delle Arti del Disegno for its patron saint with an altarpiece by Giorgio Vasari *St. Luke painting the Madonna* that contains his self-portrait. From here there is access to the **Chiostro dei Morti** (Cloister of the Dead since it was once a burial ground). Memorials and pavement tombs are still visible. The fresco above the entrance porch of the Holy Family resting on their flight to Egypt known as the ***Madonna del Sacco*** is by Andrea del Sarto (1525) who died in Florence of Bubonic plague in 1530/1 at the age of 43 and was buried in the church but the exact location is unknown. Since prominent artists are buried inside the church, the lack of a memorial may indicate that he was buried in this cloister.

The circular **tribune** with radiating chapels preceded by a Classical-inspired triumphal arch was begun by Michelozzo but completed by **Leon Battista Alberti** (1477) with the cupola fresco *Coronation of the Virgin* by Volteranno (1680–1683). In the chapel to the diagonal left of the high altar by Giovanni Battista Foggini (1682) is Perugino's *Madonna and Saints*. In the next chapel to its right is Bronzino's *Resurrection* (1552). In the central east chapel is the **Tomb of Giambologna** (died 1608) with reliefs and *Crucifix* he created for

the chapel that also contains the **Tomb of Pietro Tacca** (died 1640). The second chapel to the right of Giambologna's tomb was designed by Domenico Cresti (Il Pasignano) who also painted the altarpiece *Christ Healing the Blind Man*.

To the left of the tribune is the **Tomb of Bishop Angelo Marzi Medici** signed by Francesco da Sangallo (1546) and to the right is the **Tomb of Baccio Bandinelli** (died 1560) who made the statue group of the *Dead Christ Supported by Nicodemus* (his self-portrait) that was also the theme of Michelangelo's *Deposition* now in the Museo dell' Opera del Duomo (Tour 3) that he intended for his own tomb (died 1564). Contemporary artist Bronzino (died 1572) was buried in the ancient church of San Cristofano (Via Alessandro Allori) in a monument commissioned by his student and heir Alessandro Allori who is buried there with his family. In the last chapel on the south side is the Classical-inspired funerary **Monument to Orlando di Guccio de' Medici** by **Bernardo Rossellino** (1456) made almost a decade after his celebrated tomb of Leonardo Bruni in the church of Santa Croce (Tour 4). Orlando was a distant cousin and business associate of Cosimo the Elder who contributed to the patronage of the church.

The **Museo Archeologico Nazionale di Firenze** is in Palazzo della Crocetta (1619–1620) by Giulio Parigi built for Maria Maddalena the sister of Grand Duke Cosimo II de' Medici on the grounds of a former hunting lodge of Lorenzo the Magnificent. Self-conscious of a physical disability, she had the corridor built over Via della Colonna so she could attend mass in SS. Annunziata unseen. The Lorraine collection of Egyptian art formed by Grand Duke Leopold II with later additions was formerly displayed in the former convent of Sant' Onofrio (Monastery of Foligno) on Via Faenza (1855) but moved here in 1883. The Medici and Lorraine Grand Duke collections of Greek and Roman bronzes were transferred here from the Uffizi in 1890. The collection was damaged in the flood of 1966. Etruscan art was the catalyst for antiquarianism in the 18th century aided by Thomas Coke 1st Earl of Leicester who built Holkham Hall inspired by his Grand Tour travels in Italy. He published (1723) Thomas Dempster's *De Etruria Regali Libri Septem* written for Grand Duke Cosimo II de' Medici. The books document the earliest archeological studies of Etruscan tombs of Tuscany (ancient Etruria). The Accademia Etrusca was founded in Cortona the same year as Coke's publication.

On the **first floor**, are three famous bronze sculptures from the collection of Cosimo I: the *Chimaera* that dates to the 4th century BCE and was discovered in a field outside Arezzo in 1553. Giorgio Vasari presented it as a gift to Cosimo I de' Medici. The *Orator* (*Arringatore* in Italian) dates to the 1st century BCE and was found near Lake Trasimeno the site of the famous battle between Rome and Hannibal and is identified as Aule Meteli (Romanized as Aulus Metellus). The remarkable bronze *Head of a Youth* comes from Fiesole (late 4th century BCE). The bronze *Minerva from Arezzo* (early 3rd century BCE) may be a Greek original collected by a wealthy citizen in Arezzo in the 1st century CE. On display are Etruscan alabaster cinerary urns and small bronzes from necropolis sites in Tuscany. The fine Egyptian collection includes two statuettes of *Maidservants* (*c.*2480–2180 BCE), a *chariot* from a tomb in Thebes (14th century BCE) and a Fayyum funerary *Portrait of a Young Woman* from the Roman period (1st–2nd centuries CE).

On the **second floor** are the Medici and Lorraine Etruscan, Roman, and Greek sculpture collections. The Etruscan terracotta sarcophagus of Larthia Seianti (2nd century BCE) was found near Chiusi with reclining effigy of the deceased. The *Sarcophagus of the Amazons* (4th century BCE) discovered in 1872 in Tarquinia with a rare painted chest of a battle scene between Amazons and Greeks. Roman masterpieces in bronze include the *Idolino di Pesaro* (statue of a youth), a Roman copy of a Greek work that was discovered in Pesaro in 1530 and arrived in Florence as part of the wedding dowry of Vittoria della Rovere when she married her cousin Grand Duke Ferdinand II de' Medici; the *Torso from Livorno*; and the veristic portrait of *Gaius Vibius Trebonianus Gallus* (mid-3rd century CE). The ceramics collection (Greek, Etruscan, and Roman) were first displayed in 1899. The impressive collection of ancient Greek vases found in Etruscan tombs, including the famous black figure krater *François Vase* (*c.*570 BCE) discovered near Chiusi in 1844 that is signed by the potter Ergotimos and painter Kleitias. Famous Greek statues in bronze include the *Torso of an Athlete* (5th century BCE); the *Kouros from Milani* (*c.*530 BCE); and the *Medici-Riccardi horse head* that was formerly displayed in Palazzo Medici-Riccardi. The Jewellery collection spans Archaic Greece to the late Antique period (8th century BCE to 7th century CE).

In the courtyard are ancient Roman objects found in the area of the ancient Roman Forum during the 19th-century construction of Piazza

della Repubblica. In the garden is a reconstruction of the **Inghirami Tomb of Volterra** with a display of the 53 alabaster urns with effigies discovered at the time of its excavation in 1861.

To continue to Tour 6, exit Piazza della SS. Annunziata by Via Cesare Battisti (formerly called Via della Sapienza after a college founded by Niccolò da Uzzano in 1430) to return to Piazza San Marco past the **Istituto Geografica Militare Italiano**. From the piazza, turn left on Via Cavour (the former name Via Larga was changed in the 19th century) with impressive palazzi lining both sides of the street. The Biblioteca Marucelliana at No. 43 opened as a public library in 1752. At the corner of Via Guelfa is the 14th-century palazzo later owned by Bernadetto de' Medici (Prince of Ottaiano) at No. 31 who married Giulia the illegitimate daughter of Duke Alessandro de' Medici before leaving the city for Naples when his cousin Cosimo I became Duke of Florence after Alessandro's assassination. His brother Alessandro Ottaviano de' Medici became Pope Leo XI. At No. 18 is Palazzo Capponi by Ferdinando Ruggieri (1740) and Palazzo Ginori-Conti is at No. 13 with the crest of Count Ughi over the entrance was built on the location of former houses owned by the Medici and for a time owned by composer Gioachino Rossini. **Palazzo Medici-Riccardi** is to your right at No. 3 beyond the Corridor and Stables of the palace built into Via del Traditore. Opposite is Palazzo Covoni by Gherardo Silvani (1623) at No. 4 and Palazzo Panciatichi at No. 2 by architect Carlo Fontana who was active mainly in Rome.

For an optional visit to the Cenacolo di San Salvi for Andrea del Sarto's *Last Supper*, from Piazza San Marco, take either the # 6 or # 20 ATAF bus to the Lungo l'Affrico stop (the first stop after crossing the railway overpass) that takes about 15 minutes. From the bus stop, walk in the opposite direction of the bus a few steps to Via Tito Speri and turn left and follow to the church of **San Michele a San Salvi**. The entrance to the **Cenacolo di San Salvi** is to the right of the church on Via San Salvi No. 16.

A **long gallery** lined with 16th-century altarpieces and detached frescoes, including two lunettes by the Dominican nun **Suor Plautilla Nelli** and *Crucifix with St. Francis and St. Mary Magdalene* by Antonio del Ceraiolo leads to a room with a pietra serena lavabo by Benedetto da Rovezzano and the former convent kitchen with an enormous fireplace and 15th- and 16th-century paintings.

In the **cenacolo**, the former refectory, **Andrea del Sarto** began the *Last Supper* in 1519 and completed it in 1526–1527. Like the earlier versions of Andrea del Castagno (Tour 5) and Domenico Ghirlandaio (Tours 5 and 6), the viewer observes the interior scene as though a wall is removed. Rather than sit on the viewer's side of the table, Judas sits to the right of Christ. In Leonardo da Vinci's iconic version in Milan, Judas stands at the end with a spilled salt cellar in front of him. The two figures that observe the scene from above lend an air of contemporary casualness to the solemn historic occasion taking place below them. The viewer does not have a vanishing point in the landscape visible through windows as in Leonardo's version but the clouds behind the spectators bring the viewer's eye up the stark interior to the windows. On the deep triumphal arch that serves as a sort of theatre curtain, in the central tondo is Andrea del Sarto's *Holy Trinity* represented by three heads, a depiction that survives despite being condemned by the Council of Trent (1545–1563) and by Pope Urban VIII Barberini (1628). Other paintings and detached frescoes in the room by Andrea del Sarto include an *Annunciation* (*c.*1509) and *Pietà* (1520).

Return to Piazza S. Marco by retracing your steps to Lungo l'Affrico and cross the street to the bus stop of the # 6 or # 20 (De Amicis stop) across the street from your arrival stop.

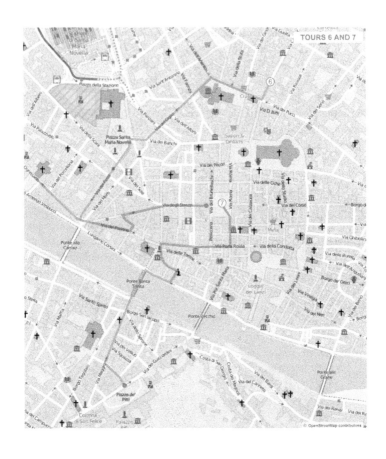

Sites: Palazzo Medici-Riccardi, San Lorenzo, Cappelle Medicee, Mercato Centrale, Santa Maria Novella, Ognisanti, Palazzo Corsini, Palazzo Rucellai, Palazzo Strozzi.
Distance: 1.8 km

PALAZZO MEDICI-RICCARDI, SAN LORENZO, MERCATO CENTRALE, SANTA MARIA NOVELLA AREA, PALAZZO RUCELLAI AND PALAZZO STROZZI

Follow in the footsteps of Cosimo the Elder and the Medici at Palazzo Medici-Riccardi by Michelozzo and the Basilica of San Lorenzo by Filippo Brunelleschi. The New Sacristy contains Michelangelo's famous tombs for family members of Lorenzo the Magnificent and the Cappella Medicee the tombs of the Medici Grand Dukes of Tuscany, beginning with Cosimo I de' Medici.

Explore the vibrant Mercato Centrale on the way to the must-see church of Santa Maria Novella with early Renaissance masterpieces, including Masaccio's *Holy Trinity*, Giotto's *Crucifix,* Brunelleschi's *Crucifix*, chapel frescoes by Domenico Ghirlandaio and the Spanish Chapel. A second Giotto *Crucifix* is in the church of Ognisanti the parish church of Amerigo Vespucci.

Framing the tour are 15th-century palaces for families connected with the Medici that are important for early Renaissance art and architecture: Palazzo Rucellai associated with the early Renaissance architects Leon Battista Alberti and Bernardo Rossellino and the stately Palazzo Strozzi.

The imposing **Palazzo Medici-Riccardi** was built by architect Michelozzo (after 1444) for Cosimo the Elder who lived here between

periods of exile and imprisonment. The numerous Medici villas, like the Villa Medici in Fiesole (Tour 10) offered opportunities to retreat from the city and its political strife. According to Giorgio Vasari, Michelozzo's design was chosen over Brunelleschi's that Cosimo I considered too ornate. The austere stone facade becomes more polished with each rise of its three stories to the heavy cornice. The palace was built in the best topographic location of the city – away from the low swampy areas behind Piazza della Signoria where the activities of the textile and leather guilds also gave the area a foul stench. This block of Via Cavour was formerly called Via Larga ('Broad Street') another sign of the palace's prime location.

The art and sculpture collections amassed by the Medici since Cosimo the Elder and restored following their return from exile were transferred to various locations when Ferdinando II sold the palace to the Riccardi family in 1659. Gabbriello Riccardi hired Ferdinando Tacca to direct renovations that were begun by architect Pier Maria Baldi but continued by Giovan Battista Foggini (*c*.1685–1695) who seamlessly expanded the palace from 10 bays to 17 in the direction of Piazza San Marco. The Riccardi lost possession of the palace in 1814 to the Habsburg-Lorraine Grand Dukes of Tuscany and in 1874 it passed into the possession of the Province of Florence after a stint as the location of the Ministry of the Interior when Florence served as capital of Italy (1865–1870). The **Biblioteca Riccardiana** contains valuable documents from the early Renaissance. Many generations of Medici lived here including Cosimo the Elder's son Piero de' Medici (the Gouty) and his grandson Lorenzo the Magnificent. Giovanni the son of Lorenzo and the future Pope Leo X de' Medici lived here after the family was restored from exile. After the death of her grandmother Alfonsina Orsini in 1520 with whom she lived in Palazzo Madama in Rome, Catherine de' Medici lived here with her aunt Clarice Strozzi. When the Medici were overthrown in 1527, Catherine was placed in convents including SS. Annunziata delle Murate until her marriage to the future Francis II, King of France in 1533. Her brother, Alessandro de' Medici the first Duke of Florence also lived here after another brief period of Medici exile until his assassination. Cosimo I lived here until moving to Palazzo Vecchio and then to Palazzo Pitti (Tour 8).

On the **ground floor** is the **Michelozzo Courtyard** or Courtyard of the Columns with a glass enclosed loggia above the portico. The

painted decoration of garlands with the Medici crest of six balls (*palle*) and reliefs with mythological subjects attributed to Maso di Bartolomeo (1462) contrasts with the stark exterior of the palace. Donatello's *Judith and Holerfernes* now in Palazzo Vecchio and the bronze *David* now in the Bargello, both commissioned by Cosimo the Elder, were displayed in courtyard fountains until seized by the Florentine Republic in 1495. The ancient marble inscriptions and sculpture reliefs, including fragments of sarcophagi that line the courtyard in Baroque trophies are from the Riccardi collection of antiquities (1719). More sculpture from the Riccardi collection of ancient statues are displayed in the **Museum of the Marbles** (Museo dei Marmi) on the basement level, including portrait busts, the *Riccardi Athlete* (2nd century CE) and a portrait of the Emperor Hadrian's wife *Vibia Sabina*.

Baccio Bandinelli's *Orpheus and Cerberus* commissioned by Pope Leo X de' Medici in 1515 at the entrance to the garden gives a sense of the original display of ancient and contemporary sculpture in the courtyard and garden. Bandinelli's copy of the *Laocoön* for Leo X now in the Uffizi was intended as a gift for Francis I of France but his cousin and half-brother Pope Clement VII sent it to Florence. It was on display here until the Riccardi bought the palace and then displayed in the Casino Mediceo in Piazza San Marco (Tour 5). The **garden** entrance is on the central axis of the original Michelozzo palace entrance that divides the garden into two symmetrical halves. Above the entrance from the palace is a crest with the Riccardi family device of keys. The rooms off of the courtyard of the former limonaia where citrus trees in clay pots were stored in the winter months is now used for temporary exhibitions.

The **first floor** is accessed from the monumental staircase (scalone d'onore) by Foggini for the Riccardi. The **Chapel of the Magi** (Cappella dei Magi) named for the celebrated fresco that wraps around the family chapel was built by Michelozzo (after 1445) and painted by Benozzo Gozzoli (1459–1463) for Cosimo the Elder. The room was altered during construction of Foggini's staircase for the Riccardi that also required a new entrance for the chapel. The figures in the procession of the Magi are portraits of the Medici and contemporaries: Lorenzo the Magnificent as Caspar dressed in gold leads a group of Medici including Cosimo the Elder and his sons Piero, Giovanni, and Carlo. Among the crowd behind them is Benozzo Gozzoli who identifies his self-portrait

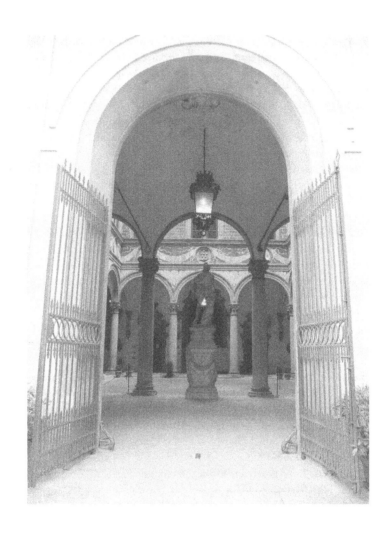

8. Michelozzi Courtyard in the Palazzo Medici-Riccardi

with his name on his hat. On the south wall, behind Balthasar dressed in a green robe is a landscape with naturalistic elements and on the west wall is Melchior with either the portrait of the Patriarch of Constantinople who died in Florence in 1439 during a council debating a reconciliation between the eastern and western churches or of the Holy Roman Emperor Sigismund of Luxemburg. The altarpiece is a copy of Fra' Filippo Lippi's *Adoration* (*c.*1458) now in the Gemäldegalerie, Berlin. It is extraordinary for the absence of Joseph and the Magi at the Nativity and the presence of the Holy Trinity and Saints John the Baptist and Bernard of Clairvaux. Its dark landscape also contrasts with Benozzo Gozzoli's luminous landscape inspired by Flemish tapestries. The choir stalls were designed by Giuliano da Sangallo and the pavement is richly decorated with porphyry and green marble panels.

The **Riccardi Rooms** have a Baroque opulence more common to the contemporary grand salons of Rome than Florence. In the Room of the Bas-Reliefs with stucco decoration designed by Foggini is Fra' Filippo Lippi's *Madonna and Child* (*c.*1452). The **Room of the Four Seasons** takes its name from tapestries designed by Jacopo Vignali and made in Florence (*c.*1643). The vault fresco of the *Apotheosis of the Medici* in the **Galleria** is by Luca Giordano (1682–1685) with wall decoration by Foggini.

The palazzo is a few steps away on Via de' Gori from Piazza S. Lorenzo in front of the Basilica of San Lorenzo. In the piazza is a seated statue of *Giovanni dalle Bande Nere* the father of Grand Duke Cosimo I by Baccio Bandinelli (1540). Facing the right side of the church is **Palazzo Della Stuffa** with an open loggia (14th–15th century). One block away from Via Cavour on Via de' Pucci is **Palazzo Pucci** where Pandolfo Pucci, the former Medici supporter, plotted to assassinate Cosimo I at the corner of Via dei Servi on his way to the church of SS. Annunziata (Tour 5). The palazzo was confiscated but restored to the Pucci, and fashion designer Emilio Pucci (1914–1992), a descendant of the family, lived and worked in the palazzo.

The **Basilica of San Lorenzo** (St. Lawrence) with its plain stone facade was built by **Filippo Brunelleschi** for Cosimo the Elder (1425) on the site of Florence's earliest church, an earlier basilica (of unknown appearance) outside the ancient walls dedicated to St. Lawrence that was consecrated by St. Ambrose of Milan in 393. St. Lawrence was martyred in Rome on a gridiron in 258 CE under the emperor Valerian.

The earlier church was the first resting place of St. Zenobius (died 417) before his relics were translated to the Basilica of Santa Reparata now the site of the Duomo (Tour 2). The humanist Pope Pius II Piccolomini visited the church in 1459. Many generations of Medici are buried here. The facade designed by Michelangelo in 1516 for Pope Leo X de' Medici was never built but the wood model that he made, now in Casa Buonarroti (Tour 4), shows two stories with a central pediment on the second storey separated from the first storey by a series of architraves creating a layered horizontal effect. Michelangelo's second funeral (the first was in Rome) was held here on 14 July 1564 organized by the Accademia e Compagnia delle Arti del Disegno.

Brunelleschi's design for the vast interior is an early Renaissance masterpiece. The harmonious manipulation of space and perspective relies on Classical architectural elements and proportions. The effect is further manipulated by the contrast of the grey *pietra serena* stone against the white interior. The view towards the high altar at the end of the nave (and coffered ceiling) is framed by a series of arches and the bronze pulpits by **Donatello** (1460) late works that were completed by his students. They are supported on ancient Ionic columns assembled in 1560. The reliefs depict the *Passion of Christ* with a remarkable *Deposition* and the *Martyrdom of St. Lawrence*. Just beyond, the porphyry disc in front of the sanctuary marks the location above Cosimo il Vecchio's tomb in the crypt.

The last chapel on the **north side** contains the 12th-century *Christ in the Carpenter's Workshop* by Pietro Annigoni who is popularly known in Great Britain for his portraits of Queen Elizabeth II. Just beyond over the door to the cloisters is a cantoria attributed to Donatello. Pontormo's faded frescoes in the choir gallery were revised in the 19th-century restoration by Gaetano Baccani (1860). Opposite the pulpit is the fresco of the *Martyrdom of St. Lawrence* by Bronzino (*c*.1565–1569). It survives the 18th-century restoration of the church by Ferdinando Ruggieri. At the start of the north transept is the **Martelli Chapel** with a funerary monument to Donatello (died 1466) who is buried in the crypt below the church. The *Tomb of Fioretta Martelli* (*c*.1464) in the form of a wicker basket is attributed to Donatello. The *Annunciation* is by Fra' Filippo Lippi (*c*.1450).

The **Old Sacristy** designed by **Brunelleschi** before his work on the main church (1418–1428) is on a central plan under a ribbed

dome. It was commissioned by Cosimo the Elder's father Giovanni di Bicci de' Medici as his burial chamber (died 1429) and he is buried in the sarcophagus with his wife Piccarda Bueri under the table with a porphyry disc in the centre of the room designed by Buggiano (*c.*1433). The Renaissance decoration designed by **Donatello** (1440–1443) survives intact: above the bronze *Door of the Martyrs* and the *Door of the Apostles* are two arched friezes with *Saints Cosmas and Damian*, the patron saints of the Medici and *Saints Lawrence and Stephen* and a frieze of cherub heads. The terracotta and plaster roundels in the lunettes depict the *Evangelists* seated at their desks. The roundels in the pendentives depict *Scenes from the Life of St. John* (1428–1443). On the wall is the bronze sarcophagus of Cosimo the Elder's sons Piero and Giovanni de' Medici by Andrea del Verrocchio commissioned by Lorenzo the Magnificent and his brother Giuliano (1472).

The high altar by Gaspare Maria Paoletti was commissioned by Grand Duke Peter Leopold (1787). Above is the *Crucifix* by Baccio da Montelupo with dome frescoes by Vincenzo Meucci (1742). The chapel to the left contains a devotional wood statue of the *Madonna and Child* attributed to Giovanni Fetti (*c.*1382). The New Sacristy in the south transept is entered by the Cappelle Medicee. Opposite the pulpit at the start of the **south side** is the *Tabernacle* by Desiderio da Settignano (1461). The second chapel from the entrance contains the Mannerist fresco the *Marriage of the Virgin* by Rosso Fiorentino (1523). On the wall is the pavement tomb slab of Francesco Landini (1398), an organist of San Lorenzo and composer of the Italian *Ars Nova* style of secular music. He is depicted playing a portative organ. Michelangelo designed the balcony on the **west wall** for Pope Clement VII de' Medici (1530).

The entrance to the cloisters, Laurentian Library and Crypt is to the left of the main entrance of the church (facing the facade). The **Cloisters** (Chiostro dei Canonici) were completed after Brunelleschi's death by Michelozzo or Antonio Manetti (1457–1462). From the cloisters beyond a statue of the historian Paolo Giovio by Francesco da Sangallo (1560) is the entrance to the **Laurentian Library** (Biblioteca Medicea Laurenziana) designed by Michelangelo (*c.*1524) for Pope Clement VII de' Medici for the important collection of manuscripts of Cosimo the Elder and Lorenzo the Magnificent. The entrance to the vestibule with disorienting vertical architectural elements is next to

Michelangelo's **elliptical staircase** made to his designs by Bartolomeo Ammannati (1559). The dark vestibule contrasts against the brightness and serenity of the horizontal oriented **reading room**, also designed by Michelangelo, including the ceiling. The floor is to a design by Tribolo (1548). The collection of Greek and Latin texts, includes a 5th-century codex of Vergil and the oldest complete text of the Vulgate version of the Bible. The Codex Amiatinus (before 716) was written in the monastery of Jarrow, England. The **Tribune d'Elci** by Pasquale Poccianti (inaugurated in 1841) originally housed the extensive book collection of Angelo Maria d'Elci given to the library in 1818.

The **Crypt** (vault under the old sacristy) also accessed from the cloisters contains the **Tomb of Cosimo the Elder** (died 1464) designed by Andrea del Verrocchio. By order of the Signoria, the rare title *Pater Patriae* (Father of the Fatherland) with antecedents in ancient Rome, including Julius Caesar (45 BCE) and Augustus (2 BCE) was carved on his tomb. The pavement **Tomb of Donatello** is nearby. The commemorative inscriptions to the Habsburg-Lorraine Grand Dukes is by Emilio de Fabris (1874). The **Treasury** includes a silver *Crucifix* (*c*.1444) by Michelozzo and reliquaries.

Exit the church left into the piazza and turn left onto Via del Canto de' Nelli to walk along the side of the church. Once you arrive behind it, look across Piazza di Madonna degli Aldobrandini at **Palazzo Riccardi Manelli** at No. 4 with a bust of Ferdinando I de' Medici that was built on the site of the house where the artist **Giotto** was born in 1266. The entrance to the Cappelle Medicee is to your left. **Palazzo Aldobrandini** in the corner of the piazza at No. 8 was the 14th-century home of Giovanna Altoviti (Madonna Giovanna degli Aldobrandini) for whom the piazza is named. She married Benci Aldobrandini. The palace was remodelled in the 15th century and eventually came into the possession of Pope Clement VIII Aldobrandini (1592–1605) who is popularly known as the pope who blessed coffee for Catholic consumption.

The **Cappelle Medicee,** Medici Chapels, entrance is through the crypt below the Chapel of the Princes with the pavement tombs of Medici family members and the wives of the Grand Dukes. The Lorraine Grand Dukes are buried in the Imperial Crypt of the Habsburgs in Vienna, Austria. An exhumation of the Medici revealed a vitamin D deficiency with evidence of rickets. Eleonora of Toledo, the

first wife of Cosimo I, had rickets as an infant and died at the age of 40 from pulmonary tuberculosis and malaria. The crypt level includes reliquaries devoted to various saints, including St. Sebastian, St. Mary the Egyptian, and St. Thomas of Canterbury. The model of the Chapel is by Ferdinando Ruggieri (1743).

The commission for the **Chapel of the Princes** (Cappella dei Principi) the mausoleum of the Medici Grand Dukes was entrusted to Vasari between 1561 and 1568 but work did not begin until 1602 under Grand Duke Ferdinand I de' Medici. Don Giovanni de' Medici hired Matteo Nigetti as architect but Bernardo Buontalenti also contributed to the design. The cupola was completed by Anna Maria Luisa de' Medici (1667–1743) the last scion of the House of Medici who was succeeded on the death of her brother Gian Gastone in 1737 by Francis Stephen of Lorraine, later Francis I, Holy Roman Emperor, the father of Marie Antoinette, Queen of France. The octagonal-shaped mausoleum contains the cenotaphs of the Medici Grand Dukes of Tuscany: Cosimo I, Francesco I, Ferdinando I, Cosimo II, Ferdinando II, and Cosimo III. Only the portraits of Ferdinando I (by Pietro Tacca) and Cosimo II were completed (by Pietro and Ferdinando Tacca). The tomb of Gian Gastone was found in a crypt beneath the pavement behind the altar in 2004.

The **New Sacristy** was commissioned by Pope Leo X de' Medici for the burials of his father Lorenzo the Magnificent whose remains were translated here from the Old Sacristy in 1559, his uncle Giuliano (killed in the Pazzi conspiracy), his brother Giuliano, the Duke of Nemours, and his nephew Lorenzo II de' Medici, Duke of Urbino, the dedicatee of Machiavelli's *The Prince*, and the father of Catherine de' Medici. As Queen Consort of France, she was buried with King Henry II in the Cathedral Basilica of Saint Denis but her remains as with the other monarchs, including Marie de Médicis were desecrated during the French Revolution. Pope Clement VII de' Medici continued construction by hiring Michelangelo who worked from 1520 until 1534 when he moved permanently to Rome before completing the project. The architectural structure is similar to Brunelleschi's Old Sacristy but the cupola with its coffered vault and oculus by Ferdinando Ruggieri (1740) is reminiscent of the Pantheon in Rome. The Medici produced four Popes: Pope Leo X and Clement VII are buried in S. Maria sopra Minerva in Rome, located behind the Pantheon. Their distant kinsmen

Pope Leo XI and Pope Pius IV are also buried in Rome in St. Peter's Basilica and S. Maria degli Angeli e dei Martyri, respectively.

The funerary monuments in the sacristy were left unfinished by Michelangelo – Lorenzo the Magnificent and his brother Giuliano are buried in simple chests over which Vasari placed Michelangelo's *Medici Madonna* and statues of Saints Cosmas (by Giovanni Angelo Montorsoli) and Damian (by Raffaello da Montelupo), the patron saints of the Medici family. For the **Tomb of Lorenzo II de' Medici** (Duke of Urbino) with Seated Portrait and reclining figures of Dusk and Dawn (1524–1531) Michelangelo gave the seated figure wearing a helmet a pensive pose. The **Tomb of Giuliano de' Medici** (Duke of Nemours) with Seated Portrait and reclining figures of *Night* and *Day* (1526–1533) depicts the Duke peering to his left.

To continue on the tour, exit the piazza by Via del Giglio. Cross Via Panzani to Via dei Banchi. Turn right and follow into Piazza Santa Maria Novella. For a visit to the Mercato Centrale before proceeding to Santa Maria Novella, exit the piazza on Via del Canto de' Nelli to retrace your steps a short distance to Via dell' Ariento. Turn left to walk on the street lined with clothing and leather market stalls to Via di Sant' Antonio for the Mercato Centrale. Before entering the Mercato Centrale, walk to the end of Via dell' Ariento to Via Nazionale to see a street tabernacle and marble fountain called the **Tabernacolo delle Fonticine** with a *Madonna and Child with the young St. John the Baptist* by Giovanni della Robbia (1522).

The **Mercato Centrale** (Mercato Centrale di San Lorenzo) is a covered market built for fresh produce, meat, fish, baked goods, wine and tourist items that was built at the same time as the Mercato di Sant' Ambrogio (Tour 4). The cast iron building is by Giuseppe Mengoni (1870–1874) who also designed the famous Galleria Vittorio Emanuele II in Milan. From the Mercato Centrale, retrace steps to Piazza di Madonna degli Aldobrandini and follow directions above to Piazza Santa Maria Novella.

In the centre of **Piazza Santa Maria Novella** two obelisks supported by bronze tortoises, the Medici family emblem, were erected by Giambologna in 1608. The obelisks served as turning posts in imitation of an ancient Roman circus when Grand Duke Cosimo I used the piazza for the *Palio dei Cocchi* chariot races that were first held in 1563 and continued into the 19th century. Across the piazza

from the Church of S. Maria Novella is the **Museo Nazionale Alinari della Fotografia** in the former Ospedale di San Paolo (13th century). The **Loggia di San Paolo** (1489–1496) contains terracotta roundels of Franciscan saints and a lunette commemorating the meeting of St. Francis and St. Dominic by Andrea della Robbia. Tradition places a meeting here but there was an earlier meeting in Rome at the church of Santa Sabina on the Aventine Hill in 1215. Grand Tour visitors to Florence stayed in hotels in the area. Emerson and Longfellow stayed at the Hotel Minerva in the piazza and at the corner of Via della Scala is the house where Henry James started to compose his first novel *Roderick Hudson* in 1874.

The vast Dominican basilica complex of **Santa Maria Novella** built on the site of an earlier chapel beginning in 1221 and consecrated in 1420 includes the must-see basilica, several cloisters, and museum with the famous Spanish Chapel. The basilica played an important role in spreading the Dominican Order in Tuscany since 1406 when Friars Giovanni Domenici and Jacopo Altoviti founded the convent of San Domenico in Fiesole (Tour 10). Visiting papal delegations to the *Council of Florence* (1439) stayed in the convent's guesthouse next to the Chapel of the Popes. The property is now jointly held with the municipality and the state.

The **facade** is based on the polychrome design of the Baptistery (Tour 2) and the basilica of San Miniato al Monte (Tour 9). The upper storey is by Leon Battista Alberti (1456–1470) who infuses the earlier Tuscan Romanesque design attributed to Fra' Jacopo Talenti with classical elements. Giovanni Rucellai commissioned the facade that combines inlaid friezes of the emblem and corporate logo of the Rucellai family (ship in full sail) with the emblem of the Medici (ring with ostrich feathers) to commemorate the joining of the families when Giovanni's son Bernardo Rucellai married Nannina, the sister of Lorenzo the Magnificent (1461). Giovanni's name appears in the inscription below the pediment and the porphyry pavement tombstone of Bernardo is at the entrance. Alberti decorated Giovanni Rucellai's tomb in the nearby former church of San Pancrazio with similar motifs. The scroll design to connect the upper clerestory storey of the nave with the lower storey was hugely influential in facade designs of churches, including the early Renaissance facade of Sant' Agostino in Rome (1483). Alberti only completed the scroll on the left. The matching scroll on the right was

added in 1920. The campanile was built onto the base of an earlier tower. The armillary and gnomon clock are by Egnazio Danti (1572).

The entrance to the basilica is through the Avelli Cemetery to the right of the facade. Gothic pillars divide the nave and two aisles and in the centre hangs **Giotto**'s *Crucifix* (*c*.1290). The frescoes of *Saints* on the nave arches date to the 14th century. The interior was remodelled by Giorgio Vasari (1565) for Grand Duke Cosimo I at which time the stone screen that divided the congregation from the choir was removed and the side chapels built. They were given a neo-Gothic appearance in the 19th century. The church retains, however, an important collection of early Renaissance masterpiece frescoes and paintings from the 13th to the 15th centuries.

On the **north** side opposite the side entrance door is **Masaccio**'s monumental fresco *Trinità* (*c*.1427), the Holy Trinity with the Virgin and St. John the Evangelist for the Lenzi family (depicted kneeling) set in a Roman triumphal arch whose proportions and perspective show the influence of Brunelleschi who designed the marble pulpit on the pier near the fresco commissioned by Giovanni Rucellai and made by Brunelleschi's adopted son Andrea Cavalcanti (known as Buggiano). Brunelleschi also made the *Crucifix* in the Gondi Chapel. The fresco discovered in 1860 when Vasari's renovation of the chapel was demolished was transferred onto canvas and moved to a new location. Restoration work revealed that Vasari was careful not to destroy the fresco. The *Cadaver Tomb* was rediscovered in the 20th century and the *Trinità* was reunited with it in its original location. The epitaph reads: *I was once what you are and what I am you also will be*. Masaccio's frescoes for the Brancacci Chapel (Tour 8) in S. Maria del Carmine show the same realism and drama. To the left is Davide Ghirlandaio's *St. Lucy and Donor* that formerly hung in the Rucellai chapel. To the right in the fourth chapel is Giorgio Vasari's altarpiece *Ressurection and Four Saints*.

At the corner of the **north transept** is a 16th-century lavabo. The **sacristy** built as the Calvalcanti Chapel (1380) with 14th-century architecture and stained glass windows is on the left with a glazed terracotta stoup at the entrance by Giovanni della Robbia (1498). The cupboard is by architect Bernardo Buontalenti (1593) with 16th-century paintings. On the north end of the transept is the elevated **Strozzi Chapel** with the frescoes of Nardo di Cione (1350–1357)

commissioned by Rosello Strozzi illustrating the *Last Judgement*, *Paradise*, *Hell* and *St. Thomas Aquinas* and the *Virtues* in the vault. The altarpiece *The Redeemer Giving the Keys to St. Peter and the Book of Wisdom to St. Thomas Aquinas* (1357) is by Nardo's brother Andrea di Cione (known as Orcagna) who assisted him in the design of the stained glass window. Below the chapel is the burial chamber with 14th-century frescoes of the *Deposition* and *Saints*.

To the far left of the sanctuary is the **Gaddi Chapel** with the tomb of Bishop Gaddi that was redesigned by Giovanni Antonio Dosio (1574–1577) with 16th-century decoration by Bronzino, Alessandro Allori, and Giovanni Bandini. Next to it is the **Gondi Chapel** designed by Giuliano da Sangallo (1503) with black, white, and porphyry marble columns perhaps from some unknown ancient monument. **Brunelleschi's *Crucifix*** is his only wood sculpture to survive. According to Vasari, its creation is connected to the *Crucifix* of his friend Donatello in Santa Croce (Tour 4) that Brunelleschi criticized for depicting Christ as a peasant. Donatello apparently dropped his lunch in admiration and agreed with Brunelleschi that he was made to carve images of Christ while he of peasants.

The **sanctuary** also called the **Tornabuoni Chapel** commissioned by Giovanni Tornabuoni (1485) whose sister Lucrezia married Piero de' Medici (the Gouty), the parents of Lorenzo the Magnificent. The masterpiece frescoes (over earlier 14th-century frescoes by Orcagna) are by **Domenico Ghirlandaio** with the assistance of his brothers Davide and Benedetto and brother-in-law Sebastiano Mainardi and others, possibly including a young Michelangelo. The chapel was painted after his celebrated frescoes in the Sassetti Chapel in Santa Trìnita (Tour 7) for Francesco Sassetti, the general bank manager of the Medici who wanted Ghirlandaio to paint this sanctuary that had been assigned to another family, the Ricci, from whom he tried to buy the rights of decoration that were eventually sold to Giovanni Tornabuoni. The cycles of the *Life of the Virgin* with a view of the Villa Medici in Fiesole (Tour 10) in the *Dormition and Assumption of the Virgin* and the *Life of St. John the Baptist* cover the three walls in rows read from the bottom to the top. Above the stained glass window designed by Ghirlandaio is the *Coronation of the Virgin*. Below are *Lives of Dominican Saints* and portrait of the donors *Giovanni Tornabuoni* and his wife *Francesca Pitti*. Domenico Ghirlandaio died of plague in 1494 and was buried in the

church but the location of his tomb is unknown. The bronze *Crucifix* on the altar is by **Giambologna**.

To the right of the sanctuary is the **Filippo Strozzi Chapel** acquired by the banker Filippo Strozzi in 1486 at a time when he was buying property to demolish for the construction of Palazzo Strozzi that began in 1489. He commissioned the frescoes from **Filippino Lippi**, the son of Fra' Filippo Lippi after his work in the Brancacci Chapel in S. Maria del Carmine (Tour 8) but he did not complete them until 1502 after an interval when he painted the frescoes in the Carafa Chapel in the church of S. Maria sopra Minerva in Rome (1488–1494). On the left wall is the Martyrdom of St. John the Evangelist and the *Raising of Drusiana*. On the right wall are the *Crucifixion of St. Philip the Apostle* and his *Miracle before the Temple of Mars*. On the vault are *Adam, Noah, Abraham*, and *Jacob*. Strozzi's black marble tomb (died 1491) is by Benedetto da Maiano (1491–1495) but the portrait bust is now in the Louvre. The trompe l'oeil frescoes on the back wall are by Lippi who also designed the stained glass window. The opening scene of **Bocaccio's *Decameron*** (1353) is set here before the group of seven women and three men leave the city for Fiesole (Tour 10) to escape the Black Death in 1348.

Next to the Filippo Strozzi chapel is the **Bardi Chapel** for the wealthy family of bankers where Duccio's *Maestà* known as the *Rucellai Madonna* (1285) now in the Uffizi hung before being moved to the Rucellai Chapel. The lunette frescoes date to the 13th century. Earlier, the Bardi had acquired the Bardi Chapel in Santa Croce (Tour 4) painted by Giotto. They acquired this chapel in 1334 and commissioned the bas-relief of *St. Gregory Blessing Riccardo Bardi*. The altarpiece *Madonna of the Rosary* is by Vasari (1570). On the south wall of the transept next to the wall mounted pavement *Tomb of Corrado della Penna*, Bishop of Fiesole (died 1312) is the elevated **Rucellai Chapel** (1320–1330) with the Tomb of Paolo Rucellai, the father of Giovanni in front on the landing of the steps. The frescoes (14th century) are by a follower of Giotto. On the left wall is the *Martyrdom of St. Cecilia* (*c.*1530–1540) by Giuliano Bugiardini for Palla Rucellai. The marble statue of the *Madonna and Child* is by Nino Pisano, son of Andrea who sculpted the statues for the former facade of the Duomo (Tour 2). In front of the altar is **Lorenzo Ghiberti**'s bronze pavement *Tomb of Fra' Leonardo Dati* (1425–1426)

the Master General of the Dominicans after whom the Dati cloister of the complex is named. To the right of the chapel is the *Tomb of the Patriarch of Constantinople* who died in the convent here in 1440, after participating in the *Council of Florence* (1439) and two more notable wall tombs: *Tomb of Aldovrando Calvalcanti*, Bishop of Orvieto who died in Florence in 1279 and *Tomb of Tedice Aliotti*, Bishop of Fiesole (died 1336) attributed to Maso di Banco.

At the end of the **south side** of the nave is the *Tomb of Giovanni Battista Ricasoli* (died 1572) near the 19th-century entrance (by Gaetano Baccani) to the **Della Pura Chapel** built by the Ricasoli family (after 1473) that houses a marble tempietto and a devotional painting of the *Madonna* (14th century). There are several 16th-century altarpieces by Giovanni Battista Naldini and funerary monuments set into the wall, including the *Monument to Giovanni da Salerno* by Vincenzo Danti (1571) that is based on the elegant canopy *Tomb of Beata Villana* by **Bernardo Rossellino** (1451). The *Angel* on the left is attributed to his brother Antonio and the *Angel* to the right, to Desiderio da Settignano. On the **west wall**, the rose window design is attributed to Andrea di Bonaiuto (*c.*1365). The lunette fresco of the *Nativity* is attributed to Botticelli but the Florentine artist (14th century) of the frescoes of the *Annunciation, Nativity, Adoration of the Magi and the Baptism of Christ* is unknown. The *Annunciation* painting on the left side is by Santi di Tito.

The **Museum** (Museo di S. Maria Novella) admission encompasses several areas off of the **Green Cloister** named after the green tone fresco cycle of *Stories from Genesis*, including *Original Sin* and the *Great Flood* by Paolo Uccello and assistants that are now displayed in the museum. The magnificent **Spanish Chapel** contains the must-see fresco cycle *Triumph of the Church* by Andrea di Bonaiuto (1365–1367) for Buonamico Guidalotti (1343) to serve as his funerary chapel. The former friar's chapter house built by Fra' Jacopo Talenti was renamed in honour of the Spanish retinue of Eleonora of Toledo (1566). On the north wall is the *Triumph of St. Thomas Aquinas* and the *Allegory of Christian Learning*; on the triumphal arch on the east wall is the *Crucifixion* with the *Way to Calvary* and *Descent into Limbo*; on the south wall is the *Allegory of the Active and Triumphant Church and of the Dominican Order* with Anolfio di Cambio's Duomo (without Brunelleschi's Dome); on the

west wall are *Scenes from the Life of Christ and St. Peter*. Beyond the Spanish Chapel is the **Cloister of the Dead** (13th–14th century) with funerary monuments and fresco decoration in the chapels. Accessible from the Green Cloister are the **Refectory** with a *Last Supper* by Alessandro Allori (1584–1597) and the *Last Supper* by **Suor Plautilla Nelli**, her only signed work known to survive, the **Ubriachi Chapel** used for the display of art and reliquaries and beyond, the **Dati Cloister**.

With the church behind you, walk through to the far left corner of the piazza continuing through Piazza degli Ottaviani (past Palazzo Ottaviani at No. 1 to your right with a sign decorated with peacocks) to Via de' Fossi famous for its antique and art shops. Follow through to **Piazza Carlo Goldoni** named for the famous Venetian playwright (1707–1793). As you stroll, look at the 16th-century exterior of the palazzo once owned by the Bourbon and Nicollini families at No. 12 to your left. Once you reach the piazza, turn right on Borgo Ognisanti a beautiful street lined with palazzi and antique shops. At No. 20 is the **Ospedale di S. Giovanni di Dio** founded by the Vespucci family (1380) and enlarged in 1702–1713 incorporating the house in which explorer **Amerigo Vespucci** (1454–1512) after whom the continent of America is named, was born. He made voyages in 1499 and 1501–1502. Follow through to Piazza Ognisanti.

Piazza Ognisanti once descended to the Arno prior to the construction of the Lungarno Amerigo Vespucci (*c*.1858) between Ponte alla Carraia (first built in 1218 after the Ponte Vecchio and rebuilt by Bartolomeo Ammannati for Grand Duke Cosimo I after a flood in 1557 and again after World War II when the retreating German Army destroyed it) and Ponte Amerigo Vespucci. In the Middle Ages, the area was the centre of woollen cloth production and the stone dyke in the river was built for the watermills. Beyond Ponte Amerigo Vespucci and the American Consulate on this side of the Arno is the public park with tree-lined avenues and cycling paths called the **Parco delle Cascine** the former hunting grounds of Duke Alessandro de' Medici where Shelley wrote *Ode to the West Wind*. A street market is held at the park on Tuesday mornings.

In the centre of the piazza is the bronze *Hercules and the Nemean Lion* by Romano Romanelli (1907). **Palazzo Lenzi** (15th century) with the painted facade (19th century) is now the Institut Français

de Florence. Next to it is **Palazzo Giuntini** (currently the St. Regis Hotel). The dome and campanile of San Frediano in Cestello (Tour 8) rise across the Arno.

The church of **Ognisanti** (All Saints) was founded by the Benedictine Order of the Umiliati (1256), active in the wool industry but was reassigned to the Franciscans in 1561. It was the parish church of **Amerigo Vespucci** whose family, as merchants, was connected to the manufacture of silk and further prospered as supporters of the Medici. The current Baroque facade (1872) in travertine replaced the original facade in *pietra serena* by Matteo Nigetti (1635–1637) that was paid for by Alessandro and Antonio di Vitale de' Medici whose father Vitale was apparently a convert from Judaism who took the last name of Grand Duke Ferdinando I at his baptism. The use of travertine is rare for Florence but common in Rome due to the availability of ancient monuments, such as the Colosseum, and the quarries around Tivoli for building materials. The glazed terracotta coat of arms refer to Alessandro and the lunette over the main portal of the *Coronation of the Virgin* is attributed to Benedetto Buglioni. The pavement tomb of Antonio di Vitale de' Medici (died 1656), philosopher and doctor, is inside the church.

Along the south side of the nave are **Domenico Ghirlandaio**'s frescoes of the *Pietà* and *Madonna della Misericordia* protecting members of the Vespucci family. The pavement marker of the **Vespucci family tomb** is to the left of the altar. The fresco of *St. Augustine in his Study* is by Botticelli (between the third and fourth altars). Opposite is Ghirlandaio's fresco of *St. Jerome* (1480) originally painted for the choir screen but relocated in 1564. In the south transept is the **Tomb of Sandro Botticelli** (Sandro Filipepi) whose family resided in the area. The high altar in polychrome marbles is attributed to Jacopo Ligozzi (1593–1595) with dome frescoes attributed to Giovanni di San Giovanni (1616–1617). In the north transept is **Giotto**'s *Crucifix* (1310–1315) that is later in date than his *Crucifix* for Santa Maria Novella. His *Ognisanti Altarpiece* formerly displayed in the church is now in the Uffizi. The entrance to the **cloisters** with Gothic columns from the original church and the **refectory** (Cenacolo di Ognisanti) of the convent with Ghirlandaio's famous *Last Supper* (1480) and other frescoes, including his *Deposition* is through the entrance at No. 42 (just to the left when facing the facade).

From the church retrace your steps to Piazza Carlo Goldoni at the Ponte alla Carraia and walk straight through to Via del Parione along the side of **Palazzo Ricasoli** (1480–1500) completed after the death of architect Michelozzo to **Palazzo Corsini** at No. 10 whose appearance is more typical of Baroque palazzi at Rome based on U shaped villas. Maria Maddelena Machiavelli the wife of Marchese Filippo Corsini bought the property from Grand Duke Ferdinando II in 1649. Many architects worked on the palace, including Ferdinando Tacca until its completion in 1737. The Corsini produced Pope Clement XII (1730–1740) whose nephew built another vast Palazzo Corsini in Rome close to the bank of the Tiber River in the area of Trastevere (1736) where many ancient sculptures were transferred. The **Galleria Corsini** has one of most important private collections in Florence but it is currently not on view.

On the block of the Lungarno Corsini facing the Arno is **Palazzo Gianfigliazzi** formerly called Palazzo Masetti (the former location of the British Consulate) at Nos. 2 and 4 where Louise Countess of Albany, widow of Charles Edward Stuart lived from 1793 to 1824, famous for her salon that attracted artists and writers, including Chateaubriand, Shelley, and Byron. From 1781 to 1783 she lived in Rome with the poet Count Vittorio Alfieri with whom she had a relationship. After his death here in 1803, she commissioned Antonio Canova to make his funerary monument for the church of Santa Croce where she is also buried (Tour 4).

Continue past Palazzo Corsini and turn left on Via Parioncino then left again on Via del Purgatorio to Via della Vigna Nuova into Piazza Rucellai. Facing the piazza at No. 18 is the elegant **Palazzo Rucellai** built for Giovanni Rucellai who funded the facade of Santa Maria Novella and the Rucellai Chapel but he was also a humanist and author of the *Zibaldone*, a compilation of quotes from Greek and Latin texts, including Aristotle and Seneca the Younger. The palace incorporates many properties that he acquired along the side of the palace for a courtyard designed by Bernardo Rossellino and two contiguous properties along the front of the street that he joined to his original house at the corner to create the celebrated facade. The date of the palace's first phase of construction (1446–1451) makes it contemporaneous with Palazzo Medici-Riccardi but the identity of the facade designer is assigned to either **Leon Battista Alberti** or **Bernardo Rossellino**. Both architects

worked closely together and they were in Rome in 1451–1455 to work for Pope Nicholas V on the apse and a new *Loggia of the Benediction* for Old St. Peter's Basilica. During his time in Rome, Rossellino remodelled the facade of Santo Stefano Rotondo. Rossellino also designed Palazzo Piccolomini in Pienza for Pope Pius II Piccolomini (1459–1464) that shares stylistic similarities with the facade of Palazzo Rucellai. The facade is the first use of Classical architectural orders in the Renaissance that delineate the three stories and is informed by Alberti's treatise *De Re Aedificatoria* (1443–1452) that expounded Vitruvius' *De Architectura* (*c*.15 BCE). The friezes incorporate Rucellai and Medici family emblems. The classicizing architecture of Alberti and Rossellino influenced architect Donato Bramante (1444–1514) who was the first architect of the New St. Peter's Basilica in Rome but his earlier *Tempietto* (*c*.1502) for S. Pietro in Montorio launched Renaissance architecture in Rome.

The street along the side of the palazzo (Via dei Palchetti then right on Via dei Federighi) leads to Piazza San Pancrazio with the church of **San Pancrazio** (founded by Charlemagne) deconsecrated except for the Rucellai Chapel (also called the Cappella del Santo Sepolchro) with the **Rucellai Sepulchre** (Sacellum) by Leon Battista Alberti (1458–1467) in which Giovanni Rucellai is buried. The church is now part of the **Museo Marino Marini** dedicated to the artist's 20th-century sculptures. The columns and architrave at the museum's entrance are from the original entrance to the Rucellai Chapel.

The **Loggia de' Rucellai** is in Piazza de' Rucellai at the corner of Via del Purgatorio (1463–1466) with arcades that were reopened in 1963. The wedding of Nannina de' Medici, the sister of Lorenzo the Magnificent and Bernardo Rucellai, son of Giovanni Rucellai was celebrated here (1466) with 500 guests occupying the loggia, the piazza and the street in front of Palazzo Rucellai on a raised dais. Their son Giovanni di Bernardo Rucellai, humanist poet and author of the tragedy *Rosmunda*, the earliest extant tragedy written in Italian, that was performed (1516) at the gardens of the Rucellai, the Orti Oricellari da Rucellai, that was the seat of the Accademia Platonica (Via Bernardo Rucellai, 6) and attended by his cousin Pope Leo X de' Medici. Giovanni Rucellai was later appointed Castellano of Castel Sant' Angelo in Rome in the 1520s by his other papal cousin Pope Clement VII de' Medici.

Exit the piazza and continue past Via dell' Inferno to your right just before you reach Via de' Tornabuoni. Wedged into the

intersection with Via della Spada is the former palazzo of Sir Robert Dudley, Duke of Northumberland (the son of Sir Robert Dudley, Earl of Leicester, the favourite of Queen Elizabeth I) who managed the Port of Livorno (Leghorn) for the Medici Grand Dukes. His nautical instruments are in the Galileo Museo (Tour 3). Behind the palazzo is the original location of the Caffè Giacosa, restored by designer Roberto Cavalli, that was moved to the Antique Shop Casoni on Via de' Tornabuoni where Count Camillo Negroni invented his famous namesake cocktail. The palazzo at No. 13 Via de' Tornabuoni was formerly the Hôtel de la Pension Suisse where George Eliot (Mary Anne Evans) stayed on her sojourn to Florence with her partner George Henry Lewes (1860).

Cross to the other side of Via de' Tornabuoni lined with 15th- and 16th-century palazzi, including **Palazzo del Circolo dell' Unione** at No. 7 with a bust of *Grand Duke Francesco I* by Giambologna over the portal and the beautiful **Palazzo Antinori** (1461–1469) at the north end at No. 3 Piazza degli Antinori, when the name of the street changes to Via degli Strozzi. The entrance to Palazzo Strozzi is to your right.

The monumental **Palazzo Strozzi** was designed by Benedetto da Maiano for the banker Filippo Strozzi (1489) but construction continued under Simone del Pollaiolo (*Il Cronaca*) until 1503. The palace was completed in 1523 by Filippo Strozzi the Younger but parts of the exterior were left unfinished. The decorative ironwork was designed by Benedetto da Maiano and made by Caparra (1491–1498). Filippo Strozzi also commissioned the Filippo Strozzi Chapel in Santa Maria Novella. In 1508 Filippo Strozzi the Younger married Clarice de' Medici, the daughter of Piero de' Medici (the Unfortunate), son of Lorenzo the Magnificent, and Alfonsina Orsini who moved to Rome and had ten children. Clarice (de' Medici) Strozzi raised her niece Catherine de' Medici after the death of Catherine's formidable grandmother Alfonsina Orsini, who had allied the Medici with the Strozzi and served as the Regent of the Republic of Florence (1515–1519) during the absences of her son (and Catherine's father) Lorenzo II de' Medici, Duke of Urbino. In 1537, Filippo Strozzi the Younger marched his troops on Florence against his nemesis Cosimo I de' Medici. After his defeat, he was imprisoned and died in the Fortezza da Basso (Fortress of S. Giovanni Battista).

The imposing facade with heavy rustication and heavy cornice was inspired by Palazzo Medici-Riccardi rather than the more elegant Palazzo Rucellai. The free-standing fortress-like palace was designed with symmetrical axes in keeping with Renaissance proportions of design. If the portal doors are open, walk into the courtyard inspired by the Michelozzo courtyard of Palazzo Medici-Riccardi, otherwise walk around to other side of building along Via degli Strozzi. The palazzo hosts international exhibitions, the **Gabinetto Scientifico Letterario G.P. Vieusseux** library and reading room founded in 1819 and visited by famous literary figures, including Giacomo Leopardi, Dostoevsky, Émile Zola, Mark Twain, and D.H. Lawrence. The **Istituto Nazionale del Rinascimento** is dedicated to the Italian Risorgimento.

To begin Tour 7, take Via degli Strozzi through Piazza degli Strozzi, with **Palazzo dello Strozzino** at No. 2 designed by Giuliano da Maiano, with its designer boutiques and through the arch to enter into Piazza della Repubblica with a view of Brunelleschi's dome and the Duomo campanile rising to your diagonal left.

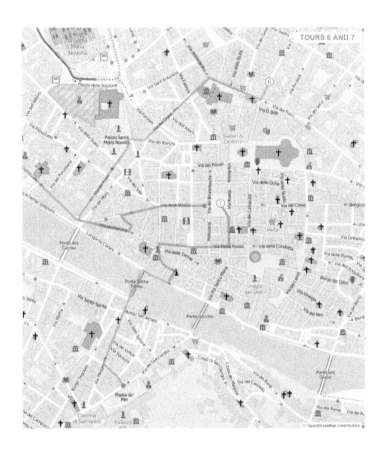

Sites: Piazza della Repubblica, Mercato Nuovo, Palazzo Davanzati, Piazza Santa Trìnita, Santa Trìnita, Santi Apostoli. Palazzo Spini-Ferroni, Ponte S. Trìnita, Oltrarno: Via Maggio

Distance: 1.7 km

Piazza della Repubblica Area, Santa Trìnita Area, Oltrarno: Via Maggio

Explore Piazza della Repubblica once the civic heart of ancient Florentia and now a symbol of Italian Unification and Florence's former status as the capital of Unified Italy prior to the fall of the Papal States in 1870. The area was once the location of the Jewish Ghetto and the tour includes other sites associated with the Jewish history of Florence on the south side of the Arno (Oltrarno) where Jews were first settled in the 15th century (Tour 8).

The nearby area of Orsanmichele was associated with powerful guilds and the palazzi of wealthy merchant families such as the Davanzati and their headquarters and tower palaces give a glimpse into 14th-century Florence. Visit the church of Santa Trìnita with famous frescoes by Domenico Ghirlandaio that offers views of 15th-century Florence.

Cross the Arno on Ponte Santa Trìnita for a stroll along the palazzo-lined Via Maggio to the imposing Palazzo Pitti for the start of Tour 8 and a circuit tour of the area of Oltrarno.

Originally called Piazza del Mercato Vecchio, the area was expanded and renamed **Piazza della Repubblica** in 1890 to commemorate Italian Unification. The *Equestrian statue of King Vittorio Emanuele II*, formerly displayed in the piazza (when it was temporarily named after him) after the demolition of the Torre dei Caponsacchi and Palazzo degli Amieri was moved to Parco delle Cascine in 1932. Medieval houses and a fish market were destroyed for the piazza's construction

(1885–1895) when the Loggia del Pesce was moved to Piazza dei Ciompi (Tour 4). This period of intense urban redevelopment in the historic centre of the city was called the **Risanamento di Firenze** (1865–1895), the 'Restoration of Florence'.

The construction of the piazza also destroyed the **Jewish Ghetto** created by Cosimo I de' Medici in 1571 after moving Jews to this side of the Arno when he was Duke of Florence and chose Palazzo Pitti as his residence on the south side of the river (Tour 8). The ghetto extended north to Via de' Pecori enclosed between two gates that were locked at night. They were opened in 1848. The cramped area had one piazza and two synagogues that were replaced by the current Synagogue (Tempio Israelitico) constructed between 1874 and 1882 (Tour 4).

The triumphal **arch** was designed by Vincenzo Micheli (1895) who also designed the Hotel Savoy on the opposite side of the piazza. The inscription ('The ancient city centre from age-old squalor restored to new life') boasts of contemporaneous antiquity and modernity. Originally a statue group of three women representing *Italy, Art*, and *Science* was placed on the top but they were popularly associated with famous prostitutes. The **Carousel** dates from the early 20th century and is still operated by the Picci family. The piazza has long attracted locals and tourists. The Caffè Giubbe Rosse (founded in 1900) is named after Garibaldi's 'Red Shirts' and has long been a cultural hub of Italian painters and poets. The Caffè Gilli in operation by the Gilli family in various Florence locations since 1733 is famous for its cappuccino.

The scale of the demolition pales in comparison to the demolition of buildings for the construction of the *King Vittorio Emanuele II Monument* in Piazza Venezia in Rome that destroyed the medieval civic centre of the city. The demolition of the area, however, for a modern-day commemorative and ceremonial piazza also brought to light the area of the Forum of ancient Florentia through archaeological excavations (1893). Architect Corinto Corinti (1841–1930) published a series of engravings based on the excavations that documented the transformation of Roman Florentia over time into the modern city (*Firenze Romana*, 1923; *Firenze antica e moderna*, 1926).

This was the civic heart of ancient Florence first founded as a colony by Julius Caesar in 59 BCE to settle retired soldiers. Via degli Strozzi, Via degli Speziali and Via del Corso formed part of the ancient

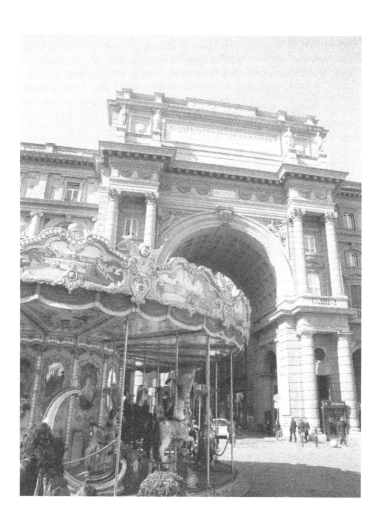

9. Carousel and Arch in Piazza della Repubblica

Decumanus Maximus (east/west) of the Roman colony of Florentia that intersected at the **Forum** (now Piazza della Repubblica) with the **Cardo Maximus** (north/south), named after a 'door hinge pole' that connected the intersecting streets, now Via Roma and Via Calimala and that was, leading into and out of the city a segment of the Via Cassia, the consular Roman road that connected to the Via Flaminia into Rome. The **Colonna dell' Abbondanza** (Column of Abundance) with the personification of *Wealth* by Giovanni Battista Foggini (1721) replaced the original statue by Donatello that had deteriorated beyond repair. The column was erected in the Forum to mark the location where the two Roman roads intersected, but it was moved to its current location in 1956. The two intersecting roads entered the town at four city gates. Five minor streets parallel to the Cardo Maximus and six minor streets parallel with the Decumanus Maximus further delineated the city into around fifty city blocks.

The ancient Forum as in all Roman towns was used for administrative and ceremonial functions. The **Capitolium** a temple dedicated to the triad of Jupiter, Juno, and Minerva faced east into the Forum. An earlier temple (1st century BCE) was rebuilt by the Emperor Hadrian when the city was monumentalized under his reign. The new temple was on a raised platform accessed by two ramps with Corinthian columns across the front. Hadrian also paved the Forum in marble at the same time that he renovated the **Roman Theatre** in Piazza della Signoria (Tour 3) and built the **Amphitheatre** outside the Roman walls (Tour 4). A marble statue of the Emperor Hadrian was excavated in the Forum highlighting the current piazza's ceremonial connections with the Roman past and its former associations with King Vittorio Emanuele II. Also on the west side of the forum was the **Curia** (*Aula Capitolina*). On the north side of the Forum was a perimeter wall but on the south side was a monumental **Arch** for entry into the heart of the colony from Via Cassia in the direction of Rome.

A **Bath** complex was located adjacent to the Forum off of the Decumanus Maximus. The semi-circular **Torre della Pagliazza** (Straw Tower) the oldest structure in Florence dating to the Byzantine period (6th–7th century) now in Piazza S. Elisabetta (Tour 2) was built into the walls of a circular structure of the baths. The tower was later incorporated into fortification walls, converted into a prison and then into the campanile of the church of S. Elisabetta (formerly S. Michele

in Palco). The largest baths, the Thermae Maximae, were located in the area of Piazza della Signoria next to the Roman Theatre (Tour 3). North of the Baths outside the entrance to the ancient northern gate near the Baptistery was an atrium centered **Domus**, small baths named after the god Mars (*Balneum Martis*) and a fullery (**Fullonica**). A second fullery was located at the entrance of the ancient eastern gate on Via del Proconsolo. Another bath complex known as the **Capaccio Baths** located on Via Calimala in the area of the Mercato Nuovo and named for the drainage basin (*caput aquae*) of the Roman aqueduct accounts for the later activities of the Wool Merchants Guild in the area. Via delle Terme that starts there and ends at Piazza S. Trìnita takes its name from the Roman baths. Like other Roman towns and cities, such as Roman London (Londinium) medieval cities were built into the structures and ruins of antiquity to form modern cities.

Exit the piazza on Via Calimala (far right corner when entering the piazza from Via degli Strozzi) and follow through to the Mercato Nuovo that is visible straight ahead on the other side of Via Porta Rossa. Along the way at Via Orsanmichele is the **Palazzo dell' Arte della Lana** (1308) to your left. The palazzo heavily restored in 1905, was the headquarters of the powerful Wool Merchants Guild that held the competition for the Dome of the Duomo won by Filippo Brunelleschi. The **Tabernacle of S. Maria della Tromba** (14th century) attached to the corner of the palazzo facing the intersection was moved here after the demolition of the Mercato Vecchio for the construction of Piazza della Repubblica. The *Madonna Enthroned with Angels and Saints* is by Jacopo del Casentino (*c*.1347) and the *Coronation of the Virgin* is by Niccolò di Pietro Gerini (1380–1385). Look to your left at Via Orsanmichele beyond the palazzo for a view of Orsanmichele (Tour 2) and niches commissioned by the guilds of Florence, including the niche that contains a copy of Donatello's *St. George*, the marble original of which is in the Bargello (Tour 4).

The Loggia del Mercato Nuovo (popularly called the Mercato del Porcellino) was built by Giovanni Battista del Tasso for Cosimo I de' Medici (1547–1551) for merchants of silk and gold on the site of an earlier market that opened after the Mercato Vecchio. It is currently the site of a clothing and leather market that preserves the area's history of wool dyeing, textile manufacturers and merchants that lined Via Calimala. On the far side is a perennial line of tourists waiting to touch

10. *Il Porcellino* in the Mercato Nuovo

the snout of *il **Porcellino***, the bronze statue of a boar known locally as the piglet, in the Fontana del Porcellino to ensure a return trip to Florence. The statue is based on an ancient Roman copy of a Greek original (now in the Uffizi) that was brought from Rome by the Medici in the mid-16th century when it was associated with the Calydonian Boar of ancient Greek mythology. It served as the model for Pietro Tacca's bronze statue (*c.*1634) intended for the Boboli Gardens that is now in the Museo Bardini (Tour 9) and replaced by the current copy. The statue appears in Hans Christian Anderson's *The Bronze Hog* in *The Poet's Bazaar*.

South of the Mercato Nuovo, the name of Via Calimala changes to Via Por S. Maria that leads directly to the Ponte Vecchio (Tour 9). The textile industry was also active in the area. The **Palazzo dell' Arte della Seta** on Via di Capaccio No. 3 was the headquarters of the silk manufacturers and merchants. Adjacent is the **Palazzo di Parte Guelfa** (14th century) with a neo-Gothic facade (19th century). It is now the seat of the Calcio Storico Fiorentino that is held in Piazza Santa Croce (Tour 4). Prior to the construction of the palazzo, the

Guelph party originally met in the adjacent former church of S. Maria sopra Porta that is named after the south gate of the old city walls and now the library of the Palagio di Parte Guelfa. A plaque at the intersection of Via Por S. Maria and Via Calimaruzza marks the location of the southern gate of the Roman town (excavations at No. 3 Via Calimaruzza) later called Porta Santa Maria after which the street is named.

Exit the Mercato Nuovo and turn left on Via Porta Rossa (with the mercato behind you) named after a secondary Roman gate and popularized in the aria *O mio babbino caro* from Puccini's *Gianni Schicchi* (1918), set in 13th-century Florence as the street where Lauretta will buy a wedding ring so she can wed her beloved Rinuccio. As you walk through Piazza Davanzati look left at Via Pellicceria (named after the furriers whose workshops lined the street) for Palazzo di Parte Guelfa. To your right is the massive **Palazzo delle Poste e Telegrafi** built in a Neo-Renaissance style (1906–1917).

Continue through Piazza Davanzati with the **Torre dei Foresi** (13th century) named after the Guelph-supporting Foresi that owned it after the Monaldi family (also once owners of the adjacent Torre dei Monaldi at No. 19) that was partially destroyed by the Ghibelline party. Opposite, at No. 13 is **Palazzo Davanzati** that was built for the Davizzi, wealthy wool merchants (mid-14th century) but passed to the Bartolini (1516) and then to the Davanzati family in 1578 that occupied the palace until 1838. The antique dealer Elia Volpi purchased and restored the palace in 1904 and opened a museum. His entire collection was sold in 1916 to the Metropolitan Museum of Art, New York and he refurnished the palace with the proceeds but the contents were again sold in 1926 later passing to the Prado Museum (Museo Nacional del Prado) in 1937. The Italian State purchased the palace in 1951 and reopened the museum in 1956 as the **Museo della Casa Fiorentina Antica** with period furnishings from the 14th to the 19th centuries and collections of lacework and ceramics.

The architecture of Palazzo Davanzati illustrates the transition of 14th-century tower palaces to early Renaissance palaces. The exterior was modified from its original appearance and functions. The once open loggia on the ground floor was used for shops and the 16th century loggia at the top of the palace replaced medieval battlements.

All of the floors have hallways that communicate with the **courtyard**. On the ground floor, the **Entrance Hall** has openings in the ceiling so visitors (and intruders) could be seen from wood covered openings in the floor of the **Audience Room** (Sala Madornale) on the **first floor** with a painted panel of the *Game of Civettino* ('Little Owl') by Giovanni di Ser Giovanni (the brother of Masaccio known as Lo Scheggia) and marble *Bust of a Boy* by Antonio Rossellino; **Parrot Room** (Sala dei Pappagalli) named for the frieze of parrots; **Studiolo** with sculpture and paintings; **Peacock Room** (Sala dei Pavoni) the main bedroom named for the frieze of birds with the coats of arms of the Davizzi and other families related to them, including the Strozzi. The *Madonna in Adoration* altarpiece (15th century) is attributed to the workshop of Filippino Lippi. One of several bathrooms in the palace with indoor plumbing is off of the bedroom. On the **second floor**: **Upper Audience Room** (Sala Madornale); the **Room of the Châtelaine de Vergy** (Sala della Castellana di Vergy) named for the fresco cycle depicting the 13th-century romance has coats of arms of the Davanzati and Alberti families. The painted *chest* (cassone) from the 15th century typically contained a bride's dowry of linens. On the **third floor** is the **kitchen** with a display of utensils and the bedroom **Impannata Room** named for its shutters.

Continue on Via Porta Rossa to Via de' Tornabuoni into **Piazza Santa Trìnita** beyond Palazzo Bartolini-Salimbeni at the corner to your left that faces the piazza. In the centre of the piazza is the **Column of Justice** (1563) that commemorates Cosimo I's victory at Montemurlo (1537) against his political opponents when he was first appointed Duke of Florence. The monolithic granite column is from the Baths of Caracalla in Rome, the source of much of the ancient sculpture in the Farnese collection now in the National Archaeological Museum, Naples. It was given to Cosimo I de' Medici in 1560 after his visit to Rome by his relative Pope Pius IV de' Medici. It is one of many ancient columns in the city given by the pope that speaks of their family bonds but also of the relative paucity of Roman ruins available for re-use compared to the city of Rome whose monuments served as quarry for the Christian transformation of the pagan city and subsequent periods. The statue of *Justice* (1581) is by Tadda (Francesco Ferrucci) and his son Romolo from a design by Bartolomeo Ammannati. The porphyry is from Rome, likely from an ancient column, and the bronze cloak

added at a later date. It took 11 years to complete and was installed (replacing a temporary wooden version) seven years after the death of Cosimo I.

The column anticipates Domenico Fontana's influential *Column of the Virgin* (1614) in front of S. Maria Maggiore in Rome for Pope Paul V Borghese with a column from the ruins of the ancient Basilica of Maxentius. Earlier, Fontana had placed the statue of *St. Peter* on the *Column of Trajan* (1588) and the statue of *St. Paul* on the *Column of Marcus Aurelius* (1589) for Pope Sixtus V to replace ancient statues of the emperors still in place during Cosimo I's visit to Rome. Cosimo I's initial impulse to have his own statue on top of the column would have been the first erected by a ruler since Imperial Rome.

The elegant piazza is famously described as having three sides but four architectural styles. **Palazzo Bartolini-Salimbeni** was built in the high Renaissance style typical of the palazzi in Rome by Baccio d'Agnolo (1520–1523). Initial criticism of the design prompted the Latin motto over the door: 'To criticize is easier than being imitated' (*Carpere promptius quam imitari*). The other motto 'Through not sleeping' (*Per non dormire*) that implies industry and vigilance contrasts with the family device of three poppies. The palace remained in the Bartolini-Salimbeni family until the early 19th century when it became the Hôtel du Nord (1839) where Grand Tourists, including James Russell Lowell, Ralph Waldo Emerson and Herman Melville stayed. The Gothic **Palazzo Spini-Ferroni** was built in 1289 for Geri Spini possibly by Lapo Tedesco, the teacher of Arnolfo di Cambio and remodelled in 1557 but still retaining its fortifications at this important entry point into the city from Ponte Santa Trìnita. The palace was heavily restored when it was bought by the Comune di Firenze (1846) and served as its council chamber from 1860 to 1870. It was bought by shoe designer Salvatore Ferragamo in 1938 and is now the Museo Salvatore Ferragamo. Next to it is **Palazzo Buondelmonti**, a late medieval/early Renaissance palazzo with a loggia on the upper floor and facade by Baccio d'Agnolo. It was home to the wealthy Buondelmonte de' Buondelmonti famous for his fierce temperament and death on his wedding day at the hand of his enemies. According to Florentine legend, at a wedding in 1216, the Guelph Buondelmonte stabbed a rival and the other nobles present decided, as restitution, he should marry a girl from the Amidei family. The Amidei claimed descent from the family line of Julius Caesar and

lived in the Torre degli Amidei on Via Por S. Maria. Buondelmonte decided to marry a girl from the Guelph Donati family instead so in retribution at the insult, the Amidei and their Ghibelline allies led by the Lamberti and Uberti families killed Buondelmonte on Easter morning as he rode in his wedding procession across the Ponte Vecchio. The episode is the proverbial cause of the enmity between the Guelphs and the Ghibellines. **Palazzo Minerbetti** at the corner of Via Parione is comprised of 12th- and 13th-century palaces.

The basilica of **Santa Trìnita** with a Mannerist facade by Bernardo Buontalenti (1593–1594) was originally built in the Romanesque style (11th century) for the Vallombrosan Order but was reworked in the Gothic style in the 14th century possibly by Neri di Fioravante who worked on the convent dormitory (1360–1362). The far left side of the facade has a niche with a statue of *St. Alexis* by Giovanni Battista Caccini (1594) beneath a scroll decoration missing on the far right side. Over the main doors is a relief of the *Trinity* by Caccini and Pietro Bernini, the father of sculptor Gian Lorenzo Bernini. The spelling of Santa Trìnita with the accent on the first i, instead of the final a according to the modern Italian spelling of Trinity as Trinità, reflects archaic Florentine pronunciation based on Latin.

The Gothic interior retains many of its earlier Romanesque elements but the fresco decoration was damaged in the Flood of 1966. On the **south side**, the first chapel has a wooden *Crucifix* (14th-century) and the third the altarpiece *Madonna Enthroned with Child and Saints* by Neri di Bicci (1481) and the detached fresco of The *Mystical Marriage of St. Catherine* possibly by Spinello Aretino. The **Bartolini-Salimbeni Chapel** (fourth) has frescoes of the *Scenes from the Life of the Virgin* and an *Annunciation* altarpiece by the late Gothic painter **Lorenzo Monaco** (1420–1425), the student of Agnolo Gaddi who became a monk and influenced the works of Fra' Angelico. In the **Sacristy** that was formerly a Strozzi chapel built by Lorenzo Ghiberti (1418–1423) is the *Tomb of Onofrio Strozzi* attributed to Ghiberti (1421) with flower decoration by Gentile da Fabriano that was commissioned by his son Palla who was one of the 500 Florentines exiled after the revolt against Cosimo the Elder in 1434.

In the important **Sassetti Chapel** (east side to right of the sanctuary) are the frescoes on the *Scenes from the Life of St. Francis* (1483–1486) by **Domenico Ghirlandaio** with his characteristic blending of biblical

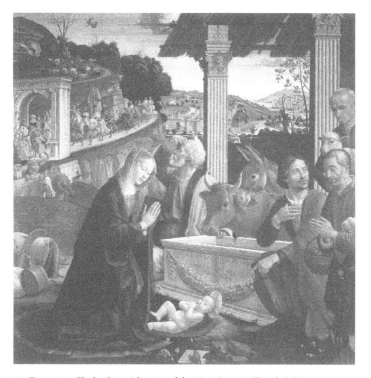

11. Domenico Ghirlandaio, *Adoration of the Magi*. Sassetti Chapel, S. Trìnita

and religious events with sites and figures from contemporary Florence. The Gothic architecture of the chapel also contrasts with the early Renaissance classicizing fresco decoration. The chapel decoration was commissioned by Francesco Sassetti (1483) the wealthy bank manager for the Medici after failing to secure the sanctuary chapel in Santa Maria Novella that was instead painted by Ghirlandaio for Giovanni Tornabuoni (Tour 6).

The decorative programme begins on the outer wall of the chapel that was rediscovered in 1895 after being whitewashed in the 18th century, with Ghirlandaio's monochrome fresco of a statue of *David* holding a shield with the head of Goliath at his feet (1485) that stands on top of a pedestal on the column that divides the chapels. The figure

of David looking down towards the scenes depicted in the chapel calls attention to it from the nave and alludes to the birth of Christ in the altarpiece. The victorious David, just as the previous versions by Donatello and Andrea del Verrocchio in the Bargello (Tour 4), also alludes to his role as the civic symbol of freedom in Florence. The shield of David references the terracotta shield of the Sassetti above the chapel entrance that is decorated with a fresco of the first Roman emperor Augustus and the *Sibyl* Tiburtina that is also connected to the decoration of the chapel vault. The founding of the church of S. Maria in Aracoeli on the Capitoline Hill in Rome is connected with the *Sibyl*'s prophecy to Augustus.

The fresco cycle in the chapel includes the *Miracle of the Boy Brought Back to Life* that is set in front of the church in Piazza Santa Trìnita. In the posthumous miracle of St. Francis, the boy who had fallen from Palazzo Spini-Feroni (prior to its remodelling in 1557) is brought back to life as St. Francis blesses him in an apparition. The view of the piazza also includes the former Romanesque facade of the church and Ponte Santa Trìnita. Above the altar in the lunette *St. Francis Receiving the Rule of the Order from Pope Honorius III* is set in Piazza della Signoria with Lorenzo the Magnificent next to Sassetti and his son with Antonio Pucci. The Classical *Sibyls* in the vault, alluding to the poet Vergil, reference the *Sibyl announcing the Coming of Christ* to the Emperor Augustus painted on the outside arch.

The masterpiece altarpiece *Adoration of the Shepherds* (1485) was influenced by the Flemish *Portinari Altarpiece* by Hugo van der Goes now in the Uffizi (Tour 3). Behind Mary is a Corinthian Column (with the painting's date on top) that is associated with her Assumption. In the distance is Jerusalem and in the immediate background the city of Florence as the new Rome. The inscription on the triumphal arch is a dedication to Pompey the Great who conquered Jerusalem in 63 BCE. The later conquest of Jerusalem and destruction of the Second Temple by Titus (70 CE) is celebrated on the Arch of Titus in Rome (82 CE). Among the figures in the foreground is Ghirlandaio's self-portrait – the shepherd who points to the Child and the garland on the ancient sarcophagus that alludes to his name. The stones below the sarcophagus allude to the meaning of the name Sassetti ('little stones or pebbles') and the goldfinch to Christ's Passion. The inscription connects the birth of Christ to the prophecy of Fulvius killed by Pompey the Great

in his conquest of Jerusalem that a God will arise from his sarcophagus. The sarcophagus also connects the birth of the Child to the marble sarcophagus *Tombs of Francesco Sassetti and his wife Nera Corsi* attributed to Giuliano da Sangallo who also kneel in adoration on either side of the altarpiece.

The **Sanctuary** walls retain fragments of the fresco cycle of *Scenes from the Old Testament* by Alesso Baldovinetti (1471–1497). On the altar a representation of the triple head of the Trinity survives despite Pope Urban VIII Barberini's order in 1628 calling for their destruction as blasphemous images. The altarpiece *Trinity* is by Mariotto di Nardo (1406). Cimabue's *Santa Trìnita Madonna* (*c.*1280–1290) now in the Uffizi was formerly displayed here. On the east side to the left of the sanctuary in the second chapel is the **Tomb of Benozzo Federighi** the Bishop of Fiesole (died 1450) by Luca della Robbia (1454–1457) that was moved here in 1896 from the deconsecrated church of S. Pancrazio (Tour 6). The north transept chapel was designed by Caccini and decorated by Domenico Cresti (Il Passignano) in 1593–1594. It contains a reliquary of St. John Gualbert (Tour 9).

On the **north side** in the **Spini Chapel** (fifth) is the remarkable wooden statue of *St. Mary Magdalene* by Desiderio da Settignano that was completed by Benedetto da Maiano (*c.*1455). In the next chapel (fourth) is the fresco transferred here from the cloister of S. Pancrazio of *St. John Gualbert Enthroned with Saints and the Blessed from the Vallombrosan Order* by Neri di Bicci (1455) who also painted the *Annunciation* (after 1475). The frescoes of *Scenes from the Life of St. John Gualbert* are by Neri di Bicci and his father Bicci di Lorenzo (confusingly, the son of Lorenzo di Bicci) who painted the fresco on the entrance arch. In the third chapel is the *Tomb of Giuliano Davanzati* (1444) attributed to Bernardo Rossellino with a 3rd-century CE Christian sarcophagus with a relief of the *Good Shepherd*. The altarpiece *Coronation of the Virgin* (1430) is by Bicci di Lorenzo. In the next chapel (second) are the *Annunciation* and *St. Jerome* by Ridolfo del Ghirlandaio. In the Strozzi Chapel (first) are frescoes by Bernadino Poccetti and other early 17th-century artists. The altarpiece of the *Deposition* by Fra' Angelico is now in the Museo Nazionale di San Marco (Tour 5).

To explore the area further before crossing the Ponte Santa Trìnita, walk straight through the piazza onto Borgo Santi Apostoli

then turn right into **Piazza del Limbo** for the entrance to the church of Santi Apostoli. The piazza is named for the cemetery formerly here dedicated to the burial of children who died before being baptized. The relief of the *Madonna* on the exterior wall of **Palazzo Rosselli del Turco** is by Baccio d'Agnolo (1507). Beyond the piazza on Borgo Santi Apostoli are palazzi of historic significance: at No. 19 is **Palazzo Usimbardi (Acciaioli)**. In the 19th century, it housed the Grand Hotel Royal that was popular with visitors on the Grand Tour, including Ruskin, Dickens, Swinburne, Longfellow and Henry James. At No. 8 is **Palazzo Acciaioli** with the Torre del Buondelmonti degli Acciaioli (11th/12th century) with the emblem of the Certosa del Galluzzo, the Carthusian monastery south of Florence founded in 1340 by Niccolò Acciaioli (also spelled Acciaiuoli). The family bank went bankrupt around the time of the collapse of the Bardi and Peruzzi banks (1344). Laudomia Acciaioli married Pierfrancesco de' Medici, the son of Lorenzo the Elder and Ginevra Cavalcanti, thus making the Acciaioli ancestors to Grand Duke Cosimo I de' Medici's branch of the family. At the corner of Via Por S. Maria is the **Torre dei Baldovinetti** (12th century).

The church of **Santi Apostoli** was built in the 11th century but was remodelled several times (15th, 16th and 18th centuries) including the 1930s when the church was restored to its Romanesque appearance. On the Romanesque facade of the church with a portal attributed to Benedetto da Rovezzano is a plaque indicating the 1966 flood level of the Arno that damaged the interior of the church extensively. According to tradition, Pazzo or Pazzino de' Pazzi the ancestor of the anti-Medici Pazzi was first to scale the walls of Jerusalem in the First Crusade (1101). As his reward, he was given three flints from the Holy Sepulchre used to light the lamps in the tomb. These are stored in the church and used in the annual festival of the *Scoppio del Carro* on Easter Sunday at the Duomo (Tour 2).

Inside, the early basilica floor plan features a nave, two aisles, and an apse with columns made from green marble from Prato. The composite capitals are spoliated from an unknown ancient building but the first two Corinthian capitals (1st century BCE) are possibly from the nearby Roman baths. The left side marble stoup is by Benedetto da Rovezzano. The wood ceiling dates to 1333 and the pavement tombs are from the 14th to the 16th centuries. The Altoviti and Acciaioli

families were patrons of the church. On the south side in the Bindo Altoviti chapel is the much-copied altarpiece *Allegory of the Immaculate Conception* by Giorgio Vasari (1540). The *funerary monument to Bindo Altoviti* (1570) over the door with statues of *Faith* and the *putti* are attributed to followers of Bartolomeo Ammannati. The *funerary monument to Antonio Altoviti, Archbishop of Florence* in the apse is by Giovanni Antonio Dosio (1573–1583). The marble busts of *Antonio Altoviti* and of *Charlemagne* over the door are by Giovanni Battista Caccini and allude to the incorrect legendary founding of the church by Charlemagne despite the 16th century inscription on the facade of the church. The Gothic altarpiece *Madonna Enthroned with Saints and Angels* (14th century) is attributed to Jacopo di Cione. The glazed terracotta *tabernacle* to the left of the apse is by Andrea della Robbia and below are panels from the *funerary monument to Donato Acciaioli* (1333). At the end of the north side is the *Tomb of Oddo Altiviti* by Benedetto da Rovezzano (1507–1510) The *Tomb of Anna Ubaldi* (1696) has a bust of the deceased by Giovanni Battista Foggini.

Exit the piazza with the church to your left and walk through the alley to the Arno. Directly across the other side of the Arno is the rear wall of the church S. Jacopo Sopr'Arno (Tour 8). Turn right on Lungarno degli Acciaiuoli that is named for the powerful banking family. The street follows the course of an ancient Roman road. Walk to the Ponte Santa Trìnita with a view of the arches of the bridge over which the dome of San Frediano in Cestello rises. In 1867, the Pre-Raphaelite William Holman Hunt resided at No. 14 in the studio vacated by artist Simeon Solomon where he painted *Isabella and the Pot of Basil* inspired by Boccaccio's *Decameron*. The Hotel Berchielli has occupied the palazzo since 1890 and guests have included Pablo Picasso. Many of the buildings along the Lungarno were damaged in World War II.

The **Ponte Santa Trìnita** was designed by Bartolomeo Ammannati in 1567 for Cosimo I after the 1252 bridge built by the Frescobaldi was destroyed by flood (1558). The bridge was destroyed in World War II by retreating German soldiers (1944) and a replica was built in 1957. Statues of the *Four Seasons* were erected on the parapet for the lavish wedding of Grand Duke Cosimo II and Archduchess Maria Maddalena of Austria, the sister of the queen of Philip III of Spain (1608) that included musical floats and mock naval battles on the Arno:

Spring by Pietro Francavilla; *Summer* by Giovanni Battista Caccini; *Autumn* also by Caccini and *Winter* by Taddeo Landini. They survived the 1944 destruction but the head of *Spring* was only recovered from the river bed in 1961. Dante Gabriel Rossetti's painting *The Salutation of Beatrice* (1859) and Henry Holiday's *Dante meets Beatrice at Ponte Santa Trìnita* (1883) were inspired by Dante Alighieri's *La Vita Nuova* (1295) in which he describes his chance meeting with Beatrice.

Cross the bridge to the south side of the Arno known as Oltrarno ('other side of the Arno'). To the left as you cross is a view of the Ponte Vecchio (Tour 9). The bridge exits into Piazza Frescobaldi. **Palazzo Frescobaldi** (Nos. 1, 2, 3 red) is to your left comprised of 13th- and 14th-century houses. Like Palazzo Spini-Feroni on the other side of the Arno, it occupies an important location next to the bridgehead and a member of the Frescobaldi family Messer Lombardo built a wooden bridge across the Arno (1252). Charles of Anjou (Charles I of Naples) and later Charles of Valois stayed here when called to Italy's defence by Pope Boniface VIII (1301). The palace was burned during a popular uprising (1343) and partially destroyed in the construction of **Palazzo dei Padri delle Missioni** at No. 1 to its left with a monumental Baroque facade by Bernardino Radi (1640) and busts of the Grand Dukes in the niches. At the intersections of Borgo San Jacopo and Via dello Sprone is a *fountain* attributed to Bernardo Buontalenti. Above is a loggetta with a Medici coat of arms.

Stroll down the beautiful **Via Maggio** (corruption of Via Maggiore) with its many art and antique shops, the ancient road that is lined with grand palazzi built for the courtiers of Cosimo I and the Grand Dukes was transformed from a squalid area into a fashionable residential district. The succession of historic palazzi is impressive. At No. 2 to your right is **Palazzo Pitti** (14th century) with the coat of arms of the Pitti and Manelli families. The bust of Cosimo I in the niche is attributed to Baccio Bandinelli. At No. 6 is **Palazzo Agostini** attributed to Baccio d'Agnolo and at No. 7 to your left is **Palazzo Ricasoli Firidolfi** (*c*.1520), also attributed to Baccio d'Agnolo. No. 8 to your right is **Palazzo Guidi** and next at No. 9 to your left at the corner of Via dei Velluti is the 16th-century **Palazzo Martellini** (later Roselli del Turco).

To your right at Nos. 16–18 is **Palazzo Machiavelli** part of which houses the Anglican **St. Mark's English Church** that opened

in 1881 following its founding by Reverend Charles Tooth several years earlier at Via Serragli, 1. **St. James Episcopal Church** near the west side of Stazione di S. Maria Novella (Via Bernardo Rucellai, 9) was officially founded in 1867 for expatriate Americans with funding by John Pierpont Morgan. The first Protestant churches in Rome opened after the fall of the Papal States in 1870 although worship is documented as early as 1816. Across the street to your left at No. 11 is **Palazzo Michelozzi** attributed to Giovanni Battista Caccini for Giovanni Battista Michelozzi. At No. 13 is **Palazzo Ridolfi Zanchini** (16th century) formerly owned by the Corbinelli family followed by the **Palazzo di Cosimo Ridolfi** (16th century) at No. 15. Mona Lisa Gherardini, the woman purported to be the sitter for Leonardo da Vinci's *Mona Lisa* (Tour 4) was born in a rented house at the corner of Via Maggio and Via Sguazza on 15 June 1449. The Pre-Raphaelite artist Simeon Solomon had a studio at No. 22 before moving to his studio on Lungarno degli Acciaiuoli later rented by William Holman Hunt.

To your right at No. 26 is **Palazzo di Bianca Cappello** built for the Venetian lover of Grand Duke Francesco I who was married to Joanna of Austria, the mother of Marie de Médicis. Following the death of his wife, the couple married in 1579 and she gave the palace to the Ospedale di S. Maria Nuova. The painted facade with *grottesche* decoration is by Bernardino Poccetti (1579–1580). At No. 28 is **Palazzo Peruzzi de' Medici** named for the family that acquired the palace (built in the 16th century for the Corbinelli family) in the 19th century.

Turn left on the narrow Sdrucciolo de' Pitti and follow into Piazza de' Pitti to begin Tour 8 at Palazzo Pitti where Dostoevsky wrote the *Idiot* at No. 21. Just beyond Sdrucciolo de' Pitti on Via Maggio is the **Casa di Bernardo Buontalenti** at No. 37 where Cosimo I's court architect lived. The now faded painted decoration is by Bernardino Poccetti. At No. 42 is **Palazzo Corsini Suarez** (14th–16th century) now the Gabinetto Scientifico Letterario G. P. Vieusseux also based in Palazzo Strozzi (Tour 6). Via Maggio ends in Piazza San Felice before turning into Via Romana to the Porta Romana.

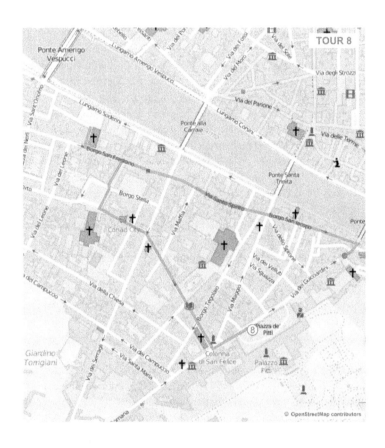

Sites: Palazzo Pitti, Boboli Gardens, La Specola, San Felice in Piazza, Santo Spirito, Cenacolo di Santo Spirito, S. Maria del Carmine (Brancacci Chapel), San Frediano in Cestello, San Jacopo sopr'Arno, Santa Felicità, Palazzo Machiavelli.
Distance: 1.8 km

Oltrarno: Palazzo Pitti, Boboli Gardens, La Specola, San Felice in Piazza, Santo Spirito, S. Maria del Carmine, San Frediano in Cestello and Santa Felicità

A circuit tour of Oltrarno the area south of the Arno that begins with a visit to Palazzo Pitti and the Boboli Gardens, given to Cosimo I de' Medici as a wedding present by his wife Eleonora of Toledo, that became the seat of the future Grand Duke's power in Tuscany and beyond as his descendants married into the royal houses of Europe, including the Bourbon and Habsburgs. The garden in the high Italian Renaissance style with grottoes and fountains is a pleasant place to stroll along tree lined garden paths.

The tour visits the major churches in Oltrarno including Santo Spirito and Santa Maria del Carmine with the famous frescoes of Masaccio and Masolino in the Brancacci Chapel and sites associated with Florence's Jewish history before ending at Piazza Santa Felicità near the Ponte Vecchio for the start of Tour 9.

The imposing **Palazzo Pitti** was built for Luca Pitti, an ally of Cosimo the Elder, on the site of the Boboli gardens that he purchased in 1418. The builder was possibly Luca Fancelli to designs of Brunelleschi who died before the start of construction (1458). The original palace of seven bays invites comparisons to the contemporary Palazzo Medici-Riccardi

for which Cosimo the Elder rejected Brunelleschi's design in favour of Michelozzo's austere facade (Tour 6) but the setting of each palace affected their designs. The three stories made from pietra forte quarried from the Boboli Gardens in a rusticated design become more refined on each storey. A balcony runs along the entire course of each level. The repetition of arched windows gives the facade the appearance of a Roman aqueduct.

The Pitti sold the palace to Eleonora of Toledo who gave it to Cosimo I as a wedding present in 1549. The grand ducal court was moved here from Palazzo Vecchio and Giorgio Vasari connected the palace with the Corridoio over the Arno across the Ponte Vecchio to the Uffizi and Palazzo Vecchio (Tour 3). The palace facade was modified with aediculed windows on the ground floor (called kneeling windows for their resemblance to prie-dieu that were first introduced by Michelangelo at Palazzo Medici-Riccardi) and was extended behind the palace towards the gardens with wings that gave the palace the appearance of a U-shaped villa fashionable in Rome. Bartolomeo Ammannati designed the sunken courtyard to connect the palace to the Boboli Gardens whose designs are attributed to Tribolo and include the amphitheatre, grottoes, fountains, and hunting grounds. Giulio Parigi extended the facade by three bays on either side of the original core for Cosimo III in 1619. The facade was again extended by an additional five bays on each side by Alfonso Parigi after 1640 for a total of twenty-three bays. The wings extending out to the front courtyard in Piazza de' Pitti with seven bays each were added by the Lorraine Grand Dukes, on the right in 1764 and on the left in 1839 following the brief occupancy of the palace by Napoleon. King Vittorio Emanuele II whose House of Savoy succeeded the Lorraine lived here from 1860 until 1871 when he moved to Rome at the time it became the capital of Italy. His grandson Vittorio Emanuele III gave the palace and contents to the nation of Italy in 1919.

The entrance to Palazzo Pitti and the Boboli Gardens is straight ahead but the ticket office is to the far right of the piazza when facing the facade. The vast palace complex is comprised of many museums, including the Porcelain Museum and the Costume Museum in the Boboli Gardens. The large Mannerist **courtyard** designed by Bartolomeo Ammannati is lined with niches with ancient statues and 16th-century restorations, including a copy of the *Farnese Hercules* (the original is in the National Archaeological Museum in Naples). The **Cappella Palatina** (1776) is

only open on special occasions. Stirred by memories of her childhood home, the courtyard influenced the design of Marie de Médicis' courtyard in the Palais de Luxembourg in Paris.

The **Galleria Palatina** of paintings and art acquired by the Medici and Lorraine Grand Dukes is displayed in the various apartments occupied by them and lastly by the House of Savoy over three centuries that were decorated in various styles during that period. The Lorraine Grand Dukes arranged the famous collection of paintings in 1771 in the magnificent reception rooms facing Piazza de' Pitti that were decorated by the leading Baroque painter and architect Pietro da Cortona in the 1640s for Grand Duke Ferdinando II de' Medici.

On the **first floor** (piano nobile) from the **Anticamera degli Staffieri** with works by Baccio Bandinelli for Cosimo I, is the **Galleria delle Statue**, a corridor of ancient statues that Bartolomeo Ammannati designed as a loggia facing his courtyard and the Boboli Gardens. The **Sala del Castagnoli** with ancient statues formerly displayed in the Villa Medici in Rome, including Imperial portraits and *Dacian Prisoners* is named after the artist Giuseppe Castagnoli who decorated the room in 1812.

From here you may visit the **Volterrano Wing** to the right with a series of rooms facing the courtyard with allegorical frescoes on the virtues of Grand Duchess Vittoria della Rovere by Baldassarre Franceschini also known as Il Volteranno (1658). The **Sala di Psiche** that faces the Boboli Gardens includes works by **Salvator Rosa**. Or continue straight ahead through the Neoclassical era rooms occupied by Napoleon's sister Elisa Baciocchi to proceed immediately to the Scalone del Mora that leads to the famous painting collection displayed in a series of grand reception rooms on Classical themes beginning with the Sala dell' Iliade. Look through the glass doors to see Antonio Canova's *Venus Italica* in the Sala di Venere.

Beyond the **Sala della Musica** with a fresco *Glorification of the Habsburgs* by Luigi Ademollo is the **Galleria del Poccetti** with frescoes by Matteo Rosselli and portraits of the *Duchess and Duke of Buckingham* (*c.*1625) by Rubens. The Duke negotiated the marriage between Henrietta Maria, the daughter of Marie de Médicis and Charles I of England. The portrait of *Oliver Cromwell* is by Peter Lely. The **Prometheus Room** contains early Renaissance paintings, including Fra' Filippo Lippi's *Tondo of the Madonna and Child* (*c.*1450), *Portrait of a Man* by Botticelli,

Baldassarre Peruzzi's *Apollo and the Muses* with the names of the Muses in Greek, and Guido Reni's *Young Bacchus*. Also here is Pontormo's *Adoration of the Magi* (1523). After three small rooms is the **Sala di Ulisse** with Raphael's *Sacred Family* also called the *Maddona dell'Impannata* (1513–1514) and Filippino Lippi's *Death of Lucrezia*. The **Empire bathroom** is by Giuseppe Cacialli (1813). In the **Sala dell'Educazione di Giove** is Caravaggio's *Sleeping Cupid* (1608) and the *Judith and Holofernes* by Cristofano Allori. The frescoes *Four Ages of Man* by Pietro da Cortona (1637) are in the **Sala della Stufa** (1637). The former loggia has a ceiling painting by Matteo Rosselli (1622).

At the top of the Neo-Renaissance **Scalone del Moro** designed by Luigi del Moro (1892–1897) is the **Atrium** with a *Fountain* by Antonio Rossellino and Benedetto da Maiano and bronze *Statue of a boy* by Bartolomeo Ammannati. The **Sala dell'Iliade** is named after scenes from Homer's *Iliad* painted by Luigi Sabatelli (1819–1825). In the centre is Lorenzo Bartoloni's *Charity* (1824). The portrait of a pregnant woman *La Gravida* is by Raphael (1505–1506). Andrea del Sarto painted the two *Assumption* paintings and the *Pala di San Marco* is by Fra' Bartolomeo. Titian painted the *Portrait of Philip II of Spain* and Velázquez the *Equestrian Portrait of Philip IV of Spain*. The *Judith and Holofernes* (1614–1620) is one of many versions by Artemesia Gentileschi. Ridolfo del Ghirlandaio painted portraits in the room. Other portraits are by the Flemish artist Justus Suttermans court painter to the Medici from 1619 until 1681.

Now begins the five reception rooms named after Olympian gods painted by **Pietro da Cortona** (Pietro Berrettini) and completed by Ciro Ferri for Ferdinando II after his masterpiece *Triumph of Divine Providence* for Pope Urban VIII's Palazzo Barberini in Rome where he was active as a principal artist of the Baroque. In the **Sala di Saturno** dedicated to Saturn are several paintings by **Raphael**. The famous tondo *Madonna della Seggiola* (*c*.1514–1515) of the Madonna seated on a wooden chair with the child Christ as a young St. John the Baptist watches. It was in Medici possession since Pope Leo X for whom Raphael painted the Raphael Rooms of the Vatican after the death of Pope Julius II della Rovere to whom he was introduced by Donato Bramante the architect of the new St. Peter's. The portrait of the Madonna seems modelled after his mistress known as La Fornarina. The *Madonna del Granduca* (*c*.1505) is named after the Lorraine Grand Duke Ferdinand III who purchased it in exile

(1800) during the Napoleonic interlude. The *Madonna del Baldacchino* (1507) was commissioned for the Cappella Dei in Santo Spirito but was not finished when Raphael left Florence for Rome. Also by Raphael are the *Portrait of Tommaso Inghirami* (*c.*1514) and the *Portraits of Agnolo Doni* and *Maddalena Strozzi* (*c.*1504). Agnolo Doni also commissioned the *Doni Tondo* by Michelangelo in the Bargello (Tour 4). In between the portraits is Raphael's *Vision of Ezekiel* (1512). The *Deposition* (1495) is by Perugino, Raphael's teacher.

The **Sala di Giove** dedicated to Jupiter was the throne room of the Medici and the decoration by Pietro da Cortona depicts *Ferdinando II in Glory with the Virtues*. Allegorical associations between Cosimo I and Jupiter appeared earlier in Palazzo Vecchio (Tour 3). In the centre is the *Victory* of Vincenzo Consani (1859). Raphael's *La Velata* (Veiled Woman) is one of his most famous portraits (*c.*1516). The *Portrait of Crown Prince Guidobaldo II della Rovere* with his dog is by Bronzino (*c.*1530). Also here are Andrea del Sarto's iconic painting of the *Young St. John the Baptist* (1523) and Fra' Bartolomeo's last work, *Deposition*. The large *Ecstasy of St. Margaret of Cortona* is by Giovanni Lanfranco (1622) commissioned by Grand Duke Ferdinando II for the church of S. Maria Nuova in Cortona designed by Giorgio Vasari (1550).

In the **Sala di Marte** dedicated to Mars the Roman god of war is Ruben's *Consequences of War* (1638) with Venus preventing Mars from entering battle. Rubens also painted *The Four Philosophers*. To either side are two *Madonna and Child* paintings by Murillo. The *Portrait of Cardinal Ippolito de' Medici* is by Titian whose clothing references the Cardinal's return from Hungary. Veronese painted the *Portrait of a Man* in fur robes (1550–1560) and Van Dyck the *Portrait of Cardinal Guido Bentivoglio* (*c.*1623). The **Sala di Apollo** has two works by Titian: *Portrait of a Gentleman* and *Mary Magdalene*. Andrea del Sarto painted the *Holy Family* and the *Deposition* (1524) that shows the influence of Fra' Bartolomeo. The *Cleopatra* is by Guido Reni (1640). Suttermans painted the portrait of *Vittoria della Rovere as a Vestal Virgin* and the double portrait of *Charles I and Henrietta Maria* is by Van Dyck. The *Sacred Conversation* is by Rosso Fiorentino (1522) for Pietro Dei for the Cappella Dei in S. Spirito.

The **Sala di Venere** takes its name from **Antonio Canova**'s Neoclassical masterpiece *Venus Italica* commissioned by Ludovico I, King of Etruria in 1804 for the Tribune of the Uffizi as a substitution for the

Medici Venus that the French under Napoleon took to the Louvre in 1802 and was returned by France in 1815. Works by Titian include his *Portrait of a Lady (La Bella)* commissioned by the Duke of Urbino in 1536 that entered the collection after Vittoria della Rovere married Ferdinando II; *Portrait of Pietro Aretino*; and a copy of Raphael's *Portrait of Pope Julius II* (1545). The *Concerto (c.1510–1512)* is attributed to Titian. The *Return from the Hayfields* and *Ulysses in the Phaeacian Isle* are by Rubens with two *Marine* scenes by Salvator Rosa. Sebastiano del Piombo painted the *Portrait of Baccio Valori*. Guercino's *Apollo and Marsyas* (1618) was commissioned by Grand Duke Cosimo II de' Medici.

The **Appartamenti Reali** were the royal apartments and state rooms of the Medici and Lorraine Grand Dukes and are decorated in the style of the House of Savoy (1880–1911). The **Sala delle Niche** over the central doors of the palace was designed by Bartolomeo Ammannati (1561–1562) and named for the black niches with ancient statues brought to Florence by Cosimo I from his trip to Rome in 1560. In the **Sala Verde** is the *Portrait of a Knight of Malta* (Antonio Martelli) by **Caravaggio** and portraits of the daughters of Louis XV Marie-Henriette as *Flora* and Marie-Adelaide as *Diana* by Jean-Marc Nattier. The **Sala del Trono**, the Throne Room of the Savoy is decorated in neo-Baroque style with French furnishings from the mid-19th century and Japanese and Chinese Vases. In the **Salotto Celeste**, the Blue Room, are portraits of Medici family members by Suttermans and a 17th-century chandelier by Vittorio Crosten. The **Chapel** occupies the space of the former bedroom of Crown Prince Ferdinando (son of Cosimo III de' Medici) known as the *alcova* with a *Madonna and Child* by Carlo Dolci (1697). The **Sala dei Pappagalli** is named for the eagles in the silk decoration that were mistaken for parrots.

The **Appartamenti della Regina Margherita** wife of Umberto I occupied these rooms until she moved to the former Palazzo Boncompagni in Rome that was renamed Palazzo Margherita following the assassination of her husband Umberto I in 1900. It is now the United States Embassy in Rome. The **Salotto della Regina** is decorated in yellow silk from the early 19th-century with furniture created for the Medici Grand Dukes by Giovanni Battista Foggini (1704). The **Camera della Regina** was used as a Games Room by the Medici before its conversion into the Queen's bedroom now decorated with a canopy bed (1885) and prie-dieu (1687). It connects to the **Gabinetto Ovale** also known as the Toilette

della Regina decorated with silk chinoiserie furnishings (1780–1783) for Grand Duchess Maria Luisa of Bourbon the Infanta of Spain who married Peter Leopold in 1765. They moved to Austria (1790) when he became Holy Roman Emperor Leopold II. The **Gabinetto Rotondo** designed by Ignazio Pellegrini (18th century) is decorated with stucco and mirrors.

The **Appartamenti del Re Umberto** were the rooms of King Umberto I from 1878 to 1900. The **Camera del Re** was furnished in the 18th century with yellow silk furnishings and canopy bed. The prie-dieu and stoup are by Giovanni Battista Foggini for the Medici Grand Dukes. The **Studio del Re** also furnished in yellow silk and the **Salone Rosso** with 19th-century furnishings were the King's private rooms.

In between the apartments of Regina Margherita and Re Umberto are the former dressing rooms and bathrooms of the Lorraine Grand Dukes known as the **Rittrata della Granduchessa** with Neoclassical decoration for Grand Duchess Maria Luisa including her round bathroom with a ceiling modelled after the Pantheon.

The **Sala Bianca** with white stucco decoration is part of the Appartamenti Reali but on the other side of the grand staircase facing the courtyard that is now used for special exhibitions. Adjacent to it is the **Sala di Bona** that is also connected to the rooms of the Appartamenti del Re. The room retains the decoration (1607–1609) of Ferdinando I in honour of his father Cosimo I who is depicted as a nude Jupiter on the ceiling. It is named for the fresco by Bernardino Pocetti that commemorates the Tuscan victory over the Turks at Bona (1607). The other fresco commemorates a victory in Albania. The **Appartamenti degli Arazzi** used by Medici as guest rooms are named for the tapestries. The ceiling frescoes of the *Cardinal* and *Theological Virtues* in the rooms are by leading painters Domenico Cresti (Il Passignano), Pocetti, Cristofano Allori and Ludovico Cigoli for Ferdinando I.

On the floor above is the **Galleria d'Arte Moderna** that opened in 1924. The nucleus of the collection formed by Grand Duke Peter Leopold (*c.*1784) as part of the Accademia di Belle Arti was later increased with acquisitions by the Savoy and Comune of Florence. Art from the mid-18th century to World War I is displayed in 30 rooms arranged by school, theme, and date.

Highlights include: **Neoclassicism** with Pompeo Batoni's *Hercules at the Crossroads* (1742) and the *Infant Hercules Strangling Serpents in his Cradle* (1743), Pietro Tenerani's *Psyche* (1816–1817), *Saxons' Oath to*

Napoleon after the Battle of Jena, 1812 by Pietro Benvenuti, and Giovanni Duprè's *Abel*; **French Interlude**: *Calliope* of Antonio Canova (1812) that may be a portrait of Napoleon's sister Elisa Baciocchi; **Demidoff Room**; **Romantic historical paintings**: Giuseppe Bezzuoli, Entry of Charles VIII into Florence (1829); **Portraits**: *Self-Portrait* by Giovanni Fattori (1854); **19th-Century landscapes**; **Cristiano Banti Collection** with paintings by Giovanni Boldini; **Diego Martelli Collection**: artists of the Macchiaioli School including Federico Zandomeneghi's portraits of Martelli; Camille Pisarro, Giovanni Fattori, Silvestro Laga, and Giuseppe Abbati; **Period between the Grand Dukes and Italian Unification**: the *Suicide* by Adriano Cecioni (1865–1867) and Silvestro Laga's *Il Canto dello Stornello* (1867); **Patriotic scenes**: *The Italian Camp after the Battle of Magenta* by Giovanni Fattori (1862); **Macchiaioli School**: Giovanni Fattori: *Staffato* (1880), *Cavallo Bianco, Libecciata*, and *Rotondo di Palmieri* (1866); Telemaco Signorini: *Bagno penale di Portoferrato*; Ambron Collection: Domenico Morelli's *Cemetery Scene in Constantinople*; Giuseppe de Nittis: *On the Banks of the Olfanto*; **Late 19th-Century Tuscan works**: *Leith* (1881) by Telemaco Signorini; *Ecce Homo* by Antonio Ciseri (1891); and *Portrait of Bruna Pagliano* (1904) by Edoardo Gelli; **Portraits by Elisabeth Chaplin** and **Early 20th-Century works**.

Also on this level is the **Quartiere D'Inverno** with apartments used by the Medici in winter and last occupied by the Savoy. The Galleria d'Arte Moderne has plans to exhibit post-World War I art in the **Mezzanino degli Occhi** on the top floor of the palace.

The entrance to the **Silver Museum** (Museo degli Argenti) is from the main courtyard located in the summer apartments of the Grand Dukes. On the **ground floor**: **Sala di Luca Pitti**: terracotta busts of the Medici Dukes and Grand Dukes; a *Portrait of Luca Pitti* (15th century); Japanese and Chinese porcelain. **Sala di Giovanni da San Giovanni**: frescoes by the artist (1634) including the cycles of the *Apotheosis of the Medici through Lorenzo the Magnificent*. **Sala Buia**: 16 vases in pietre dure owned by Lorenzo the Magnificent; Roman and Byzantine objects in pietre dure; the *Death mask of Lorenzo the Magnificent* and his portrait by Luigi Fiammingo; **Sala delle Cornice**: a display of frames by Vittorio Crosten and relief by Grinling Gibbons presented to Cosimo III by Charles II of England in the small grotto (Grotticina); **Cappella** (1623–1634); **Reception Rooms**: *Trompe l'oeil* frescoes by Angelo Michele Colonna

and Agostino Mitelli (1635–1641) and a cabinet by Giovanni Battista Foggini (1709) in pietre dure that Cosimo III gave to his daughter Anna Maria Luisa; **Ivories Collection** from the 17th century including a *Madonna* by Daniel Schenck (1680); an ivory dog given by Cosimo II to his bride Maria Maddalena as a wedding present and vases by Marcus Heiden and Johann Eisenberg.

On the **mezzanine floor** is the **Medici Jewellery Collections** of ancient Roman and Renaissance jewels, gems, and cameos first assembled by Cosimo the Elder and numbering around 1,800 pieces at the death (1743) of the last ruling Medici dynasty heir Anna Maria Luisa, the Electress Palatine. **Exotic treasures** include works in shell and gold and silver from the Treasury of Ferdinand III displayed in the former loggia with painted decoration by Michelangelo Cinganelli (1622). On the ground floor are the two rooms of the **Camera da letto del Granduca Gian Gastone** the bed chamber of the last Medici Grand Duke with displays of amber, ivories and rock crystal objects from the 16th century.

Entry into the **Boboli Gardens** is from the palace courtyard. The gardens were begun by Tribolo for Cosimo I but after his death a year later, work was continued under Bartolomeo Ammannati and later under Bernardo Buontalenti. This is one of the most important high Renaissance style gardens in Italy that were inspired by Pliny's description of his villa at Laurentum disseminated by Leon Battista Alberti in his *De Re Aedificatoria* as a place of retreat but also as a display of power and wealth characterized by terraces accessed from stairs, fountains, sculpture, a wood (*bosco*), grottoes, and a secret garden (*giardino segreto*).

After emerging from the courtyard, Francesco Sussini's **Fountain of the Artichoke** (Fontana del Carciofo) (1641) comes into view. The fountain, named after a sculpture of an artichoke that once crowned it, is elevated to be seen from the piano nobile of the palace. It replaced the allegorical *Juno Fountain* by Bartolomeo Ammannati (1556–1561) now in the Bargello that was removed from Palazzo Vecchio and installed here in 1588. Below the fountain is the entrance to the secret hanging garden, the **Garden of the Camellias** (Giardino delle Camelie) with two grottoes with a porphyry statue of *Moses* that has an ancient torso and planted with camellias in the early 19th century.

The area of the **Amphitheatre** was excavated for stone for the construction of Luca Pitti's original palace. Terence's *Andria* the ancient

Roman comedy (166 BCE) was performed here in 1476. The Medici continued the tradition of staging spectacle entertainment especially for weddings. Jacopo Peri's *Euridice* (1600) that he composed for the wedding celebrations for Marie de Médicis and Henry IV King of France and Navarre was performed in the palace. For the lavish wedding of Cosimo II to Maria Maddalena (1608) the bride arrived at the palace in a triumphal procession and the musical and scenic productions lasted for days including Lorenzo Allegri's *Notte d' Amore* and *The Judgement of Paris* written by Michelangelo's grand-nephew Michelangelo Buonarroti. The amphitheatre was inaugurated in 1637 for the wedding of Fernando II de' Medici and Vittoria della Rovere. The tiered seats evoke an ancient amphitheatre with statues and urns that were added by Giulio and Alfonso Parigi (1630–1634). The *Fountain of Oceanus* now in the Piazzale dell' Isolloto was originally installed in the centre of the amphitheatre.

The Egyptian *obelisk* (1500 BCE) was brought to Rome from Heliopolis for the Temple of Isis. It is the matching pair of the obelisk now near Piazza della Repubblica in Rome commemorating the Battle of Dogali. The obelisk was displayed in the Villa Medici and brought to Florence by Grand Duke Peter Leopold in 1788 and added to the amphitheatre in 1789 in evocation of an ancient circus. It is balanced on tortoises, symbol of the Medici, like the obelisks in Piazza S. Maria Novella. The ancient granite *tub* is from the Baths of Caracalla in Rome and was added in 1880.

The central axis leads up to the **Bacino del Nettuno** a lake created in 1777–1778 with a statue of *Neptune* by Stoldo Lorenzi (1565–1568). Ancient statues are displayed around the lake: the emperor *Septimius Severus*, the goddess *Demeter*, and a *Magistrate* displayed on an ancient funerary altar. To the left of the lake is the Neoclassical **Kaffeehaus** pavillion designed by Zanobi del Rosso (1776) for Peter Leopold that descends to the **Meadow of Ganymede** named for the *Fountain of Ganymede* (17th century) to the Grotto delle Capre.

On the next level from the Bacino del Nettuno on the central axis is the colossal statue of *Abundance* with the features of Joanna of Austria the wife of Francesco I that was begun by Giambologna (1608) but completed by Pietro Tacca and Sebastiano Salvini (1637). It was originally intended for the top of a column in Piazza San Marco (Tour 5) but the project was not realized. The garden borders the walls of the Forte di Belvedere (Tour 9).

To the right is the **Giardino del Cavaliere** with the **Porcelain Museum** (Museo delle Porcellane) in the **Casino del Cavaliere** (*c*.1700) built for Gian Gastone by his father Cosimo III and rebuilt by Zanobi del Rosso for the Lorraine Grand Dukes. The museum displays 18th–19th century porcelain from the Medici and Lorraine collections produced at the leading manufacturers from Italy, Germany, France and England.

Continue to Avenue of the Cypress Trees (Viale dei Cipressi) planted in 1637 in the Prato dell' Uccellare in the area of the gardens designed as hunting grounds at a right angle to the succession of gardens facing the palace. To the left is the **Viottolone** the broad statue-lined boulevard that steeply descends to the Piazzale dell'Isolotto. At the start of the Viottolone are statues of the Athenian *Tyrranicides* with ancient Roman torsos copied from the Greek bronze originals by Kritios and Nesiotes (447 BCE). The ancient Roman statues of a *Divinity* and *Matron* were given to Cosimo I on his visit to Rome in 1560. Midway to the left at the intersection with statues of the *Four Seasons* is the **Ragnaia della Pace**, a covered bower path whose branches resemble a spider web that was used to hunt song birds who flew down the path attracted to the sound of running water at the far end from the **Fontana dei Mostaccini** named for the tiered fountain with *grottesche* heads and were caught in nets. Song birds remain a Tuscan delicacy. The fountain runs along the 13th-century walls parallel to the Viottolone. The bust of *Jupiter* (Jove Olimpico*)* is by Giambologna (*c*.1560).

In the centre of the **Piazzale dell' Isolotto** is the **Isolotto** (basin) designed by Giulio Parigi in 1612 with the **Fountain of Oceanus** by Giambologna (1576) in the centre surrounded by statues of the *Nile, Ganges*, and *Euphrates* rivers that was originally designed for Francesco I and installed in the amphitheatre. The statue by Raffaello Romanelli (*c*.1910) replaced the original statue of *Oceanus* that is now in the Bargello (Tour 4). The *Perseus on Horseback* and *Andromeda* statues are attributed to Giovanni Battista Pieratti. The cultured setting belies one of the fountain's functions. Following the chase of a stag down the Viottolone, hunters would wash the carcass in the fountain. Citrus trees in terracotta pots were cultivated by the Medici in their villas throughout Tuscany, including the Villa Medici in Castello, the childhood home of Giovanni dalle Bande Nere and his son Cosimo I with over 500 specimens.

South of the piazzale is the **Hemicycle** with ancient busts set in the hedge that encloses the **Meadow of the Columns** designed in the English manner with urns on two Roman columns made from Egyptian granite in the centre. Lord Cowper sold the urns to Grand Duke Peter Leopold. At the Porta Romana entrance is a *Perseus* by Vincenzo Danti originally from the Villa Medici di Pratolino.

Exit either the hemicycle or the piazzale by the right path (with the Viottolone behind you) to the Viale della Meridiana that runs parallel to Via Romana outside the garden to return to the amphitheatre. The **Limonaia** (1777–1778) by Zanobi del Rosso was built for the storage of the citrus trees in the Piazzale dell' Isolotto in winter. The garden area in front was formerly a zoo with exotic animals that were preserved after death for display in La Specola. Pope Leo X de' Medici famously kept an elephant named Hanno in the Belvedere Courtyard of the Vatican.

Next to the Limonaia is the **Pallazina della Meridiana**; built for Grand Duke Peter Leopold (1776) it was the residence of the Lorraine Grand Dukes and the House of Savoy until 1946. It is the location of the **Costume Museum** (Museo del Costume) that displays fashion from the 16th century to the present, including garments of Cosimo I and Eleonora of Toledo.

The **Meadow of Pegasus** (Prato del Pegaso) is named for the statue of *Pegasus* made by Aristodemo Costoli (1865). Born from the blood of the Gorgon Medusa in Greek mythology, Pegasus struck his hoof and created Hippocrene the fountain of Mount Helicon that is associated with Apollo and the Muses. With Classical allusions to poetry and inspiration, Pegasus became an important iconographic feature in Renaissance gardens such as the gardens at Villa Lante in Bagnaia (Viterbo) and Villa d'Este in Tivoli.

Retrace your steps to the amphitheatre and continue past the amphitheatre with an iconic view of Brunelleschi's dome that was painted by generations of painters, including Jean-Baptiste-Camille Corot whose *Florence. Vue prise des Jardins Boboli* (*c.*1835–1840) is now in the Louvre.

The **Garden of the Madama** (Giardino di Madama) was laid out by Davide Fortini and Marco del Tasso for Eleonora of Toledo (1553–1555) with statues by Baccio Bandinelli and Giovanni Fancelli. At the end of the garden is the **Grotticina della Madama** also called the Grotto of the Goats (Grotto delle Capre) after the Medici device was designed by Bernardo Buontalenti for Giovanna of Austria (*c.*1570).

The **Grotta Grande** was begun by Giorgio Vasari (1557) but completed by Bernardo Buontalenti (1583–1593) for Francesco I who added Michelangelo's four unfinished *Prisoners* or *Slaves* (1586) that were moved to the Accademia in 1908 (Tour 5) and now replaced with copies. In the inner chamber is a copy of Giambologna's *Venus Emerging from her Bath* (*c.*1570) now in the Bargello and a copy of the *Capitoline Antinous* by Francesco Carradori. The *Paris and Helen* is by Vincezo de' Rossi (1560) suggesting the setting for a romantic rendezvous. The oculus was once topped with a gold fish bowl to refract light inside the grotto.

Walking towards the palace with the grotto behind you is the **Fontana del Bacchino** with Cosimo I's court dwarf Morgante sitting on a tortoise by Valerio Cioli (1560). At the entrance to the **Garden of Jupiter** (Orto di Giove) are two *Dacian Prisoners* in porphyry from a Trajanic monument in Rome that were transferred here from the Villa Medici. The ancient reliefs with figures of *Victories* on the bases come from the Arcus Novus that stood on Via del Corso in Rome (formerly called the Via Lata) near the church of S. Maria in Via Lata. The symbols of Rome's Imperial power communicate the political power now embodied by the Grand Dukes of Tuscany. The seated figure of *God the Father* is by Baccio Bandinelli (1556) for the high altar of the Duomo but was moved here in 1824 when it took on the name of *Jupiter*.

Exit Piazza de' Pitti onto Via Romana that is the continuation of Via de' Guicciardini to enter Piazza San Felice with the church of San Felice to your right. Continue on Via Romana a few steps to La Specola in Palazzo Torrigiani at No. 17 to your left. Just beyond is the **Porta Romana** designed by Andrea Orcagna (1328) with a *giglio* sculpted on the keystone by Giovanni Pisano.

La Specola (Museo di Storia Naturale e Museo Zoologico) the Natural History and Zoological Museum was founded by Grand Duke Peter Leopold and opened to the public in 1775. It is named for the astronomical observatory in the tower. Grand Duke Leopold II commissioned Giuseppe Martelli to design the Neoclassical **Tribune** in Galileo's memory (1841) for whom the Museo Galileo is dedicated (Tour 3). The *statue of Galileo* is by Aristodemo Costoli. The collection reflects the Medici and Lorraine patronage of the sciences that was originally more diverse before the collection of specimens and instruments was spread out between 1870 and 1930 among museums and universities as scientific disciplines developed. Specimens are displayed in 19th-century

glass cases that progress from invertebrates to humans. A now-stuffed hippopotamus was kept as a pet by the Medici in the Boboli Gardens in the area in front of the Limonaia.

The museum is famous for its **anatomical wax figures** of over 1,400 pieces made in the workshop of the museum from 1771 to the end of the 19th century, the best collection in the world. Terracotta figures were also produced and are on display in the Museo Galileo. Among the famous models, is the écorché figure of *lo scorticato,* an anatomical model of a man without skin. The full body figures, such as the anatomical Venus, have wigs and sensual Baroque poses with dissections that reveal their organs and muscle tissues. The wax figures by **Clemente Susini** (from 1773) were important for the study of anatomy before the publication of *Gray's Anatomy* in 1856. Dr. Gray dissected unclaimed bodies from workhouses and hospital mortuaries after the Anatomy Act (1832) but the fear of body snatchers was prevalent in Victorian England and 19th-century North America.

In the centre of **Piazza San Felice** is a marble **column** set up by Cosimo I in 1572 which was removed by Leopold II (1838) and returned in 1992. A marble plaque commemorates the erection of the column on the wall of the house at No. 3 that faces the church.

The church of **San Felice in Piazza** was built in the 14th century by the Benedictine Order on the site of an 11th-century church. The facade with the elegant tympanum over the entrance is by **Michelozzo** (1457–1460). In 1513 it passed to the Camaldolese Order and then to the Dominican nuns of San Pietro Martire in 1552. Restorations to the church following a fire in 1926 exposed the trestle ceiling and returned the choir windows to their original design. In World War II, the church was the site of resistance activity. Ring at No. 6 to see the *Last Supper* by Matteo Rosselli (1614) in the refectory of the convent of the church when classes in the adjoining school are not in session.

The fascinating interior has traces of 14th-century frescoes along the nave walls. On the south side, the fresco of the *Pietà* in the 1st chapel is attributed to Niccolò di Pietro Gerini (1405–1410). In the 5th chapel is a terracotta *Deposition* from the workshop of Giovanni della Robbia (1500–1515). Above are fragments from the 14th-century fresco *Baptism of Christ.* The *Madonna Enthroned with Child and Saints* and the *Eternal Father* in the lunette are by Ridolfo del Ghirlandaio and Toto del Nunziata (*c.*1515). Over the high altar with a triumphal arch by

Michelozzo (1458) is the *Crucifix* by **Giotto** (*c*.1308). The seventh chapel on the north side has the fresco of *San Felice comforting San Massimo* by Giovanni da San Giovanni completed after his death in 1636 by Baldassarre Franceschini also known as Il Volterranno. In the sixth chapel is the fresco of the *Madonna and Child with St. James and St. Sylvester* attributed to the Maestro del Bargello (after 1362) and triptych by Neri di Bici (1467). The painting *Christ Saves St. Peter from a Shipwreck* in the third chapel is by **Salvator Rosa** (*c*.1660). In the first chapel, the triptych is attributed to the school of Botticelli. On the west wall are fresco fragments attributed to Maestro di Signa (1470–1480) and early 18th-century funerary monuments.

From Piazza San Felice, turn left on Via Mazzetta. Within a few steps of the piazza, look up to your right to see the marble plaque that commemorates Elizabeth Barrett Browning's poem ***Casa Guidi*** named for the 15th-century palazzo at No. 8 Piazza San Felice at the corner of Via Maggio that she shared with her husband Robert Browning and their son Pen in a suite of eight rooms on the piano nobile from 1847. The palace was acquired in 1619 by Count Camillo Guidi who served as secretary of state for the Medici. The salon of the Brownings attracted British travellers and literati but the home of Theodosia Trollope, the first wife of English writer Thomas Adolphus Trollope in the current Piazza dell' Indipendenza (then called Piazza Maria Antonia) was also a centre of British culture in Florence for expats. After a sojourn in Rome (1860–1861) the Brownings returned to Florence and Elizabeth Barrett Browning died on 29 June 1861. She was buried in the English Cemetery (Tour 5) and Robert Browning and son Pen returned to England. The Browning Society operates the museum that recreates several rooms from the period of their occupancy.

Follow Via Mazzetta that leads into Via Sant' Agostino past Via Caldaie named for the wool dyers whose shops lined the street to enter the lively Piazza Santo Spirito. The **statue of Cosimo Ridolfi** the founder of the Accademia dei Georgofili is by Raffaello Romanelli (1896). The fountain in the centre was moved here (1812) from the first cloister of Santo Spirito. Facing the piazza is **Palazzo Guadagni** at No. 10 attributed to Simone del Pollaiolo (Il Cronaca) *c*.1505 that was influential for the design of Renaissance palazzi in Florence.

The basilica of **Santo Spirito** with the stark 18th-century facade was designed by **Brunelleschi** for the Augustinian Order (1434–1435) on

the site of an earlier 13th-century church that originally faced the Arno but construction did not begin until 1444 two years before his death. The piazza in front of the reoriented church was created at this time. The campanile with the inscription *Auspiciis Cosmi* ('Under the auspices of Cosimo') is by Baccio d'Agnolo (begun in 1503 and completed in 1570) on an earlier foundation (1490). Bartolomeo Ammannati was commissioned to renovate the church but he only remodelled the second cloister. The convent and its library were important centres for humanism in the 14th and 15th centuries, attracting Boccaccio, Petrarch. Leonardo Bruni, Poggio Bracciolini, and Niccolò Niccoli.

The vast interior on a Latin cross by Brunelleschi is a Renaissance masterpiece on a more ambitious scale than his design for the church of San Lorenzo (Tour 6) but the effect of the perspective achieved through the alignment of the Corinthian columns and spatial proportions is now obscured by the Baroque baldacchino over the high altar. Thirty-eight semicircular niches encircle the interior walls with altars commissioned by leading families, including the Capponi. The Baroque baldacchino is by Giovanni Caccini and Gherardo Silvani (1599–1608). The high altar (1599–1607) with a ciborium in pietre dure is based on the proposed design of the altar for the Cappella dei Principi in San Lorenzo and replaced Brunelleschi's original altar. Salvi d'Andrea completed the cupola (*c.*1480).

In the first chapel on the **south side** is the *Immaculate Conception* altarpiece by Pier Francesco Foschi (1544–1546). The copy of Michelangelo's *Pietà* in the second chapel is by Nanni di Baccio Bigio (1545). In the seventh chapel is the altarpiece *Martyrdom of St. Stephen* (*c.*1602) by Domenico Cresti (Il Passignano). At the corner is the Cappella Della Palla-Portinari with the marble and stucco altarpiece *Raphael and Tobias* (1698) by Giovanni Baratta.

In the second chapel on the west wall of the **south transept** is Pier Francesco Foschi's *Transfiguration* (1545). Along the south wall, in the third chapel is the *Madonna el Soccorso* by Domenico di Zanobi (1475–1485) with the Madonna armed with a stick protecting the child from a demon. Next to it is the Cappella De Rossi designed by Bernardo Buontalenti (1601) with a wooden *Crucifix* that survived a fire in the convent in 1471. In the Cappella Nerli (fifth) is the *Pala Nerli* by Filippino Lippi (1493–1494) with a view of Florence. In the sixth chapel is a copy of Perugino's *Vision of St. Bernard* by Felice Ficherelli (1656)

that is now in Munich. In the Cappella Capponi (seventh) the *Marriage of the Virgin* (1713) by Giovanni Camillo Sagrestani replaced Piero di Cosimo's *Visitation* (*c*.1489) now in the National Gallery of Washington. The sarcophagus of Neri Capponi is attributed to Bernardo Rossellino (1458).

Behind the altar are eight chapels. In the first on the south wall is the *Madonna and Saints* by the Master of the Conversation of Santo Spirito. Next to it, the polyptych *Madonna and Child with Saints* is by Maso di Banco (*c*.1345). In the Cappella Pitti (fourth) acquired by Luca Pitti in 1458 is Alessandro Allori's altarpiece *Eleven Thousand Martyrs* (1574) commissioned by the Pitti family. A portrait of Cosimo I de' Medici is in the centre. In the predella, Luca Pitti is depicted in front of Palazzo Pitti before its acquisition by the Medici. The original altar frontal (*paliotto*) is by Neri di Bicci. Alessandro Allori also painted the altarpiece *Christ and the Adulteress* (1577) in the Cappella Frescobaldi (fifth) that preserves the original 15th-century stained glass tondo and altar front.

Along the east wall of the **north transept** in the eighth chapel is the Sacred Conversation altarpiece by the Master of Santo Spirito identified as brothers Donnino and Agnolo del Mazziere. The *St. Monica enthroned with Augustinian Nuns* altarpiece by Francesco Botticini (1460–1470) in the seventh chapel is also attributed to Andrea del Verrocchio. The *Madonna Enthroned with Child and Saints* altarpiece (sixth chapel) is by Cosimo Rosselli (1482). In the Cappella Corbinelli (fifth) is the marble *Altar of the Holy Sacrament* by Andrea **Sansovino** (1490–1492) with Classical inspiration including its triumphal arch design. In the fourth and third chapels are altarpieces by the Mazziere brothers. On the west wall in the Cappella Segni (second) is the altarpiece *Madonna Enthroned with Child and Saints* (1501–1505) by Raffaellino del Garbo.

The entrance to the **Sacristy** is by a door under the organ and through a vestibule built by Simone del Pollaiolo (Il Cronaca) to designs of Giulio da Sangallo who also designed the sacristy (1489) that shows the influence of Brunelleschi. On display is **Michelangelo**'s *Crucifix* discovered in the church in 1963 that reveals a knowledge of anatomy that he acquired through dissecting corpses under the protection of Prior Niccolò Bicchielli in 1492 when he was 17 years old. The cadavers came from the adjoining **Cloister of the Dead** (Chiostro dei Morti) built by Giulio and Alphonso Parigi the Younger (*c*.1620) that served as a cemetery. The **Large Cloister** (Chiostro Grande) is by Bartolomeo Ammannati (*c*.1565)

with a portico of three arches on each side. The **Cappella Corsini** was the funerary chapel of the Corsini whose family members included Pope Clement XII. The pope is buried in San Giovanni in Laterano in Rome. His funerary monument here is by Gherardo Silvani (1731). The grand Palazzo Corsini is across the Arno (Tour 6).

On the **north side** in the Cappella Dei (seventh chapel) the copy of Rosso Fiorentino's *Pala Dei* now in the Palazzo Pitti is by Francesco Petrucci (1691). Raphael's *Madonna del Baldacchino* (1507) also in Palazzo Pitti was commissioned for the Cappella Dei but it was not finished when he left Florence for Rome. The copy of Michelangelo's *Christ the Redeemer* (1519–1520) in the church of S. Maria sopra Minerva in Rome is by Taddeo Landini (1579). In the first chapel is Pier Francesco Foschi's altarpiece of the *Transfiguration* (1537). On the **west wall** the stained glass oculus with the *Descent of the Holy Spirit* was designed by Perugino.

The entrance to the **Cenacolo di Santo Spirito** is to the left when facing the facade. Since 1946, the former refectory of the church with the damaged fresco of the *Crucifixion* and *Last Supper* by Orcagna (Andrea di Cione) is the seat of the **Fondazione Salvatore Romano**. Named for the collector and antiquarian Salvatore Romano (1875–1955), the collection of late Antique and Romanesque sculpture includes works by Tino di Camaino and sculpture fragments attributed to Donatello and the school of Jacopo della Quercia. Many statues and objects come from the provinces of Puglia and Campania.

Exit Piazza Santo Spirito by returning to the end of the piazza with the statue of Cosimo Ridolfi and turn right on Via S. Agostino (the continuation of Via Mazzetta). Cross Via de' Serragli when the name changes to Via S. Monica. Continue past Via dell' Ardiglione where **Fra' Filippo Lippi** was born in a house behind the convent of Santa Maria del Carmine (there is a plaque on the facade of the house just beyond the archway) through to Piazza del Carmine. The church is to your left and the entrance is on the right hand side of the facade.

The church of **Santa Maria del Carmine** was begun in 1268 and completed in 1476 for the Carmelites whose convent complex was devastated by fire in 1771 and rebuilt by Giuseppe Ruggieri (1775). The **Corsini Chapel** in the north transept in honour of St. Andrew (Andrea) Corsini was built in the Roman Baroque style by Pier Francesco Silvani (1675) for the Saint's descendants Bartolomeo and Neri Corsini with

bronze and marble decoration and reliefs by Giovanni Battista Foggini (1676–1683). The ceiling is by Luca Giordano (1682). In the choir is the *funerary monument of Piero Soderini* the last gonfaloniere of the Republic by Benedetto da Rovezzano (1512–1513).

The decoration of the **Brancacci Chapel** was commissioned by Felice Brancacci (1423), the enemy of the Medici, with the must-see frescoes by **Masaccio** whose innovative style in the frescoes here and his *Trinità* in Santa Maria Novella (Tour 6) influenced the direction of painting in 15th-century Florence. He worked alongside his frequent collaborator the older and less innovative **Masolino da Panicale** until *c*.1427–1428 when he left Florence for Rome where he died in 1428 at the age of 27. Masolino's work was interrupted by the Medici's exile of Felice Brancacci (1436) and the chapel was left unfinished. **Filippino Lippi** (whose father Fra' Filippo Lippi was born nearby and entered the convent as a friar) was influenced by Masaccio's frescoes and completed the chapel decoration in 1480. The frescoes were damaged in the fire of 1771. The altarpiece (*c*.1270) **Madonna del Carmine** revered as the Madonna del Popolo was likely commissioned for the high altar of the original 13th-century church.

The narrative cycle begins with Masolino's *Temptation of Adam and Eve* on the upper level on the right side of the arch and continues on the left side with Masaccio's iconic *Expulsion of Adam and Eve from Paradise*. Continuing to the right on the upper level, Masaccio's *Tribute Money* (left wall); Masolino's *St. Peter Preaching* (left side of altar); Masaccio's *St. Peter Baptising* (right side of altar); Masolino's *St. Peter with St. John Brings Tabitha to Life* and *St. Peter Heals a Lame Man* (right wall) with views of Florence but the figures on the left are attributed to Masaccio.

Returning to the left side of the arch on the lower level is Filippino Lippi's *Liberation of St. Peter from Prison*. Continuing to the right is Masaccio's *St. Peter Enthroned* (left wall) that was completed by Lippi. The figures of Carmelites to the left of the throne are by Masaccio except two of the kneeling figures that are by Lippi. To the right are portraits: Masaccio's self-portrait (man dressed in red) with Brunelleschi behind him, Masolino with the small head and perhaps Leon Battista Alberti in profile dressed in grey. The other scene *St. Peter Bringing the Emperor's Nephew to Life* was begun by Masaccio but completed by Lippi. To the left of the altar is Masaccio's *St. Peter Followed by St. John Healing the Sick with his Shadow* that was discovered when the 18th-century altar

was removed. To the right of the altar is Masaccio's *St. Peter and St. John Distributing Alms*. On the right wall is Filippino Lippi's *Sts. Peter and Paul Before the Proconsul* and the *Crucifixion of St. Peter*. On the arch is Filippino Lippi's *St. Peter in Prison Visited by St. Paul*.

From the church of Santa Maria del Carmine, walk through to the far side of the piazza to Borgo S. Frediano (look up to your left to see the dome of San Frediano). Turn left. Artisan and antique shops are clustered around the **Galleria Romanelli** at No. 70 in the former sculpture studio of **Lorenzo Bartolini** that was acquired by sculptor **Pasquale Romanelli**. At the end of the street is the **Porta San Frediano** attributed to Andrea Pisano (1324) with a section of medieval walls (1284–1333). The church of S. Frediano in Cestello is to your right at the corner of Via di Cestello at No. 12. The entrance is in Piazza di Cestello that faces the Arno River. Turn right on Via di Cestello and walk under the archway to enter the piazza with the **Granary of Cosimo III** by Giovanni Battista Foggini (1695). The entrance to the church is to your right.

The church of **San Frediano in Cestello** with its elegant dome and unfinished facade was rebuilt in a late Baroque style by Antonio Maria Ferri (1680–1689) on the site of an 11th-century church dedicated to the Irish St. Fridianus. Giulio Cerutti and Gheardo Silvani contributed to the church's design. The dome frescoes are by Antonio Domenico Gabbiani (1702–1718) with fresco and stucco decoration in the chapels by Gabbiani and other leading Florentine painters of the late 17th and early 18th centuries. In the third chapel on the north side is the 14th-century wood polychrome statue *Madonna del Sorriso* (Madonna of the Smile). In the **cenacolo** is a *Last Supper* by Bernardino Poccetti.

Retrace steps to Borgo S. Frediano. Turn left and walk past Piazza del Carmine to your right. The name of the street changes to Via di Santo Spirito on the other side of Via de' Serragli that developed as a fashionable area for Florence's elite. At No. 58 red at the bridgehead of the Ponte alla Carraia is the **Palazzetto Medici** with a pietra serena portal and balcony. Across the street is **Palazzo Rinuccini** at Nos. 39–41 built by Giovanni Caccini and Ludovico Cigoli for the Soderini family that was confiscated by Cosimo I de' Medici. The palace includes the Teatro Rinuccini (1753) built for the Rinuccini family and now a public theatre operated by the Province of Florence and the Istituto Lucrezia Tornabuoni. **Palazzo Bardi-Guicciardini** is to your left at No. 14 with a garden overlooking the Arno that was built for Roberto Capponi but confiscated by Cosimo

I de' Medici following the Pucci conspiracy (Tour 6). On the right at No. 23 is **Palazzo Manetti** built for the humanist Giannozzo Manetti. British Ambassador Horace Mann occupied the palace in the 18th century and hosted Florentine and visiting members of the European elite. The facade of the 16th-century **Casa Pitti** at No. 15 was originally decorated by Bernardino Poccetti. Next to it is **Palazzo Frescobaldi** at Nos. 11–13 (1621–1644) with a large courtyard garden. The 15th-century **Palazzo Machiavelli** at the corner of Via de' Coverelli at Nos. 5–7 was owned by the Machiavelli family that lived on Via de' Guicciardini.

Continue past Via Maggio when the name changes to Borgo San Jacopo past Palazzo Frescobaldi and the church of **San Jacopo sopr'Arno** to your left founded in the 10th century and later given a Romanesque portico (12th–13th century) that was removed from the church of San Donato in Scopeto destroyed in the siege of Florence in 1529. The church with fresco decoration from the 17th and 18th century by Florentine artists is often used for concerts.

Via dei Romaglienti to your right was formerly known as the Via dei Giudei where Jews were first settled in the 15th century. The dark narrow street gives a sense of the **Old Jewish Quarter** since the later Jewish Ghetto was demolished for the construction of Piazza della Repubblica (Tour 7). The street is similar to the streets in the former Ghetto of Rome established by Pope Paul IV Carafa following the migration of Jews from Trastevere to the other side of the Tiber River over the previous centuries. Cosimo I de' Medici relocated Jews to the area of Piazza della Repubblica after he took up residency in Palazzo Pitti at which time Via Maggio and other streets in the area became fashionable for courtiers.

At the end of the street at Via de' Guicciardini in a niche of the Torre dei Rossi-Cerchi to your right is a copy of Giambologna's *Bacchus*. The original is in the Bargello (Tour 4). It was formerly part of a fountain with a Roman sarcophagus for the basin that was destroyed in World War II. The Ponte Vecchio is to your left for the start of Tour 9 but turn right on Via de' Guicciardini to enter Piazza Santa Felicità. Via de' Guicciardini is named for the historian **Francesco Guicciardini** (1482–1570) who wrote the *Istorie Fiorentine* (1508–1509) Florentine histories from the Ciompi revolt (1378) to the Battle of Agnadello (1509). He was born at No. 15 in Palazzo Guicciardini-Benizzi.

Piazza Santa Felicità marks the terminus point of the Roman consular road, the **Via Cassia** (123 CE) on the south side of the Arno

River. The granite **column** in the centre of the piazza was erected by the Benedictine nuns of the convent of Santa Felicità in 1381 on the site of an ancient pyramid monument that was most likely a pagan tomb that lined the Via Cassia outside the city gate with other tombs where the church of Santa Felicità was founded. Its proximity to the gate recalls several pyramid tombs in ancient Rome constructed after Augustus' victory over Cleopatra and Mark Antony at the Battle of Actium in 31 BCE that were located outside the city walls close to city gates, such as the *Pyramid of Gaius Cestius* at the Porta San Paolo in Piazzale Ostiense. Christian funerary inscriptions from the 5th century were discovered at the same necropolis site as the pyramid with names that indicate the area was occupied by Syrian Greek merchants in the 2nd century CE.

Just beyond the piazza to your right at No. 18 Via de' Guicciardini is **Palazzo Machiavelli** the family home of the Machiavelli family where the author and politician **Niccolò Machiavelli** (1469–1527) died. Machiavelli was exiled by the Medici for his role in the coup that led to their exile (1498–1512). He wrote his famous *The Prince* (1513) in exile at his family estate in Sant' Andrea in Percussina. Among other literary works, he wrote an *Istorie Fiorentine* (1526), Florentine histories that covered more periods than the histories written by his friend Francesco Guicciardini, from the fall of the Western Roman Empire to the death of Lorenzo the Magnificent (1492). It was commissioned by Pope Clement VII de' Medici and published in 1532, two years after the author's death. He is buried in the church of Santa Croce (Tour 4).

The church of **Santa Felicità** (St. Felicity) was founded in 405 only a few years after the consecration of the Basilica of San Lorenzo in 393 (Tour 6). Both churches are of early date for the founding of churches in Italy and both were built outside the walls of ancient Florentia like the first basilicas in Rome founded by Constantine that were built on Imperial property outside the Aurelianic Walls: San Giovanni in Laterano (*c.*313–318) and St. Peter's (consecrated 326). The construction of Christian churches did not end pagan worship immediately: the College of the Vestal Virgins in the Roman Forum in Rome was closed by Coelia Concordia, the last Vestal Virgin in history in 394. The church designed by Ferdinando Ruggieri (1736–1739) was built on the site of the Benedictine church. The **Corridoio** of Vasari passes along the front of the church facade. St. Felicitas of Rome was martyred in Rome (*c.*165) under the reign of emperor Marcus Aurelius with her seven children and is

often confused with the mother of the Maccabees in the Old Testament. Another St. Felicitas was martyred with St. Perpetua in the amphitheatre of Carthage (203 CE).

On the south side, in the **Cappella Capponi** (first chapel) are famous paintings by **Pontormo** painted from 1525 to 1528 for Ludovico Capponi who bought the chapel from the Barbadori family and altered the original design by Brunelleschi (1419–1423). Several palaces were owned by the Capponi on Via de' Bardi behind the church (Tour 9). Pontormo was the student of Andrea del Sarto and these stylized paintings are synonymous with the Mannerist style of Renaissance art. On the wall with the window is the fresco *Annunciation* in which Gabriel's dynamism contrasts with the Virgin's *contrapposto* pose. Over the altar is the oil painting *Deposition* with a counter-clockwise vortex of figures in pastel coloured clothing. Pontormo painted the tondi of the *Evangelists* in the cupola that are also attributed to his student Bronzino.

In the fourth chapel on the south side is the altarpiece *Martyrdom of the Maccabee Brothers by Antonio Ciseri* (1863). The sanctuary was designed by Cigoli (Ludovico Cardi) the friend of Galileo for the Guicciardini family and contains the **Tomb of Francesco Guicciardini** (1540). He also designed the Choir Chapel (1610–1622). The high altarpiece *Adoration of the Shepherds* is by Lorenzo Viani (called Lo Sciorina). The sacristy was designed by Brunelleschi and built after his death by Giovanni Canigiani (1470). On display is a *Madonna and Child with Saints* polyptych by Taddeo Gaddi (*c.*1355) and Neri di Bicci's *Santa Felicità and her Sons* (*c.*1465). At the beginning of the north side, the Cappella Canigiani decorated by Bernardino Poccetti (1589–1590) was built to match the Capponi chapel opposite. In the **Chapter House** are the *Crucifixion* of Niccolò di Pietro Gerini (1387) and a collection of Christian funerary inscriptions from the ancient necropolis in the area of Piazza Santa Felicità.

Retrace your steps to the Ponte Vecchio to return to Piazza della Signoria (Tour 3) or to stay on this side of the Arno to begin Tour 9 for a stroll up to San Miniato al Monte and Piazzale Michelangelo.

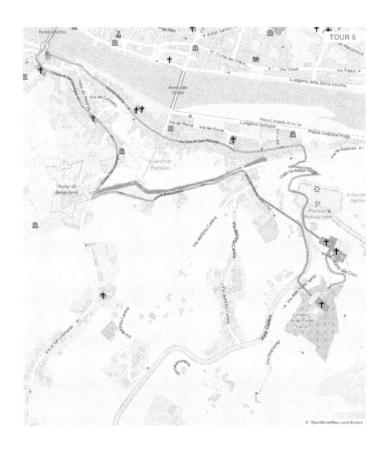

Sites: Ponte Vecchio, Piazza Santa Felicità, House of Galileo, Villa and Giardino Bardini, Porta San Giorgio, Forte di Belvedere, Porta San Miniato, San Miniato al Monte, Cimitero delle Porte Sante, San Salvatore al Monte alle Croci, Piazzale Michelangelo, Porta San Niccolò, San Niccolò oltr'Arno, Palazzo de' Mozzi, Museo Bardini, Palazzo Torrigiani, Via de' Bardi.
Distance: 3.2 km

Ponte Vecchio to
San Miniato al Monte

A tour of Oltrarno east of Palazzo Pitti that begins and ends at the Ponte Vecchio that takes you outside the medieval gates to the House of Galileo. From the Villa Bardini are garden terraces overlooking the historic city centre. Continue the journey uphill to the Forte di Belvedere and the hilltop church of San Miniato al Monte that is one of the most beautiful and unspoiled Romanesque churches in Tuscany. There are panoramic views of the historic city centre and surrounding hills from Piazzale Michelangelo.

Stroll back to the Ponte Vecchio on the historic streets of Via di San Niccolò with palazzi belonging to the Capponi family and Via de' Bardi that is lined with palazzi associated with the famous Bardi banking family and the feud between the Guelphs and Ghibellines. Tour 10 to Fiesole offers more hilltop views outside the city centre and traces of Florence's Etruscan and Roman past.

The iconic **Ponte Vecchio** was designed by Neri di Fioravante (1345) to replace several wooden versions of the bridge that collapsed due to flooding in 1117 and 1333 since the construction of a Roman bridge that crossed the Arno from the Via Cassia, the consular road that connected ancient Rome to Florence. The bridge provided the only crossing point over the Arno until the construction of the Ponte alla Carraia in 1218 (Tour 6). The Ponte Santa Trìnita was first built in 1252 (Tour 7). Over the shops on the east side, the **Corridoio** of Vasari built for the Medici, passes across the bridge and past the **Torre dei Mannelli** on the south end (the only one of four towers originally built on each corner of the bridgeheads to survive) to connect Palazzo

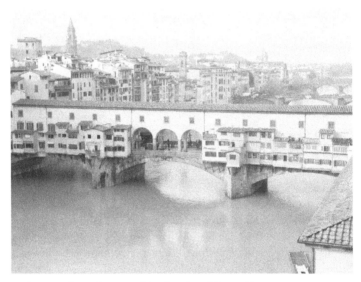

12. Ponte Vecchio with a view of the *Corrodoio* of Giorgio Vasari

Pitti (Tour 8) to the Uffizi and Palazzo Vecchio (Tour 3). The world famous jewellery shops with medieval store fronts (*madielle*) moved here from the area of Via Porta Rossa after the butchers from the Arte della Lana ai macellai e verdurai formerly located on the bridge were moved in the 16th century. The bronze portrait bust of famous goldsmith *Benvenuto Cellini* is by Raffaello Romanelli (1900). On the opposite side of the bridge is a plaque that commemorates the location where Buondelmonte de' Buondelmonti was killed (1216) during his wedding procession (Tour 7). It is the only bridge in Florence not bombed by retreating Germans (1944) in World War II.

From the Oltrarno side of the Ponte Vecchio there are two options. For a scenic stroll to San Miniato al Monte, walk straight through to Piazza Santa Felicità on Via de' Guicciardini. Exit the piazza through the arch into Piazza dei Rossi and take Costa San Giorgio (on the right hand side) that winds its way up the hill past the church of **Ss. Girolamo e Francesco alla Costa** to your right at No. 39 that was restored 1515–1520 for Cardinal Antonio Pucci, the Bishop of Pistoia. Continue past the church of **S. Giorgio alla Costa e dello Spirito**

Santo to your right at No. 32 that was redesigned by Giovanni Battista Foggini on medieval foundations (1705–1708) with a gold and white stucco Baroque interior. To your right at No. 19, is the House of Galileo Galilei.

If you would prefer to reach San Miniato al Monte by the most direct route, from Ponte Vecchio, turn left on Via de' Bardi and continue when the name changes to Via di San Niccolò beyond Piazza de' Mozzi. Turn right on Via di San Miniato al Monte to arrive at the Porta San Miniato and follow tour directions from there. The stroll down from San Miniato al Monte will retrace this route with descriptions of sites and monuments.

The **House of Galileo Galilei** with its painted facade has a marble plaque over the main door that acknowledges the majesty of Grand Duke Ferdinando II who protected Galileo during his trial for heresy and secured a sentence of house arrest for him in place of imprisonment. Galileo purchased this house in 1634 perhaps hoping to return to Florence but he lived at his Villa Il Gioiello in Arcetri from 1633 until his death in 1642.

Continue up the hill around the next bend. The entrance to the **Villa Bardini** and the **Giardino Bardini** is to your left at Costa San Giorgio No. 2. They may also be accessed from Via de' Bardi No. 1 on the stroll down from San Miniato al Monte. The Villa Bardini was built by Gherardo Silvani (1641) for Francesco Manadori and originally called the Villa Manadora. English style gardens were added to the original Baroque terraces with panoramic views of the city when ownership of the villa passed to Giacomo Le Blanc. It was next bought by the Mozzi (1839) to serve as the garden for the adjacent Palazzo de' Mozzi on Via di San Niccolò. Stefano Bardini bought the villa and the Palazzo de' Mozzi from the Austrian Prince Carolath-Beuthen in 1913 and restored the villa that was renamed for him. The villa is home to the **Museo Roberto Capucci** and the **Museo Pietro Annigoni**. Currently, the Giardino Bardini may be visited on the same entrance ticket to the Boboli Gardens.

Continue through **Porta San Giorgio**. This is the oldest surviving gate in Florence (1260). The interior contains a fresco *The Virgin with St. George and St. Leonard* by Bicci di Lorenzo (1460). Look up on the other side of the arch to see a copy of the frieze of San Giorgio (the original is in Palazzo Vecchio) and the fleur-de-lys decoration on the

capstone of the arch. The **Forte di Belvedere** (entrance to your right at Via San Leonardo No. 1) was built as the Fortezza di San Giovanni Battista by Antonio da Sangallo the Younger for Pope Clement VII de' Medici (1534–1537) within the 13th-century walls. Michelangelo assisted in the design of the fortifications in 1529 while he was in Florence working on the Medici Chapel in the church of San Lorenzo despite his friendship and the patronage of Pope Clement VII de' Medici who later excused his participation in the rebellion of 1530. After the Medici moved their residence to Palazzo Pitti from Palazzo Vecchio, the hill was further fortified by Bernardo Buontalenti for Grand Duke Ferdinand I (1590) to allow a place of retreat for the Medici accessible from the Boboli Gardens in case of an attack on the city but it later became a refuge with a panoramic view of the surrounding hillside from the Palazzetto in the centre and ramparts.

Make a sharp left at Porta San Giorgio to round the corner onto Via di Belvedere (there is no street sign) to walk in the opposite direction from which you were walking with the wall to your left for the stroll down the hill. There is light traffic coming up the hill in the opposite direction but the walk is pleasant with olive trees and square towers to your left. Look into the distance for a view of Porta San Niccolò. At the bottom of the hill in an arch of the wall is the 14th-century **Porta San Miniato**.

With Porta San Miniato to your left as you reach the bottom of the hill, turn right on Via del Monte alle Croci to the base of the terraced steps that will take you to San Miniato al Monte. Like St. Denis, St. Minias is represented as a cephalophore and according to tradition, after his martyrdom (*c.*250) he carried his decapitated head up the steep hill. A plaque commemorates Dante's climb and as you make your way up, turn around for views of the Duomo and Palazzo Vecchio. Behind the fence to your right are the altars of the *Way of the Cross* propagated by St. Leonard of Port Maurice in the 17th century throughout Italy that give the hill known as the *Mons Florentinus* the name of **Monte alle Croci**. St. Leonard was invited to the monastery by Grand Duke Cosimo III de' Medici. A rose garden with sculpture by Jean-Michel Folon (died 2005) is visible on the opposite side.

When you arrive at Viale Galileo Galilei, the church of San Salvatore al Monte is straight ahead and a bronze copy of Michelangelo's *David*

in Piazzale Michelangelo is to your left but to visit San Miniato al Monte first, turn right and walk on either side of the road to reach the final flight of steps in white travertine (19th century) leading up to the church past a cemetery (1839). From the terrace is a panoramic view of Florence.

The construction of the Basilica of **San Miniato al Monte** on the site of St. Minias' tomb was begun by Bishop Hildebrand in 1018 for the Benedictine Cluniac Order whose monastery was also founded here but construction continued until 1063. The monastery was wealthy and owned wool mills (from 1164) along the banks of the Arno near Porta San Niccolò. The monastery complex passed to the Olivetan Order (1373) but returned to the Cluniac Order in 1924. Together with the Baptistery (Tour 2), it is one of the most important Romanesque buildings in Tuscany. The Romanesque **facade** (begun *c.*1290) with a green and white marble geometric design inspired by the Baptistery influenced the decoration of Santa Maria Novella (Tour 6). In the aedicule is a 13th-century mosaic restored in 1861 depicting *Christ between the Virgin and St. Minias*. On top is a gilded eagle, the emblem of the Arte di Calimala that administered the church since 1288, with outstretched wings standing on a bale of cloth.

The Romanesque interior is largely untouched since its construction with wood beam ceiling, cosmatesque pavement, and a raised choir above the crypt. Beautiful 13th to 15th-century frescoes of *Saints* and other scenes in various states of preservation line the south and north aisle walls. The *Madonna Enthroned with Six Saints* at the start of the **south side** is signed by Paolo Schiavo (1436).

On the **north side** is the beautiful **Chapel of the Portuguese Cardinal** (Cappella del Cardinale del Portogallo) that was completed in 1473 in honour of Cardinal Jacopo di Lusitania who died in Florence (1459) at the age of 25. Brunelleschi's student Antonio Manetti began construction of the chapel that was inspired by the Old Sacristy of San Lorenzo (Tour 7). Construction was likely completed after his death by Antonio Rossellino who carved his tomb (1461–1466), perhaps with the assistance of his brother Bernardo. The five ceiling medallions of the *Cardinal Virtues* and the *Holy Spirit* are by Luca della Robbia (1461). The altarpiece of *Sts. Vincent, James, and Eustace* is a copy of the original by Antonio Pollaiolo with his brother Piero (1466–1468) that is now in the Uffizi (Tour 3). The fresco decoration on the wall

behind it is also by Pollaiolo. Above the bishop's throne by Manetti is an *Annunciation* by Alesso Baldovinetti (1466–1473) who also painted the frescoes of the *Evangelists* and *Fathers of the Church* in the lunettes and spandrels.

At the end of the nave (cordoned off to preserve the cosmatesque floor) is the **Cappella del Crocifisso** with painted cabinet panels by Agnolo Gaddi (1394–1396). Inside, is the *Crucifix* that miraculously bowed to St. John Gualbert, founder of the Vallombrosan Order of Benedictines after he pardoned his brother's assassin. Piero the Gouty de' Medici commissioned Michelozzo to design the **tabernacle** in 1448. The enamelled terracotta roof and ceiling are by Luca della Robbia and the copper eagles by Maso di Bartolomeo.

The raised **choir** is up the stairs past the fresco of the *Virgin Annunciate* and fragment of a *Nativity Scene* (13th century). The marble screen (transenna) and pulpit date from 1207 and the carved stalls from 1466 to 1470. Six spoliated Roman columns are incorporated into the **apse** with a mosaic of *Christ between the Virgin and St. Minias with symbols of the Evangelists* (1297). Behind the **altar** is a *Crucifix* attributed to della Robbia. The altarpiece to the right of the apse with *Scenes from the Life of St. Minias* is by Jacopo del Casentino. The entrance to the **Sacristy** (1387) with fresco decoration by Spinello Aretino is on the choir level that is also accessed by the staircase at the end of the south aisle. On the walls of the choir outside of the sacristy are frescoes of *Saints* (13th century). In the **crypt** (11th century) with columns supporting the raised choir and fresco decoration by Taddeo Gaddi is an altar (11th century) containing the relics of San Miniato. On the **west wall** are the *tomb of the poet Giuseppe Giusti* (1800–1850) and the *funerary monument to artist Giuseppe Bezzuoli* (1784–1855) by Emilio Santarelli.

The **cloister** (begun *c*.1425) is to the right of the church (facing the facade). On the upper loggia are frescoes, including the damaged frescoes in *terraverde* by Paolo Uccello. The sinopie are displayed in a room off of the cloister with a fresco fragment attributed to Andrea del Castagno and a fresco signed by Bernardo Buontalenti (16th century). Also to the right of the church is the **Bishop's Palace** (1295) with a crenellated roof that served as the summer residence of the Bishops of Florence from the 14th to the 16th centuries. Before the complex was returned to the Benedictines, it was used as barracks

and a hospital. On the left side of the piazza facing the church is the **Farmacia** (pharmacy) that contains gift items and extracts made by the monks recalling a garden's historic function as a source of medicine.

The entrance to the **Cimitero delle Porte Sante** is to the left of the church facade. The cemetery was laid out in 1854 by Niccolò Matas, the Jewish architect who designed the marble facade of Santa Croce (Tour 4) and contains unique funerary monuments with portraits and family vaults in various styles, including Neoclassical and neo-Gothic that line the paths. Buried here is Carlo Collodi (the pen name of Carlo Lorenzini) the author of *Pinocchio*, sculptor Libero Andreotti (1875–1933) and John Temple Leader (1810–1903) who died at Piazza de' Pitti No. 14.

From the cemetery entrance area, exit through the gate in the wall to begin the descent down the hill. The path directly in front of the gate is difficult to walk down so walk down the winding Via del Monte alle Croci to reach San Salvatore al Monte alle Croci that is straight ahead in the centre of a Cypress grove.

San Salvatore al Monte alle Croci was built by Simone del Pollaiolo (Il Cronaca) the architect of Palazzo Strozzi (Tour 6) for the Franciscan Order Friars Minor on land donated by Luca di Jacopo del Taso (1417). Construction was funded by the Quaratesi family and the Arte di Calimala that both shared the eagle emblem incorporated throughout the church. The Nerli family was also a benefactor of the church. The hilltop location appealed to Lorenzo the Magnificent who planned a cultural centre around the church as an Acropolis in imitation of Athens, Greece. The monastery was an important centre for Franciscans: San Bernardino of Siena lived in the friary with his early disciples, including San Giacomo della Marca (St. James of the Marches). Botticelli's *Madonna and Child with Angels* (*c*.1478) formerly in the church is now in the Gemäldegalerie, Berlin. Michelangelo called this church his 'pretty country maid' (*la mia bella villanella*) and the alternating tympanum design over the windows of alternating semicircles and triangles influenced Renaissance architecture including his own designs.

The stark interior, the first to use a superimposed double architectural order has chapels on both sides of the single nave. Perugino designed the stained glass windows (after 1506), including *God the Father* with the

emblem of the Peruzzi family over the south entrance. The **altar** contains relics of St. Francis but the cloak that he wore during his stigmatization brought here from Castello di Montauto (1503) was returned to the Sanctuary of La Verna in 2000. The painted wooden *Crucifix* is by Andrea di Pietro Ferrucci (*c.*1506). On the left wall of the sanctuary is a *Madonna Enthroned* painting by Giovanni da Ponte (1434).

At the end of the north side is a *Pietà* painting by Neri di Bicci (after 1475). Just beyond, over the entrance to the Nerli Chapel is a painted terracotta *Pietà* by Giovanni della Robbia (*c.*1509). Opposite at the end of the south side are panels with *Sts. Cosmas and Damian, St. Francis and St. Anthony of Padua* by Rossello da Jacopo Franchi, a student of Lorenzo Monaco. On the west wall is the *Funerary monument to Marcello Adriani*, the humanist and politician, by Andrea Ferrucci (*c.*1526).

From the church, follow the path that winds from the front of the church to Viale Galileo Galilei. Turn right to enter the broad terrace of **Piazzale Michelangelo** designed by Giuseppe Poggi (1875) with a monument that he designed to Michelangelo with a bronze copy of his *David* and statues from the Medici tombs in San Lorenzo (Tour 6). The piazzale offers sweeping views of the city centre and surrounding hillsides, including Fiesole (Tour 10). Equally impressive views are available from terraces on the lower tiers on the descent down to Piazza Giuseppe Poggi at the base of Porta San Niccolò.

To reach the piazza below, exit Piazzale Michelangelo either by the staircase at the centre or the steps to the left as you enter from Viale Galileo Galilei passing the entrances to the **Iris Garden** (Giardino dell' Iris) and **Rose Garden** (Giardino dell Rose) on the left side. Continue down the slope of the hill by walking across several ramps keeping an eye on Piazza Giuseppe Poggi at the base of the towering Porta San Niccolò as your destination.

The **Porta San Niccolò** in Piazza Giuseppe Poggi (1865–1876) was built in 1324 and is the only intact tower in Florence retaining its original height. The medieval walls were demolished for the construction of the piazza. In the lower arch is a fresco (15th century) of the *Madonna and Child with St. John the Baptist and San Niccolò of Bari*.

From Piazza Giuseppe Poggi, exit onto Via di San Niccolò that is lined with medieval houses and buildings with artists' studios, galleries,

and printing presses. It follows the course of an ancient Roman road that continues on Via de' Bardi. At No. 2 is the deconsecrated Oratorio dei Buonomini.

To your right is the church of **San Niccolò oltr'Arno** with a large oculus window in the facade that was founded in 1184 and remodelled several times, including by Giorgio Vasari. A popular legend relates that Michelangelo hid from the Medici at the base of the campanile following his role in the siege of 1530. A flood marker on the left side of the facade indicates the water level of the flood of 1557. On the side wall facing Via dell' Olmo is a water marker from the flood of 1966 that caused extensive damage to the interior of the church. Restoration of the 16th-century altars (with paintings by Alessandro Allori, Giovanni Battista Naldini, Jacopo da Empoli, Il Poppi, and others) in the single nave interior revealed 15th-century fresco decoration, including the first altar on the south side with a fresco and its sinopia of *St. Ansanus* attributed to Francesco d'Antonio. On the second altar is a painted wooden *Crucifix* attributed to Michelozzo.

There is a collection of paintings in the **sacristy** located in the Quaratesi Chapel (15th century), with the *Madonna della Cintola* (1450) that is attributed to Alesso Baldovinetti, Michelozzo and others. Also here is the *Madonna and Saints* (1440) by Bicci di Lorenzo and *Trinity with Four Saints* (1463) by his son Neri di Bicci. The polyptych of the *Virgin and Jesus interceding before the throne of God the Father* with side panels of *Saints* is by Gentile da Fabriano who also painted the original polyptych for the high altar also commissioned by the Quaratesi family that is now in the Uffizi.

Behind the church is **Palazzo Serristori** (1520–1522) in Piazza Demidoff with a monument to Count Nikolai Demidoff (1774–1828) who occupied the palace in 1822. Napoleon's brother Joseph Bonaparte lived in exile in the palace until his death in 1844. The palace was built for the Bishop of Bitetto Lorenzo Serristori whose nephew Averardo served as a diplomat for Cosimo I and built an Italian-style garden along the banks of the Arno that was altered in the 19th-century to an English-style garden.

Continuing on Via di San Niccolò beyond Via dell' Olmo with the studio of contemporary artist Clet Abraham at the corner (famous for his stick figures that appear on traffic signs throughout Florence) are several 14th-century palazzi that were modernized in

later periods. At No. 24 red is the **Fondazione Il Bisonte**, an early international graphic arts and print making gallery and school. At No. 54 is the 16th-century **Palazzo del Rosso Vitelli** and next to it at No. 56 is **Palazzo Demidoff** with an 18th-century facade by Alfonso Parigi. **Palazzo Alemanni** at No. 68 has demon decoration copied from Giambologna. Beyond the fortified **Torre Quaratesi** at No. 87 is **Palazzo Vegni** (14th century) with 17th-century alterations and **Palazzo Cambiagi** at No. 68 with 19th-century alterations. **Palazzo Nasi** at No. 99 (14th century with original colonnade in the courtyard) was altered in the 15th century and given a new facade in the 16th century by Baccio d'Agnolo. There is another **Palazzo Nasi** at No. 107 and beyond, at No. 117 is **Palazzo Pecori Giraldi**.

Just before you enter into Piazza de' Mozzi to your right that connects to **Ponte alle Grazie** (formerly called the Ponte Rubaconte) and the area of Santa Croce on the north side of the Arno, **Palazzo de' Mozzi** is to your left at No. 2. The Mozzi were members of the Guelph party and built several palaces on the site of earlier palaces destroyed by the Ghibellines in 1260. The first palace with battlements facing the Arno was built from 1266 to 1273 and hosted Pope Gregory X in 1273 when he negotiated a truce between the Guelphs and Ghibellines on the way to Lyons for the *Second Ecumenical Council* in 1274. The Mozzi bought the Villa Manadora in 1839 that was later bought by the antiquarian and art dealer Stefano Bardini in 1913 and renamed the Villa and Giardino Bardini.

Facing the long piazza is the **Museo Bardini** in Palazzo Corsi Bardini with the adjacent church of **San Gregorio della Pace** (13th century) built in honour of Pope Gregory X. The entrance is at the far end of the piazza on Via dei Renai No. 37. Stefano Bardini bought the palace complex from the Mozzi in 1881 for use as an art gallery. He left his eclectic collection of over 3,600 works of art, architecture, rugs, and leather goods to the Comune of Florence in 1922 that includes architectural pieces saved from the demolition of buildings that were cleared for the construction of Piazza della Repubblica and other areas of the historic centre.

The **ground floor** is dedicated to the history of Florence and works of art once displayed in public. Beyond a *Head of a Woman* by Nicola Pisano is the main hall with Tino di Camaino's *Charity* (1311–1313). In the room with Giambologna's bronze *Diavolino* commissioned by

Bernardo Vecchietti for an exterior corner of his palace on Via Strozzi is Pietro Tacca's bronze version of *il Porcellino* from the Mercato Nuovo (Tour 7). In the former church of San Gregorio della Pace is a collection of arms and armour. On the **mezzanine floor** is the Room of the Madonnas with two works by Donatello: the *Madonna dei Cordai* (*c.*1443) and his relief *Madonna and Child*. On the **second floor** are Antonio Pollaiolo's painted standard of *St. Michael* (*c.*1465) and Guercino's *Atlas* (1645–1646). An important collection of Persian and Turkish rugs is displayed on the staircase leading to a room with a wooden *Crucifix* by Bernardo Daddi.

Also in Piazza de' Mozzi is **Palazzo Torrigiani** at Nos. 4 and 5 comprising of two palaces built for the Nasi family (*c.*1540) and bought by the Torrigiani in the 19th century. A facade of the palace faces the Arno and gives its name to the Lungarno Torrigiani along the river.

Beyond Piazza de' Mozzi, the name of Via di San Niccolò changes to **Via de' Bardi**. The Bardi owned palazzi and fortified strongholds near the bridgehead of Ponte alle Grazie on the Oltrarno side of the Arno that were destroyed in the popular uprising against wealthy aristocrats in Oltrarno, including the Frescobaldi, Rossi, and Nerli in 1343, the year before the Bardi and Peruzzi banks collapsed due to unpaid loans to King Edward III of England. As a consequence, the Duke of Athens was invited to rule the Signoria by the Guelphs but he was ousted for putting financial strains on the aristocrats and merchants that had invited him. The Bardi were exiled and returned as the Dukes of Vernio with the support of Holy Roman Emperor Charles IV to the area of Oltrarno in Palazzo Tempi and later to Palazzo Bardi-Tempi and Palazzo Busini-Bardi (Tour 4) on the north side of the Ponte alle Grazie bridgehead in the area of Santa Croce. The nobility of the Bardi helped them to maintain their status in diplomatic and commercial activities and in the following century Cosimo the Elder's marriage to Contessina de' Bardi in 1415 elevated the status of the Medici. The Bardi remained allies with the Medici Grand Dukes. Pandolfo Bardi was confidant to Francesco I's affair with Bianca Cappella and his brother secretly married them shortly after the death of Joanna of Austria (Tour 7). The Bardi funded the voyages of Christopher Columbus and John Cabot to America.

To your left at No. 1 is an alternate entrance to the **Giardino Bardini**. Continue on Via de' Bardi passing the church of **Santa Lucia dei Magnoli** at No. 24 with a painting of *St. Lucy* by Pietro Lorenzetti. The **tabernacle** across the street commemorates a visit by St. Francis of Assisi during his first visit to Florence in 1211. At No. 30 is **Palazzo Larioni dei Bardi** with a courtyard begun by Michelozzo. The Capponi family that commissioned Pontormo to decorate their chapel in the church of Santa Felicità (Tour 8) owned several palaces on the street. **Palazzo Capponi Canigiani** at Nos. 28–30 attributed to Michelozzo was built on the site of the 13th-century Ospedale di Santa Lucia. The terracotta **tabernacle** of the *Madonna and Child with St. John the Baptist* is by Giovanni della Robbia. To the left of the portone is a plaque commemorating the Renaissance sculpture scholar Sir John Pope-Hennessy (1913–1994) who resided here. Across the street on the wall is a plaque (1565) with a Latin inscription stating Cosimo I's order that houses that had collapsed not be rebuilt on the unstable hillside. One of the palaces destroyed in the landslide of 1547 was **Palazzo Nasi** with Raphael's *Madonna of the Goldfinch* (*c.*1505–1506) that he painted for his friend Lorenzo Nasi who married Sandra Canigiani. The painting was damaged but repaired immediately and later sold to Cardinal Giovanni Carlo de' Medici in 1639. Today, it is in the Uffizi.

The **Palazzo Capponi delle Rovinate** is to your right at No. 36 and takes its name from the unstable hillside prone to collapsing. It is also called Palazzo Capponi-da Uzzano since it was built (1406–1426) for the Gonfaloniere of Justice **Niccolò da Uzzano** possibly by Lorenzo di Bicci with assistance by Filippo Brunelleschi and the palace passed to the Capponi through marriage with Niccolò da Uzzano's daughter. At the base of the staircase is an ancient Roman *lion statue* in porphyry (2nd century CE). Its matching pair is in the Metropolitan Museum of Art, New York. The Capponi art collection that is displayed in rooms decorated in the 18th and 19th centuries includes works by Salvator Rosa, Pontormo and Suttermans. The portrait bust of *Niccolò da Uzzano* by Donatello is in the Bargello (Tour 4).

Beyond the open space along the Arno is **Palazzo Tempi** at the corner of Piazza S. Maria sopr'Arno No. 1. The palace was first owned by the Bardi and was the principal residence of the family on Via de' Bardi upon their return from exile. The palace is associated with the

legend of Dionora de' Bardi, daughter of Amerigo de' Bardi (also known as Leonora and Dianora) with whom Ippolito de' Buondelmonti, from a rival family, fell in love. Like the Trojans of Classical mythology, the beauty of the Buondelmonti was proverbial. According to the famous romance, after concealing their engagement from their families, Ippolito was caught in the vicinity of the palace or descending a rope ladder from the palace and to protect the identity of Dionora he claimed that he was there to rob or assassinate her father depending on the version. Sentenced to die, he was spared when Dionora halted the procession to his execution by announcing their engagement. They were married avoiding more animosity between the warring factions. It passed to the Medici as part of Contessina's dowry to her marriage to Cosimo the Elder. Subsequent ownership passed to several families including the Capponi until it was bought by the Tempi in the 17th century who commissioned Matteo Nigetti to renovate it.

The church of **S. Maria dei Bardi** also called S. Maria sopr'Arno that was built in 1229 was suppressed in 1785 and demolished in 1869 for the construction of the Arno embankment. The area beyond the church was largely rebuilt in the 1950s following extensive damage caused by retreating Germans in 1944.

Proceed into Piazza S. Felicità. The Ponte Vecchio is to your right.

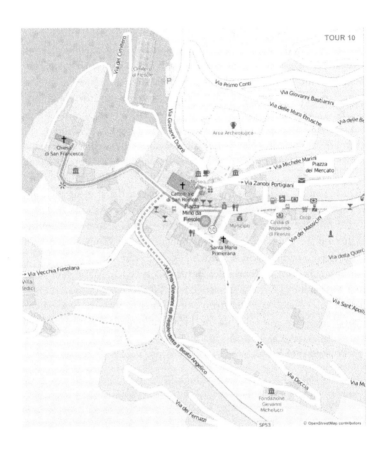

Sites: Piazza Mino da Fiesole, Palazzo Pretorio (Palazzo Comunale), S. Maria Primerana, Duomo di San Romolo, Archaeological Area and the Museo Civico Archeologico di Fiesole, Museo Bandini, Palazzo Vescovile, Sant' Alessandro, San Francesco, Villa Medici in Fiesole, San Domenico. Distance: 1.65 km

FIESOLE

The beautiful hilltop town of Fiesole 8 km northeast of Florence is the perfect destination for a stroll away from the bustling streets of the historic centre of Florence. Built on Etruscan, Roman and Lombard settlements, the town occupies a strategic position overlooking the fertile Arno valley. In the Middle Ages, it was independent but it was conquered by the Florentines in 1125. Boccaccio's *Decameron* is set here and Fiesole with its cool breezes far from the crowded city streets and activities of the cloth and leather industries attracted wealthy Florentines during the period of the Black Death and afterwards, including the Villa Medici considered the first Renaissance villa and garden. Over the centuries, Fiesole has attracted notable residents and visitors, including John Temple Leader, Gertrude Stein, Alice B. Toklas, and Frank Lloyd Wright (1910). Today, it still attracts Florentines and tourists looking to escape from the city and enjoy the beautiful views and summer breezes.

Fiesole is only 30 minutes by ATAF bus # 7 from the bus station at Stazione di S. Maria Novella or from Piazza San Marco (on the San Marco side of the piazza) to arrive at Piazza Mino da Fiesole. Purchase 3 bus tickets if you would like to visit S. Domenico at the base of the hill where Fra' Angelico entered the Dominican Order.

The charming **Piazza Mino da Fiesole** is named for the Tuscan sculptor (*c.*1429–1484) whose works are in the Duomo. Artists from Fiesole include Lorenzo Monaco (1370–1424) and Fra' Angelico (*c.*1395–1455) now known as Beato Angelico since his beatification by Pope St. John Paul II in 1982. The area of the Duomo di San Romolo occupies the location of the ancient **Capitolium** and **Roman Forum of ancient Fiesole (Faeuslae)**. On the upper slope of the

piazza is the **Equestrian monument** by Oreste Calzolari (1906) that commemorates a pivotal event in the Unification of Italy, the meeting and handshake between the future Italian King Vittorio Emanuele II and Giuseppe Garibaldi at Teano in 1860. Behind the monument facing the piazza are Palazzo Pretorio and the small church of S. Maria Primerana. Facing the monument at the far end of the piazza is Palazzo Vescovile (Bishop's Palace) next to Via di San Francesco. Opposite the bus stop are the Duomo di San Romolo and the entrance to the Archaeological Area. From the bus stop, walk through the right hand side of the piazza. Archaeological excavations have uncovered a Lombard necropolis site in the area of the piazza. The artifacts are now displayed in the Museo Civico Archeologico.

The **Palazzo Pretorio** (14th century) is now the town hall (Palazzo Comunale) of Fiesole. Family crests of podestà (1520–1808) line the walls of the loggia. Adjacent to it is the small church of **S. Maria Primerana** that was first documented in 966. Remodelling began in the 16th century, including its facade with painted decoration by Lodovico Buti (1592–1595) but it was not completed until 1801. In the sanctuary is a painting of the *Madonna Enthroned with Child* (*c.*1255) in the Gothic tabernacle. In the south transept are two marble bas-reliefs by Francesco da Sangallo including one with his *self-portrait* (1542) and the other of *Francesco del Fede* (1575). The large *Crucifix* on the wall dates to the 14th century and the glazed terracotta *Crucifix with the Madonna and Saints* in the north transept is by Andrea della Robbia. The damaged frescoes (late 14th/early 15th century) with *Scenes from the Life of the Virgin* are by Niccolò di Pietro Gerini.

The **Duomo di San Romolo** is dedicated to St. Romulus the disciple of St. Peter who first preached Christianity in the town of Faesulae. It was built in 1028 with alterations in the 12th, 13th and 19th centuries on the foundations of structures as early as the 4th century BCE. Later structures occupied the site in the Roman period (1st–2nd centuries CE). A large building corresponding to the orientation of the nave of the original church is the **Capitolium** that was identified by a stone marker (*cippus*) with an inscription referring to the Capitoline Triad of Jupiter, Juno and Minerva. It faced the Roman Forum in the area of Palazzo Vescovile. The ruins are visible below the pavement and some of the columns in the nave have ancient Roman capitals. The bell tower

(1213) with clock is visible from Florence. Cathedral status formerly belonged to the church at the location of the current Badia Fiesolana at the foot of the hill.

The plan of the church is similar to that of S. Miniato al Monte (Tour 9) with a raised **choir**. In the apse are frescoes with *Scenes from the Life of St. Romulus* by Nicodemo Ferrucci (*c.*1590) and a marble reliquary. The high altar (1273) altarpiece of the *Madonna Enthroned with Child and Saints* is by Bicci di Lorenzo (*c.*1450). On the south side of the choir is the **Cappella Salutati** with an *altarpiece* and *Tomb of Bishop Leonardo Salutati* (completed before the Bishop's death in 1466) by Mino da Fiesole. The frescoes in the lunettes of the *Evangelists* are by Cosimo Rosselli. Below the choir is the **crypt** built into the foundations of the Capitolium with fresoces at the entrance of *St. Benedict* (*c.*1420–1430) and a later *St. Sebastian* attributed to the school of Perugino. The columns of the altar of St. Romulus incorporate Ionic capitals from the first church. The granite baptismal font is by Francesco Ferrucci who is known as Francesco del Tadda (1569). On the west wall is a niche with a glazed terracotta statue of *St. Romulus* by Giovanni della Robbia (1521).

From the side of the Duomo facing the piazza walk behind the apse onto Via Portigiani. The entrance to the **Archaeological Area** is straight ahead at No. 1.

Ancient Fiesole was an Etruscan town called **Faesulae** (Romanized spelling of Viesul or Vipsl) that flourished from the 9th to 4th centuries BCE. As with other Etruscan sites, it evolved from the earlier indigenous Villanovan culture that had absorbed the migration of peoples to Etruria (ancient Tuscany) from Asia Minor. It was not one of the twelve major city states that formed an Etruscan League in Etruria, including Chiusi, Volterra and Arezzo and closer to Rome, Veii, Caere, and Tarquinia but it was an important centre in areas in Italy that later came under Etruscan influence. The Etruscans were trading partners with the Phoenicians and Greeks whose pottery filled their tombs.

After conquering Veii in 396 BCE, an expanding Rome challenged Etruscan control of Italy and the Tyrrhenian Sea (based on the Roman name for the Etruscans) a period that corresponds to the construction of the monumental Etruscan Walls of Faesulae in the 4th century BCE. The Hellenistic period indicates trade with other Etruscan areas of northern Etruria. Rome later acquired more control of the

Mediterranean after the end of the First Punic War against Carthage in 241 BCE. Like Greeks and Oscans living in settlements in central and southern Italy, the Etruscans were Romanized and their culture became indistinguishable. Etruscan tombs from the 4th to 3rd centuries BCE were excavated (from 1830 to 1957) on Via del Bargellino the continuation of Via Gramsci out of Piazza Mino da Fiesole. The necropolis site was likely located outside an eastern gate to the city. The grave goods, including cinerary urns are displayed in the Museo Civico Archeologico.

Faesulae was famous for its school of augury to which Rome enrolled 12 men each year. It was defeated by Rome in 283 BCE at the Battle of Lake Vadimo against a coalition of Etruscans and Gallic tribes of the Boii and Senones and was the scene of the *Battle of Faesulae* (225 BCE) between the Roman Republic and allies from central Italy against the Gauls living in the Po Valley. Faesulae was also allied with Rome against Hannibal (217 BCE). It was conquered by the consul L. Porcius Cato in 90 BCE for siding against Rome in the Social Wars and established as a Roman colony for veterans by Sulla in 80 BCE. The Roman monuments of the Forum and Archaeological Areas were built beginning in the 1st century BCE and were restored in the 3rd century CE.

In the period of the later Roman Empire, Stilicho defeated the Visigoths here in 406 CE and protected access to the Via Flaminia that connected Rome to Ravenna. The first reference to a Bishop of Fiesole dates to 492–496 CE. The ancient Etruscan walls and later fortifications were razed by the Byzantine general Justinus in 539 during the Gothic War in Italy (536–553). The area of the Roman monuments, such as the baths, theatre and temple, used as a necropolis site from the 4th century CE decayed into the Middle Ages. In the 6th to 7th centuries, Fiesole fell to the Lombards and the tombs from a necropolis site in Piazza Garibaldi (a short distance from Piazza Mino da Fiesole at the start of Via Gramsci) are now displayed in the Museo Civico Archeologico.

The **Roman Theatre** with a seating capacity of 3,000 spectators was excavated and restored in 1873 under the supervision of Marquis Carlo Strozzi. It is one of the best preserved Roman theatres with its seating area (*cavea*) largely intact but it is missing the wall behind the stage (*scaenae frons*) that was decorated with columns and niches for

13. Roman Theatre. Fiesole

statues. It was begun in the reign of Augustus and completed under the emperor Claudius. It was restored in the 3rd century CE. Etruscan actors are first attested in Rome in the 4th century BCE even though the first scenic performance in Rome was staged in 240 BCE following the First Punic War. Dancers and musicians are portrayed in Etruscan tombs such as the famous *Tomb of the Leopards* in Tarquinia.

The surviving arches of the **Roman Baths** complex are behind the theatre to the right. In the covered area of the complex was a *frigidarium* (cool water pool). The reconstructed hypocausts, the underground heating system for producing steam and warming the water indicate the areas for the caldarium (hot water pool) and the tepidarium (warm water pool). In the outdoor area of the complex was another cool water pool and areas for exercise. The complex was restored in the 3rd century CE.

The **Etruscan-Roman Temple** is to the left of the bath complex. A Roman temple was built into the foundations of an Etruscan sanctuary (7th–6th century BCE) after 90 BCE and enlarged to include a stoa, a covered portico. The discovery of an owl statuette indicates that the

Roman temple was dedicated to Minerva whose cult was later absorbed into the cult of the Greek Athena.

A line of the **Etruscan Walls** runs between the Etruscan-Roman Temple and the Baths. A staircase leads down to the area at the base of the walls. The line of walls ran 2.5km around the city made from local stone carved into massive blocks (4th century BCE).

The **Museo Civico Archeologico di Fiesole** was opened in 1878 in two rooms of Palazzo Pretorio but the collection was moved to the current Neoclassical building in 1914. On the **ground floor** are archaeological finds from the area of Fiesole, especially the monuments in the Archaeological Area and surrounding territories including the Etruscan tombs from Via del Bargellino. Exhibits of architectural fragments, daily life items, funerary and votive objects progress from the Iron and Bronze Ages, Etruscan and Roman periods through to the Lombards, including the Etruscan *Stele Fiesolana* (early 5th century BCE) with a funerary banquet scene.

On the **first floor** are donations from the collections of Marquis Carlo Strozzi and Marquis Edoardo Albites, including the famous portrait from the beginning of the 2nd century discovered in Rome and attributed as *Vibia Matidia*, the sister of the Emperor Hadrian's wife Vibia Sabina. An extensive collection of Greek, Villanovan and Etruscan pottery from the important Alfiero Constantini collection is also on display. Recent additions to the museum collections include reconstructions of the **Lombard tombs** excavated from the necropolis in Piazza Garibaldi and other newly discovered artifacts.

The **Museo Bandini** is on Via Duprè No. 1 next to the Duomo only a few feet from the entrance to the Archaeological Area. Built by Giuseppe Castellucci (1913) to house the collection of Canon Angelo Maria Bandini (1726–1803) from Fiesole that is displayed on two floors. On the **first floor** are paintings from the 13th to 17th centuries, including a painting of *Christ* on glass from the workshop of Giotto (1305–1310); Taddeo Gaddi's *Annunciation* (*c*.1340–1345) and *Four Saints* (1335–1340); Bernardo Daddi's *St. John the Evangelist* (*c*.1335–1340); and Nardo di Cione's *Madonna del Parto* (1335–1350). In the second room are Lorenzo Monaco's *Crucifixion and Saints* (*c*.1420–1425); Giovanni del Biondo's *Coronation of the Virgin* (1373); paintings by Lorenzo di Bicci, Bicci di Lorenzo and Neri di Bicci; and Jacopo del Sellaio's *Four Triumphs* (*c*.1480–1485).

On the **ground floor** are glazed terracottas from the Della Robbia family, including Andrea della Robbia's *Adoration of the Child* (*c*.1495) and *Idealized Effigy of a Boy* identified as St. Ansanus (*c*.1500); Giovanni della Robbia's *St. John the Baptist in the Wilderness* (*c*.1520); and Benedetto Buglioni including his *St. Romulus* (*c*.1515–1520). Giovanni Bandini's marble relief of *St. John the Evangelist* (1575–1580) is a portrait of his teacher Baccio Bandinelli. Florentine Renaissance works on display in the fourth room of the museum includes Luca Signorelli's *Tondo Baduel* (*c*.1492–1500) and early 14th-century relief sculptures from the old altar of the Baptistery of Florence (Tour 2).

Return to Piazza Mino da Fiesole and walk along the wall of the Duomo to **Palazzo Vescovile.** Built in the 11th century, the facade was redesigned with a Baroque staircase in 1675. St. Andrew (Andrea) Corsini, Bishop of Fiesole from 1349 to 1373 lived and died here. The palace occupies the site of the ancient **Roman Forum**. In the garden is a section of Etruscan walls that continues into the garden of the **Seminary** (1637) across Via di S. Francesco that were at the base of the Etruscan acropolis on top of the hill.

Continue on Via di S. Francesco that winds its way up the hill and turn around as you walk up for panoramic views of the surrounding hillside. At No. 7 is a 14th-century house built as a copy of the Church of the Holy Sepulchre of Jerusalem. The **Giardino Pubblico** is to your left that has scenic overlooks with excellent views of the Duomo (S. Maria del Fiore) and the historic centre of Florence in the distance. The garden contains a War Memorial (Ara ai Caduti) by Ezio Cerpi and Giulio Bargellini that evokes the much-copied ancient Tomb of Scipio Barbatus (Vatican Museums, Rome). Exit the garden and continue on Via di S. Francesco for more sweeping views of Florence. The Basilica of Sant' Alessandro is to your right at the base of the next series of steps that lead to the church of San Francesco.

The Basilica of **Sant' Alessandro** was built, according to legend, on the site of a pagan temple that Theodoric converted into a Christian church in the 6th century that was rebuilt in the 11th century and remodelled several times in the 16th and 18th centuries. The Neoclassical facade is by Giuseppe del Rosso (1815–1819). The columns with Ionic capitals that line the nave are spoliated from an ancient Roman building, perhaps the Roman temple that stood here.

Continue past the little church of Santa Cecilia and walk up the flight of steps to the church of **San Francesco** that was built on the site of the Etruscan acropolis. The church was built in 1125 as an oratory and expanded in 1399 for the Franciscans. It was remodelled in a neo-Gothic style (1905–1907) by Giuseppe Castellucci. On the south side, on the first altar is the *Marriage of St. Catherine* by Cenni di Francesco. On the second altar is Piero di Cosimo's *Immaculate Conception* (1480). Over the high altar is a *Crucifixion and Saints* by Neri di Bicci. The choir arch is attributed to Benedetto da Maiano. Adjacent to the sacristy is access to the little cloister with the **Museo Etnografico Missionario Francescano**. On the north side, second altar, is the A*nnunciation* by Raffaellino del Garbo and an *Adoration of the Magi* by the school of Cosimo Rosselli over the first altar.

The entrance to the old **cloisters** (14th and 15th century) is to the right of the facade that incorporate ruins of Etruscan walls. Walk up the stairs to see the cells of San Bernardino of Siena that he occupied in 1417 and other Franciscan friars whose names are painted over the doorways.

Return to Piazza Mino da Fiesole and turn right at the end of Via di S. Francesco and follow Via Beato Angelico that winds down to your left (it is the same road that the bus took to arrive in Fiesole). You are walking along the Villa Medici (visits by appointment only) whose monumental gate entrance is to your right at No. 2.

Vasari assigned the design of the **Villa Medici in Fiesole** to Michelozzo for Cosimo the Elder who bought the property from Niccolò Baldi (*c.*1450) for his son Giovanni de' Medici with whom Michelozzo redesigned the villa between 1451 and 1461 with collaborations by other architects, including Leon Battista Alberti and Bernardo Rossellino. The childless Giovanni left the villa to his nephew Giuliano da' Medici but after his assassination in the Pazzi Conspiracy, the villa passed to Lorenzo the Magnificent. It became a retreat for him where he gathered his circle of humanist friends, including Marsilio Ficino, Giovanni Pico della Mirandola, Cristoforo Landino and Agnolo (Angelo) Poliziano. Guests also included the young **Michelangelo**. Domenico Ghirlandaio inserted a view of the villa in his frescoes for the Cappella Tornabuoni in Santa Maria Novella (Tour 6) as it appeared in 1485. Another view of similar date appears in Biagio d'Antonio's *Annunciation* in the Accademia di San Luca, Rome.

This is the first Renaissance villa and its design without a central courtyard influenced the development of Renaissance gardens as architectural extensions of villas. The original entrance to the villa was from Via Vecchia Fiesolana. The upper garden with lemon trees on the level of the piano nobile was originally entered from the west loggia of the villa. The low walls facing the Arno valley date to the time of Giovanni de' Medici and indicate that tall walls or towers were not needed for fortifications but were designed to allow a view of the outside world unlike enclosed medieval cloisters and walled towns open only to the sky. Panoramic views of the Arno valley and of Florence follow the precepts of Alberti's *De Re Aedificatoria* (influenced by Pliny the Younger's description of his villa at Laurentum) that a villa should look onto gardens with views beyond them onto a city, sea, or mountains. Water flowed on each level for the garden fountains.

The lower terraces are now accessed by the path on the entrance side of the mosaic stone gate behind the belvedere with the Medici crest. An inscription on a plaque near the wall identifies the ruins of Etruscan walls discovered in 1865. The garden terraces were not connected by the artful ramps and staircases of high Renaissance gardens that connected multiple levels that were formerly unlinked in medieval gardens. Architects of high Renaissance and Baroque gardens would later incorporate water into the design of staircases as part of the visual entertainment of gardens.

Successive owners altered the appearance of the villa and garden after Grand Duke Cosimo III sold the villa in 1671. The upper gardens and limonaia were designed by Gaspare Maria Paoletti (1772) for Lady Margaret Orford, the sister-in-law of Horace Walpole, who also added the carriage entrance from Via Beato Angelico. The Mozzi who owned the villa from 1781 to 1862 sold it to the Buoninsegni family from Siena. William Spence next bought the villa (*c*.1862) and hosted Pre-Raphaelite artists, including William Holman Hunt and John Everett Millais. Cecil Pinsent and Geoffrey Scott linked the terraces with a pergola and designed the 15th-century parterre of the lower garden for Lady Sybil Cutting (1911–1923), the mother of author Iris Origo. In 1959, the villa was bought by the Mazzini family.

Retrace your steps to Piazza Mino da Fiesole. For an optional stroll through **Montececeri Park** with hiking trails and panoramic views of Florence, exit the piazza onto Via Giuseppe Verdi and follow

to Via Montececeri and then Via Adriano Mari with remnants of Etruscan walls for views from the highest summit and the location that commemorates where **Leonardo da Vinci** experimented with his flying machines.

Take Bus # 7 to return to Florence or to take it down the hill to the church of San Domenico. The bus stop is two stops away and is in front of the church. If you decide to walk to the church instead, the walk down the hill comes with panoramic views of Florence. Follow the winding Via Vecchia Fiesolana out of the piazza passing the original entrance to the Villa Medici in Fiesole, the **Villa Le Balze** at No. 26 built for Charles Augustus Strong (1913) by Geoffrey Scott with garden rooms designed by Cecil Pinsent and now owned by Georgetown University. The **Riposo dei Vescovi** (Resting Place of the Bishops) at No. 62 is where the Bishops of Fiesole in the 16th century rested on their journey up the hill to their residence in Palazzo Vescovile.

The church and convent of **San Domenico** was founded in 1406 by friars from Santa Maria Novella in Florence: Giovanni Domenici and Jacopo Altoviti, the future Bishop of Fiesole. Construction was completed in 1435 but the portico and campanile designed by Matteo Nigetti were added in 1635. Cosimo the Elder installed the Dominican Order from here at the convent of San Marco in Florence (Tour 5). Fra' Angelico (**Beato Angelico**) entered the Dominican Order here and was in residence from 1429 to 1440 before relocating to the convent of San Marco in Florence (1440–1445). An early work, the *Madonna Enthroned with Child and Saints* (1425) was intended for the high altar but is now in a side chapel. The background was repainted by Lorenzo di Credi (1501) whose *Baptism of Christ* is in the church. The predella paintings are copies of the originals now in the National Gallery, London. Fra' Angelico's fresco *Crucifixion* (1430) is in the convent that now houses the European University Institute (also in the Badia Fiesolana) but many of his paintings, formerly displayed in the church, are now in museums, including the *Crucifixion with St. Dominic* (1435) now in the Louvre and *Annunciation* (1435) now in the Prado.

Opposite the church on Via della Badia dei Roccettini is the **Badia Fiesolana** founded at the location where San Romolo (St. Romulus) was martyred under the reign of the emperor Domitian. Until 1025, it was the Duomo of Fiesole originally dedicated to Saints Peter and Romulus and the monastery to St. Bartholomew. The church was

rebuilt (1456–1467) under the patronage of Cosimo the Elder. The incomplete facade incorporates the facade of the original Romanesque church. Entry into the church is through the cloister (15th century). In the interior based on a design by Brunelleschi is a high altar by Pietro Tacca (1612) and inscription (1466) dedicated to Piero de' Medici (the Gouty), the father of Lorenzo the Magnificent. The former convent is the location of the **European University Institute** that was founded in 1976.

Return to Florence from the bus stop in front of San Domenico.

Opening Hours of Churches, Monuments and Museums

The opening and closing times of churches vary and some are only open on Sunday and for evening rosary. All monuments and museums operated by the Italian State and the City of Florence are closed Mondays, 25 Dec. and 1 Jan., and some also on 1 May. Ticket offices close a half-hour to an hour before closing time. (D = daily, cl. = closed). S. = Saint; Ss. = multiple Saints; SS. = Most Holy.

Badia Fiorentina Open for prayer daily 8–6 except Mon. when open to tourists incl. the Chiostro degli Aranci Mon. 3–6.

Baptistery (Battistero di S. Giovanni) Mon.–Sat. 9:30–5:30; Sun. and Holidays 1–5:30.

Bargello (Museo Nazionale del Bargello) Mon.–Sun. 8:15–5:00. Cl. 2nd and 4th Sun. and 1st, 3rd and 5th Mon.

Bibilioteca communale centrale Mon. 2–8; Tues.–Sat. 9–Midnight.

Biblioteca Nazionale Centrale di Firenze Mon.–Fri. 8:15–7; Sat. 8:15–1:30.

Cappelle Medicee Mon.–Sun. 8:15–5.

Casa Buonarroti D. 9:30–4. Cl. Tues.

Casa di Dante D. 10–6. Cl. Mon.

Casa Guidi Mon., Wed. and Fri. 3–6. Cl. Tues., Thurs., Sat. and Sun.

Cenacolo di Ognisanti Mon., Tues. and Sat. 9–12. Cl. Sun.

Cenacolo di San Salvi D. 8:15–1:50. Cl. Mon.

Cenacolo di Sant'Apollonia D. 8:15–1:50. Cl. 2nd and 4th Mon. and 1st, 3rd and 5th Sun.

Chiostro dello Scalzo 8:15–1:50 Mon–Thurs; 1st, 3rd and 5th Sat; 2nd and 4th Sun.

Cimitero delle Porte Sante: Mon.–Sat. 8–5 (1 Oct. to 31 Mar.); 8–6 (1 Apr. to 30 Sept.); Sun and Holidays 8–1.

Duomo di Firenze (S. Maria del Fiore) Mon.–Sat. 10–5; Sun. and Holidays 1:30–4:45.

Duomo di S. Romolo (Fiesole) D. 7:30–12; 3–5.

English Cemetery Mon. 9–12; Tues.–Fri. 2–5.

Forte di Belvedere (Currently closed).

Galleria dell'Accademia Tues.–Sun. 8:15–6:50. Cl. Mon.

Galleria Corsini (Currently closed).

Galleria degli Uffizi Tues.–Sun. 8:15–6:50. Cl. Mon.

Giardino dei Semplici (Orto Botanico di Firenze) D. 10–7 (1 Apr.–15 Oct.); Sat.–Sun. 10–4 (16 Oct.–31 Mar.). Cl. Wed.

La Specola (Museo di Storia Naturale e Museo Zoologico) Tues.–Sun. and Holidays 9:30–4:30 (1 Oct.–31 May). Cl. Mon.

Museo Archeologico Nazionale di Firenze Tues.–Fri. 8:30–7:00; Sat., Sun. and Mon. 8:30–2.

Museo Bandini (Fiesole) Fri., Sat. and Sun 9–7.

Museo Bardini Fri.–Mon. 11–5; Cl. Tues.–Thurs.

Museo Civico Archeologico and Archaeological Area (Fiesole) D. 9–7.

Museo del Bigallo Mon.–Sat. 10:30–4:30; Sun. and Holidays 9:30–12:30.

Museo dell' Opera del Duomo D. 9–7; Mon., Fri. and Sat. 9–9 (Nov. to Apr.); 9–10 (May to Oct.).

Museo di Firenze com'era (Currently closed).

Museo Galileo Mon. and Sun. 9:30–6:00; Tues. 9:30–1.

Museo Gucci Sun.–Thurs. 10–8; Fri. 10–11; Sat. 10–8.

Museo Horne Mon.–Sat. 9–1. Cl. Sun. and Holidays.

Museo degli Innocenti D. 10–7.

Museo Marino Marini Sat., Sun. and Mon. 10–7; Wed.–Fri. 10–1. Cl. Tues.

Museo Nazionale Alinari della Fotografia (Currently closed for renovation).

Museum of Anthropology and Ethnology Mon., Tues., Thurs. and Fri. 9:30–4:30; Sat., Sun. and Holidays 10–4:30 (1 Oct.–31 May); Mon., Tues., Thurs. and Fri. 10:30–5:30; Sat., Sun. and Holidays 10:30–5:30 (1 Jun.–30 Sept.). Cl. Wed.

Ognisanti Mon.–Sat. 9–12; 4–5:30; Sun. and Holidays 4–5:30.

Opificio delle Pietre Dure Mon.–Sat. 8:15–2. Cl. Sun. and Holidays.

Orsanmichele D. 10–5.

Palazzo dell'Arte della Lana Mon. 10–5.

Palazzo Davanzati D. 8:15–1:50; Cl. 2nd and 4th Sun; 1st, 3rd and 5th Mon. (1 Jan.–31 May); Thurs. 5–8 (July).

Palazzo Medici-Riccardi D. 8:30–7. Cl. Wed.

Palazzo Pitti: Galleria Palatina Tues.–Sun. 8:15–6. Cl. Mon. Royal Apartments closed every Jan. Boboli Gardens, Silver Museum, Porcelain Museum and Costume Museum D. 8:15–6:30 (Apr., May and Sept.); 8:15–4:30 (Jan., Feb., Nov. and Dec.); 8:15–5:30 (Mar.); 8:15–6:30 (Oct.); 8:15–6:30 (Jun., Jul. and Aug.); Cl. 1st and last Mon.

Palazzo Strozzi D. 9–8 Except Thurs. 9–11 p.m.

Palazzo Vecchio D. 9–7 Except Thurs. 9–2 (Oct.–Mar.). D. 9–11 p.m., Except Thurs. 9–2 (Apr.–Sept.).

Sant' Ambrogio D. 7:30–12; 4:30–6. Sun. 10–12.

SS. Annunziata D. 4–5:15.

Ss. Apostoli D. 10–12; 3–5.

S. Carlo dei Lombardi Mon. 1:30; Tues.–Fri. 10–5:30; Sat. 6:30. Cl. weekdays in Aug.

S. Croce and Museo dell'Opera di S. Croce Mon.–Sat. 9:30–5:30; Sun. 2–5:30.

S. Domenico (Fiesole) D. 7:30–12:30; 4:30–6:30 (Summer). D. 8:30–12; 4–5 (Winter).

S. Felice in Piazza Mon.–Fri. 9–11:30; 4–7. Sat. 9–11:30.

S. Felicità Mon.–D. 9:30–12:30; 3:30–6. Sacristy: Fri. 3:30–6.

S. Francesco (Fiesole) D. 9–12; 3–7 (Summer); 3–6 (Winter). Sun. and Holidays 9–11; 3–6:30 (Summer); 3–5 (Winter).

S. Frediano in Cestello D. 9:30–11:30; 5–6.

S. Jacopo sopr'Arno D. 9–11:30.

S. Lorenzo Mon.–Sat. 10–5:30; Sun. 1:30–5:30.

S. Marco and Museo Nazionale di San Marco Mon.–Fri. 8:30–1:50; Sat. and Sun. 8:30–7. Closed 1st, 3rd and 5th Sun. and 2nd and 4th Mon.

S. Margherita de' Cerchi D. 8–12:30; 5–7.

S. Maria del Carmine D. 10–5 Except Tues. Holidays 1–5.

S. Maria degli Innocenti D. 10–7.

S. Maria Maddalena dei Pazzi D. 9–12; 5–7.

S. Maria Novella and Museo di S. Maria Novella Mon.–Thur. 9–7; Fri.

11–7; Sat. 9–5:30; Sun. 1–5:30.

S. Maria Primerana (Fiesole) D. 9–12; 3–8.

S. Martino del Vescovo Mon.–Sat. 10–12; 3–5.

S. Michele a San Salvi 8:30–12; 4–7. Cl. Mon.

S. Miniato al Monte Mon.–Sat. 9:30–1; 3–7. Sun. 3–7.

S. Niccolò oltr'Arno D. 8–10:30; 6–7 (Summer); 5:30–6:30 (Winter).

S. Salvatore al Monte alle Croci Sat. 5:30–6; Sun. 8:30–5:30.

S. Spirito: Church and Museum (Cenacolo di S. Spirito) D. 9:30–
12:30; 4–5:30. Closed Wed.

S. Trìnita D. 8–12; 4–6. Sun. 8–10:45; 4–6.

Synagogue (Tempio Israelitico) and Jewish Museum (Museo Ebraico)
Mon.–Thurs. and Sun. 10–6:30; Fri. 10–5 (Jun.–Sept.). Mon.–
Thurs. and Sun. 10–5:30; Fri. 10–3 (Oct.–May). Cl. Sat. and
Holidays.

Villa and Giardino Bardini Tues.–Sun. 10–7. Cl. Mon.

Villa Medici in Fiesole By appointment.

Glossary

ambo (pl. ambones)	pulpit in a basilica
apse	semicircular area at the end of a sanctuary or chapel that is usually vaulted
arcade	covered gallery supported by arches
baldacchino	canopy over an altar
basilica	ancient Roman civic law court building whose architectural form was adopted by Christians for the design of churches
capital	top part of a column or pilaster usually of the Doric, Ionic, Corinthian or Composite architectural order
cella	interior room of a temple
cippus (pl. cippi)	stone marker usually indicating place of burial
colonnade	a row of columns that supports an arcade, entablature, or roof
confessio	crypt beneath the high altar where saint relics are kept
cosmatesque	refers to the inlaid marble work of the Cosmati
crypt	subterranean chamber used as a chapel or burial vault
duomo	church in Italy holding cathedral status
entablature	elements of a temple above the columns: architrave, cornice and frieze
forum (pl. fora)	open space in the centre of an ancient town for business and assemblies often with commemorative monuments
gens	clan or family group in ancient Rome
hypogeum	subterranean burial chamber

lantern	the top of a dome, covering an oculus that may have its own dome
loggia	covered balcony
meta	turning post in the circus; a marker of any sort including an obelisk or pyramid
pietra dura	hard stone used for in-lay mosaics or building blocks
pietra serena	grey sandstone (Macigno stone) quarried in Fiesole and other cities in Tuscany, including Arezzo and Cortona
pomerium	sacred boundary
portico	the porch, atrium or narthex (if a church) entrance of a building usually defined by a colonnade
quadriporticus	squared courtyard lined with colonnaded porticoes
sinopia (pl. sinopie)	fresco sketch on a wall in a red pigment
spoliation	reuse of architectural or sculptural materials from a monument
temple	a place of worship devoted to a god or gods built following an architectural order or combination of orders in the ancient Greek and Roman world with variations among Jewish, Egyptian and Etruscan buildings
titulus	inscription that defines a property or burial location also used to describe the board placed on Christ's cross with INRI inscribed on it
tribune	raised platform that normally defines the sanctuary of a church or gallery
tufa	travertine (a type of limestone) quarried near Tivoli
verone	loggia

INDEX

Printed in the USA
CPSIA information can be obtained
at www.ICGtesting.com
LVHW020834171024
794056LV00002B/213

9 781780 762142